SNIPER'S NEST:

Art That Has Lived with Lucy R. Lippard

Edited by David Frankel

EXHIBITION TOUR

Center for Curatorial Studies
Bard College
Annandale-on-Hudson, New York

Gallery of Contemporary Art
University of Colorado
Colorado Springs, Colorado

Scales Fine Arts Center
Wake Forest University
Winston-Salem, North Carolina

Spencer Museum of Art
University of Kansas
Lawrence, Kansas

Archer M. Huntington Art Gallery
College of Fine Arts
University of Texas at Austin, Texas

Museum of Fine Arts
Santa Fe, New Mexico

The collection of Lucy R. Lippard is an intended gift to the Museum of Fine Arts, Santa Fe, New Mexico, which will also be the last stop on the exhibition tour.

Published by the Bard Publications Office, Ginger Shore, Director
Annandale-on-Hudson, NY 12504-5000

Distributed by the Center for Curatorial Studies, Bard College, Annandale-on-Hudson, New York 12504-5000

ISBN 0-941276-14-7

Art Director: Juliet Meyers
Designer: Natalie Kelly
Photographers: Douglas Baz, exhibition photographer;
Peter Woodruff, p. 2; Ray Parker, p. 4; Caroline Hinkley, p. 9;
Matthew Gray, p. 56; Ann Stockhamp, p. 70.
Text Editor: Paul De Angelis
Front cover painting: Rachael Romero, *Gregory with Dollar Bill*, 1985.
 Acrylic on paper. 44" x 30" x 1". Photograph by Douglas Baz.
Inside cover photo: *Collection of tchotckes, natural objects, political buttons, and other works.* Photograph by Douglas Baz.

 Center for Curatorial Studies
Director of the Museum: Vasif Kortun
Museum Secretary: Lory A. Gray
Registrar: Marcia Acita
Preparator: Dean Lavin
Director of the Graduate Program: Norton Batkin
Assistant to the Director of the Graduate Program: Letitia Smith
Librarian: Susan Leonard

 Printed on recycled paper

CONTENTS

SNIPER'S NEST:
Art That Has Lived with Lucy R. Lippard

Organized by Neery Melkonian

ACKNOWLEDGMENTS

We would like to direct our sincere thanks to the artists and to the other individuals
who in various ways have helped to bring this project to fruition:

*Stuart Ashman, Director, Museum of Fine Arts, Santa Fe, NM, for partial support of the exhibition cata-
logue; Charlotte Jackson and Rosina Yue Smith for helping to bring the exhibition to the Museum of Fine
Arts, Santa Fe; Maurice Berger, Ronald Feldman, New York, for expert counsel; Linda Norden for her
contributions; Maurice Berger and Elizabeth Hess for their essays; Onnig Kardash, Staatsburg, NY, for the
exhibition design and installation; Julie Ault, Rudolf Baranik, Judy Chicago, Jimmie Durham, Charles
Frederick, Arlene Goldbard and Don Adams, Leon Golub, Harmony Hammond, Jennifer Heath and Jack
Collom, Caroline Hinkley, Jerry Kearns, Suzanne Lacy, Yong Soon Min, Jolene Rickard, Moira Roth, Nancy
Spero, May Stevens, Michelle Stuart, Susana Torre, Anne Twitty, and Kathy Vargas for their reminiscences;
Marcia Acita for her "Registrar's Note"; the Center's graduate students, Anastasia Shartin, William Stover,
and Gilbert Vicario for research on the exhibition; and Pip Day and Andrew Gerharty for research on the
exhibition wall texts and the interview; Sarah Granett, Sherleen Green, Brian McKee, Jamie Blackman,
Voki Kalfayan, and Beverly Hurwitz; Susanna Singer for the Sol LeWitt wall drawing; Lawrence Weiner
for* Arctic Circle Shattered*; and Cavin-Morris Gallery, New York, and David White.*

Special gratitude to Lucy Lippard, whose inspiration and guidance has made this exhibition possible.

—Vasif Kortun, Director, Center for Curatorial Studies Museum

LIVING SPACE
Lucy R. Lippard

Objects and spaces together define memory. This show is sort of a memorial to a still living space, the loft in Lower Manhattan where I spent twenty-six emotionally, aesthetically, and politically exhilarating years. This narrow, grimy, book-jammed, scruffy-plant-infested, light-only-at-the-front space still reverberates with meetings, dancing, dinner parties, intense discussions, loud music, a ringing phone (no machine), and the faulty door buzzer that replaced the yell-and-throw-the-key-out-the-window of earlier years. On walls, shelves, floor, and ceiling, the art and not-art set the scene.

My three-year-old son Ethan and I moved into the sniper's nest in November 1968, on the very heels of the furniture-refinishing business that had moved out the same day. I had every intention of creating a clean, light, sparsely decorated space—the image of the SoHo loft just being fashioned (as opposed to the old-style rough-and-ready artist's live-in studio), and a minimalist model I had come to enjoy when living on the Bowery with Robert Ryman. Left to my own devices, however, nature soon reasserted herself. Within a few years I'd filled the place up with stuff, some of which was art—not a "collection" but a visual record of friend-ships, obsessions, and political struggles.

It started six months after I moved in, when I finally got the place painted white. Sol LeWitt—an old friend from the days when we both had flunky jobs at MoMA—made a wall drawing on a big bricked-in arch where I thought the couch would be, but it was too dark there in the middle of the loft. So his field of pencil lines stayed invisible in what became a storage area that was a good

JULIE AULT
THE ABSENCE OF BORDERS

In the introduction to her most recent book, The Pink Glass Swan: Selected Feminist Essays in Art, *Lucy Lippard writes, "I've been accused of being a moving target. But what target in its right mind wouldn't move?... Mobility (and flexibility) has become a strategy as well as a temperament and intellectual preference." For Lucy, the temperament came first—self-possessed, she has a critical spirit, an instinct for movement, a democratic mind and approach, and, always, a position. She is continually deaccessioning intellectually, making space.*

The features of Lucy's personality—how she lives in the world—are manifest in every aspect of her cultural production: her writing (in its stunning scope of interests and forms); her teaching, instigating, collaborating, starting things up (groups, organizations, conversations). A picture emerges, its elements and their configurations always in flux: unafraid of involution (self- and with others), she is grounded in

CONTINUED

1

an interrogating (not just questioning) of her own internal formations, all the while acting and fighting for changes in our social system, and using different methods for different times.

As for what a person like this might come by over time, what she might own: Lucy is not particularly acquisitive, but is always receiving (many many gifts) and always producing (art, shows, organizations, books, events). Her collection is socially accumulated. A spectrum of art and artifact unlimited by aesthetic allegiances, it is culture in its very broadest sense; like her writings, it reveals private and social histories—not purchased, or gathered or observed from a distance, but lived—and evidences her ethical path, alliances, and contributions to decades of aesthetic-political discourse.

It's fascinating how people arrange their belongings—books, art, all sorts of stuff. Thought processes (chaotic, ambivalent, controlled) are indicated, at least superficially. One gets a sense of another's composition, boundaries, and permeability. Lucy's coffee table is always piled high to

CONTINUED

place to dance. (These wall drawings have many lives, though: from Prince Street to Bard, 1969 to 1995.) LeWitt also made me a table and I inherited another made by sculptor Herbert Ferber. Rosemarie Castoro did a "Moving Ceiling"—wheels on a patch of the stamped tin that remain there to this day to puzzle the observant. Bob Huot marked every corner in the place with tiny squares of luminescent green tape so the space was spectrally articulated in the dark. Marianne Scharn made a handsome geometric abstraction with tape on the wall over the sink. Seth Siegelaub temporarily left me his brick floor piece by Carl Andre, which I once used as a table for a kids' birthday party. Charles Simonds and his invisible Little People colonized the loft with their red-clay dwellings. A luminescent heart was painted on the ceiling over my bed as a Valentine's Day surprise, and the purple bathroom filled up with political mementos.

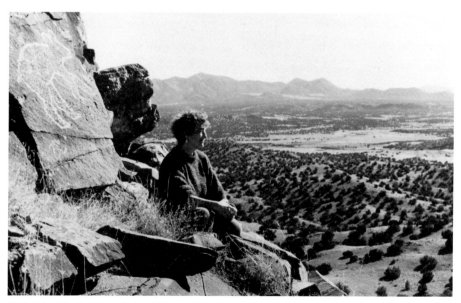

With rock art in the Galisteo Basin, 1993.

2

Most of the art moved around the loft all the time, as my passions and interests changed. I've always seen my life as a collage and I've always said that everything I know about art I've learned from artists. My environment has affected my writing, or vice-versa. The loft was always in process. I never had a closed-off bedroom or study because I needed to live up front near the light. The mess, the raw materials, were always visible. I look around a lot, at what's on the walls and out the windows, and connect it with what I'm writing, thinking, or organizing about. In the early '60s I started a "salon" wall of edge-to-edge art over my desk. The bookshelves were/are lined with tchotchkes and images that have struck my fancy. New concerns called for rearrangements, additions, subtractions. Things got buried in the mess and then resurfaced.

Outside, the neighborhood was changing too. First it was an illegal, then a legal, artists' stronghold, as the loft living laws changed and adapted to our persistence in living where we weren't supposed to be (spaces zoned for manufacturing). Cheap space was worth the hassles. Firemen came to the door early one morning around 1970 when I was cooking breakfast and my kid was in his pajamas. Are you living here, they asked? No, I said staunchly. They rolled their eyes. I co-curated the first show at Paula Cooper's new Prince Street gallery and hung a Chilean protest show at Ivan Karp's second space before the sheetrock was on the walls. Other galleries, with weaker ties to the artists' community, arrived along with boutiques and expensive restaurants; artist renters were priced out; only those lucky enough to have bought cheap and early were able to stay. The tourist parade—for whom shopping was more important than art—began, at first on weekends and later week-long. The bakery next door, whose barrels of Viennese Artificial Coffee Cake Flavoring had perfumed and nauseated the neighborhood and whose fat-filled smokestack in the airshaft had almost burned our building

overflowing with a wildly diverse mixture of books and journals, an unarranged assembly informed by mistrust of hierarchy and suspicion of order and fixed systems. There's always room for more in this environment, which, like her work, continues to grow in volume and variety.

I once heard Lucy described as a "national treasure," and always liked that portrayal. What should be collectively treasured? What should be held and revered over time? Integrity of process… dialogue… the simplicity of treating each other well… flexibility? Operational democracy seems so out of reach these days; maybe it always was, but somehow it's still a dear ideal and practice. Dispensing with intellectual and emotional borders that require dogmatic defense is a lifelong process, one that Lucy chooses to make transparent and public through her writing. Her willful and reasoned resistance to categories, borders, labels, compartments, and containment is central to cultural democracy.

Moving target as national treasure.

END

RUDOLF BARANIK

A ROMANTIC VIEW

The Sniper's Nest, which was built piece by piece in such various places as the heart of SoHo, a cove in Maine, the snowy mountains of Colorado, not to speak of jets crisscrossing the continent, has made a festive stop north of New York, on the Hudson, and from there will fly to the semidesert highlands of New Mexico, to Santa Fe, not far from the sleepy village of Galisteo, where the sniper dwells in a casita on land flat under broad horizons.

The travels of the SN, as I will call it, are of great importance to me because its spiritual owner, Lippard, Lucy, is a dear friend and also because in the SN collection(?) amassment(?) mess(?) there is a raven-black feather that was once mine, and it wants to talk to the white feathers of Robert Ryman, but can it? Can it be heard in a nest full of rusty nails, broken razor blades, sharp shards of stone and shell? Can it be heard where yellow and red shout at each other in raspy voices? Can the raven black and ashy off-black

CONTINUED

down, became a museum that never opened and then a classy gallery complex including an uptownish jewelry store.

The neighborhood was going downhill to the right but the loft was moving left. My 1968 move coincided with my belated politicization, and Prince Street became a convenient place for meetings and organizing over the years—from the Artworkers Coalition to the Ad Hoc Women Artists Committee to Heresies to PADD to Artists Call to a proto-WAC group. When the Vietnam war ended, the Artworkers Coalition's 1969 *And Babies . . . ?* poster gave way to Sheila de Bretteville's feminist *Pink* grid and Judy Chicago's *Red Flag*. At one point in the '80s I was startled when a visitor said she didn't know how I could stand to look around me; the place was "decorated" with Central American atrocities, defiant women, murdered revolutionaries, torture victims, leering right-wing politicians, and a homeless man holding a dollar bill over his mouth.

I've been accused of caring less about art than about changing the world, and that's probably

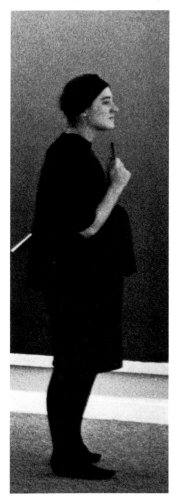

Pregnant art critic (at Ray Parker show) working on first "New York Letter" for Art International, *Nov., 1964.*

accurate. It's not the objects I love so much as their images, their meanings, their content, the ways they connect to each other—-formally and contextually, the way one image can conjure up so many more and inform the whole world in the process. I don't differentiate between the aesthetic and evocative nourishment I get from a geometric abstraction by Henry Pearson or a grid of black circles by Eva Hesse or a militant collage by Jerry Kearns or a root sculpture by Bessie Harvey or a Susan Meiselas photo poster or an anonymous African *ibeji* figure or an old family crazy quilt or an arrowhead washed out of a prehistoric site in Maine.

At the same time, my relationship to the art I write about does differ from my relationship to the objects in my house. I'm most interested in work that is out in the world and/or is trying to change or call attention to the world. Most of it is either ephemeral, large-scale, or contextualized beyond the living room. The art around me, on the other hand, although it is visually arresting and formally satisfying in the ways associated more with objects than with actions, is intimate, recalling dialogues with the artists who made it, which have in turn stimulated my writing about this and other art.

Over my desk for years were images of a typewriter sending up flames and a typewriter greening with leaves. Sometime in the early '70s, when I was wondering (yet again) why I was an art critic, I got a fortune cookie at a Chinatown restaurant that said "Think Not Ill of Your Craft"; later, a friend gave me a padded postcard of Saint Lucy holding her eyes on a platter—the perfect patron saint for an art critic. My critical "career" has been seen from the outside as a series of sharp breaks and new directions, but from the inside it all flows quite smoothly. There was no violent rejection of Minimal and Conceptual art when I was radicalized and then became a feminist; many of the artists were doing that kind of work, though the women were coming from new places. Feminist artists' activism in

ever sleep amidst clenched fists and angry slogans?

Admirable Lucy. Nothing is as is. Everything is as could be, should be, will be. A young Dominican friend who met her, but forgot her name, called her, in conversation with me, la Inquieta—*the unquiet one, the restless one. Lucy's relentlessness transforms desire into fact. This English-speaking New Englander's belief in multiculturalism moved her to put a sign on her door,* "Chinga el Inglés Oficial," *even if her Spanish is far from fluent.*

And so with the SN. In bringing together subtle abstraction, political imagery, posters, folk art, and items of mass culture, Lippard is taking a stand against elitism. But in reality the SN is a manifesto for the importance of art, all art, in life. And that is a romantic view, even if the term "romantic" is one of the ever alert sniper's targets.

END

JUDY CHICAGO

I first met Lucy Lippard in early 1960. I had taken a year off from UCLA and was living in the then-unfashionable East Village with a rebellious young man named Jerry Gerowitz, whom I would wed the following year. Somehow Jerry met Lucy, who was working at the Museum of Modern Art, and she would let him into the museum for free. She was living with an AWOL sailor not too far from the cockroach-infested place that Jerry and I resided in during that sojourn when I was discovering Abstract Expressionism and developing disciplined work habits, painting every day from 8 A.M. to sometime in the afternoon.

I didn't know Lucy all that well but I remembered her when, some years later, she came to L.A. By that time she had somewhat of a reputation as a critic, and I was becoming established as one of the few recognized women artists in an art scene that was decidedly macho. I do not recall how it happened that Lucy and I became friends, but we did, maybe because by the late '60s both of us had experienced some "click" of

CONTINUED

turn led me to broader socialist issues and new alliances among cultural workers. Neither the women's movement nor the left nor "multiculturalism" is associated with any particular style, so my natural eclecticism has always had free rein. In the last few years, as I write a book about "the lure of the local," photography and place-specific art have become more charged for me. But exclusions and conclusions ("either… or") have never been my forte. One thing or idea always leads to another, canyons branching off and leading to new views.

I didn't choose most of the objects on the walls of sniper's nest. I don't think of them as decoration or acquisition. I resist calling this "stuff" a collection, not out of any disrespect for the artists, but because I deserve no credit. Almost everything here was found or was a gift—tokens of friendship, I trust, not obligation or ass-kissing. Attached as I am to these objects, they don't form an image of my taste but of my life. I could go on and on about them. Every object has its story and part of the story is mine. This would be a painless way to write an autobiography.

Totally aside from art-world trends and my own activities, I've always loved found objects and images, especially postcards (sometimes I make little "pieces" from them, for lack of a better word, juxtaposing the images to form a kind of visual sentence) and rocks—above all, rocks. I've never "collected" art the way I've collected rocks. (They're free.) In college I made big woodcuts of rocks and sea; when I learned to print my own photographs they were mostly of rocks. My houses are always full of rocks that might catch no other eye but mine. I love to handle their rough and smooth surfaces and think about compacted geological time, historical time, personal time. They are reminders of spaces and places, of life beyond the mind, of sensuous experience outdoors, of other lives. Eventually I was led by a line of rocks to prehistoric monuments and the book called *Overlay*.

The sniper's nest isn't really the loft; it's my trajectory within and without the art world. I've always felt enough of an outsider there to snipe at the center from the margins, or to try to establish new centers on the margins. If a lot of my friends and accomplices, whose art I've lived with, have eventually become central to the art market, it doesn't mean they don't still snipe (and gripe) too, or indulge in shape-changes designed to confuse the faithful. One model sniper who impressed me mightily was

With son Ethan Isham Ryman at his third birthday party, Grand St., NYC, 1967.

Ad Reinhardt; all I own of his is an unsigned print I bought and a chest of drawers his wife Rita gave me after his death. He offered me a little black painting after I wrote his Jewish Museum catalogue in 1966. I was horrified. He said it was done that way; he'd given one to Sam Hunter, who'd curated the show, and I might as well have one too. We were having a lovely time arguing the pros and cons of gifts from artists to critics, bribes, payoffs, sellouts, etc., and then he died. I was still horrified when Bob Huot gave me a painting a couple of years later. When I said so, he got really pissed off and said Fuck you if you can't forget you're a goddamn critic and

consciousness about the incredible sexism of the art world, both East and West.

Throughout the '70s we would meet in one or another city where we happened to be at the same time, our goal to forge some connection between the East and West Coast feminist art movements. These were very different and so were Lucy and I. But somehow we felt allied in our values and goals, though there is much we have never hashed out between us. For example, I am someone who expresses herself rather directly whereas Lucy always used to say that she couldn't tell me what she thought until she sat down to write. But when she did, the words seemed to be clearer and more perceptive than anyone else's.

Over the more than three decades of our friendship, we have often disagreed. We still do. Nevertheless, we are bonded in some deep way. Often, I would be in a city lecturing after Lucy had been there and would be asked a question to which my answer would produce the response that Lucy had said almost the same thing. Odd how often this has occurred.

Probably the most surprising thing to me

CONTINUED

7

during the years of our friendship was when Lucy—product of an East Coast WASP upbringing (with a stint in New Orleans, which might account for her unpredictability)—began to come to the West and discover both wide open spaces and wide open psychic realities. She used to live primarily from the neck up (except for her libido, which was always strong), but suddenly she was finding alternative paths. This strikes me as just another example of her capacity for change and growth. But the thing I most want to stress is that if I were to spell Lucy's name, it would amount to this: INTEGRITY, which is what I admire most in her even though she often drives me crazy. But that is part of her charm.

END

JIMMIE DURHAM

LUCY'S TOOLBOX

It is surprising and odd to imagine that Lucy Lippard, of all people, might have an art collection. And then, having thought that, I ask myself why it's so odd. I sold her

CONTINUED

you can't just accept a present from a friend. I felt bad and gratefully accepted *Lucy's Lolly* and from then on I avoided the rhetoric and just said thank you.

Sometimes I should have said no thank you. I've always been overcommitted, speeding, impatient, and a lousy housekeeper. Some beautiful things were damaged beyond repair. A fiberglass Bruce Nauman that I bought in California around 1966—a molded floor piece with a fluid edge that looked like melted ice cream—-bit the dust when my son rode his tricycle over it, repeatedly. (He also threw a ball at one of his father's, Robert Ryman's, purest white-enamel surfaces and cracked a patch.) A Rauschenberg print lived in broken glass for so long it was permanently stained. When I sold off some early artist's books to help fund an activist manual countering the official version of Columbus's quincentennial, I was told I'd have gotten a lot more for them if they hadn't been dog-eared, dirty, and overperused in exhibitions I'd curated. But what's art for if not to be seen? The priorities have been activity and communication rather than maintenance and connoisseurship.

I remember coming home one night with a friend who pointed at the high school seniors sitting around the table and said, There's the next generation of artists. It was the first time I'd seen my son's friends that way and he was right. Now the loft has undergone another transformation and the next two generations are nested in the living space; the art is by Max Becher, Andrea Robbins, and Cordy Ryman. Faced a year ago with a move into two small rooms with no wall space (and windows giving onto a soul-satisfying vastness), I chose to live (almost) without art. But all the art I've lived with still lives with me, and the loft remains a home in my mind, a living space. I'll always haunt it. ■

Peeling potatoes at land rights camp in Tierra Amarilla, NM, 1989.

one of my pieces, after all, and like everyone who visited her place in SoHo, I used to nose around all of the things she had.

It did not look like an art collection, though; more like the things she was working with, like tactile and visual evidence of projects and discussions we were all in (and I'm sure we're all still in those discussions, only I'm not in New York much either).

I feel that I've known Lucy since the mid-'70s, because I should have, in the sense that we were both in New York then, trying to connect art and politics. It was during that time that I made the armadillo-skull piece she later bought. There is no dominant story to most of my work—I try for an interruptive and self-canceling complexity—and the armadillo skull is no exception, but these days I'm most likely to say that it tries to connect to the longhorn skulls and buffalo skulls inlaid with turquoise that Santa Fe teaches Indians to make. At the time, though, I wanted primarily to force a great amount of my attention and care, an intensity of work, into "material" that was slightly absurd and at

CONTINUED

9

the same time already full of intensity. So I even wrote a (not-very-good) poem about the making of the piece, in which I asked the poor skull to play a political role. In return for that I promised always to remember the dead armadillo's spirit and to send it to Mexico. That actually worked, at least for the armadillo spirit I carried in my memory, because in 1987 I moved to Mexico myself, and I stayed there until the Indian wars there in 1994.

I'm sorry, I got a little sidetracked. So anyway I met Lucy at the beginning of the '80s and we became friends immediately, as well as political allies. That is the most typical history with her, I guess. She makes friends carefully and quickly. Everyone knows that she does everything; that she works like a whirlwind—it is astounding how many friends she maintains and promotes. Clearly that is part of a political effort (or vice versa).

Not to dwell nostalgically on (supposedly) past times, but there was, as there is now, an incredible war in art circles, especially in places such as New York, where very much money is at stake. Basically the war is

C O N T I N U E D

Objects and spaces together define memory. This show is sort of a memorial to a still living space, the loft in lower Manhattan where I spent twenty-six emotionally, esthetically, and politically exhilarating years. This narrow, grimy, book-jammed, scruffy plant-infested, light-only-at-the-front space still reverberates with meetings, dancing, dinner parties, intense discussions, loud music, a ringing phone (no machine), and the faulty door buzzer that replaced the yell-and-throw-the key-out-the window of earlier years. On walls, shelves, floor and ceiling, the art and not-art set the scene.

"Living Space," *Sniper's Nest* exhibition catalogue essay

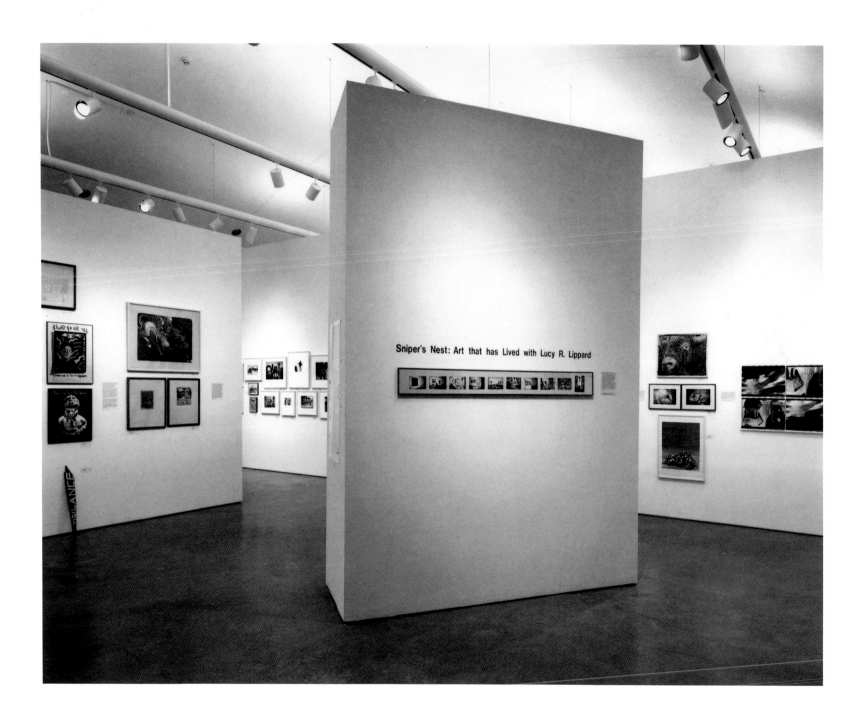

Sniper's Nest: Art that has Lived with Lucy R. Lippard

between the forces of stupidity, which seem to require us all to agree to a norm more and more stupid, and art that accepts no arbitrary limits (such as the stupid platitudes "Art and politics don't mix"). Art that constantly investigates and looks for connections can always be interesting to many people; it doesn't agree to be stupid. That, strangely, can make it "unpopular"— unpopular to those who feel they might participate in the "power" of some elite if they pretend to play their cards wrong.

Long before I met her, Lucy was my hero. Her art-and-culture column in The Village Voice *was intelligent, sharp, compassionate, and on the side of my intelligence. The column drew together all of us who wanted to be in discussion with each other. There was not then the administrative death called "multiculturalism," so we more or less felt solidarity, instead of commercially strategic alliances. Oh, I see that maybe that does sound nostalgic. Well, perhaps not; where will we all be next year when the art councils disappear and the art market circles its wagons? I'm sorry, that doesn't matter at all, does it? It's only*

CONTINUED

Hopes that "conceptual art" would be able to avoid the general commercialization, the destructively "progressive" approach of modernism, were for the most part unfounded. It seemed in 1969 that no one, not even a public greedy for novelty, would actually pay money, or much of it, for a xerox sheet referring to an event past or never directly perceived, a group of photographs documenting an ephemeral situation or condition, a project for work never to be completed, words spoken but not recorded; it seemed that these artists would therefore be forcibly freed from the tyranny of a commodity status and market-orientation. Three years later, the major conceptualists are selling work for substantial sums here and in Europe; they are represented by (and still more unexpected-showing in) the world's most prestigious galleries. Clearly, whatever minor revolutions in communication have been achieved by the process of dematerializing the object (easily mailed work, catalogues and magazine pieces, primarily art that can be shown inexpensively and unobtrusively in infinite locations at one time), art and artist in a capitalist society remain luxuries.

On the other hand, the aesthetic contributions of an "idea art" have been considerable. An informational, documentary idiom has provided a vehicle for art ideas that were encumbered and obscured by formal considerations. It has become obvious that there is a place for an art which parallels (rather than replaces or is succeeded by) the decorative object, or, perhaps still more important, sets up new critical criteria by which to view and vitalize itself (the function of the Art-Language group and its growing number of adherents). Such a strategy, if it continues to develop, can only have a salutary effect on the way all art is examined and developed in the future.

Six Years: The Dematerialization of the Art Object, p. 263, 1973

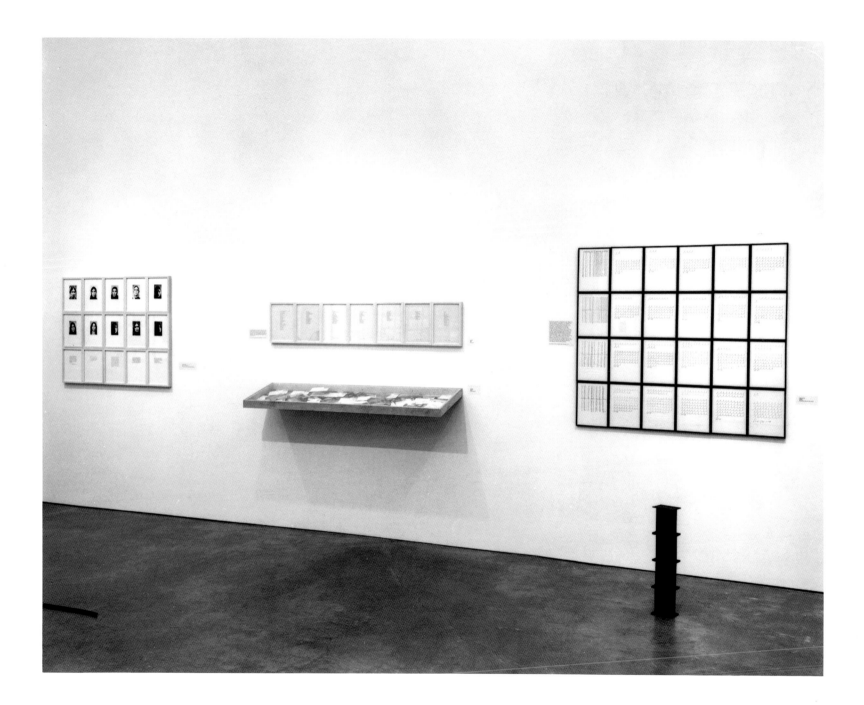

more of the same stupid discourse we've been taught—I wish I were exempt, but I don't seem to be.

Yes, if Lucy had an "art collection" it would be in the nature of a toolbox. At that thought I am suddenly delighted that one of my works might be used for subversion because of what's happened to it after I made it and sold it. A good gift.

END

CHARLES FREDERICK

LUCY EXHIBIT

I first came across Lucy when I read a piece she had published in Block *magazine in about '79–'80. I was taken with her discussion of collage, of the signifying social/political dimensions of formal choices in art. These were ideas I had been working with, both in my performance work and in my theoretical/critical interests in the historical avant-garde. I began an imagined conversation with her.*

I wonder if I saw her as representing a world of art and talk about art that I both

CONTINUED

The experience of looking at and perceiving an "empty" or "colorless" surface usually progresses through boredom. The spectator may find the work dull, then impossibly dull; then surprisingly, he breaks out on the other side of boredom into an area that can be called contemplation or simply aesthetic enjoyment, and the work becomes increasingly interesting.

Changing: Essays on Art Criticism, p. 134, 1971

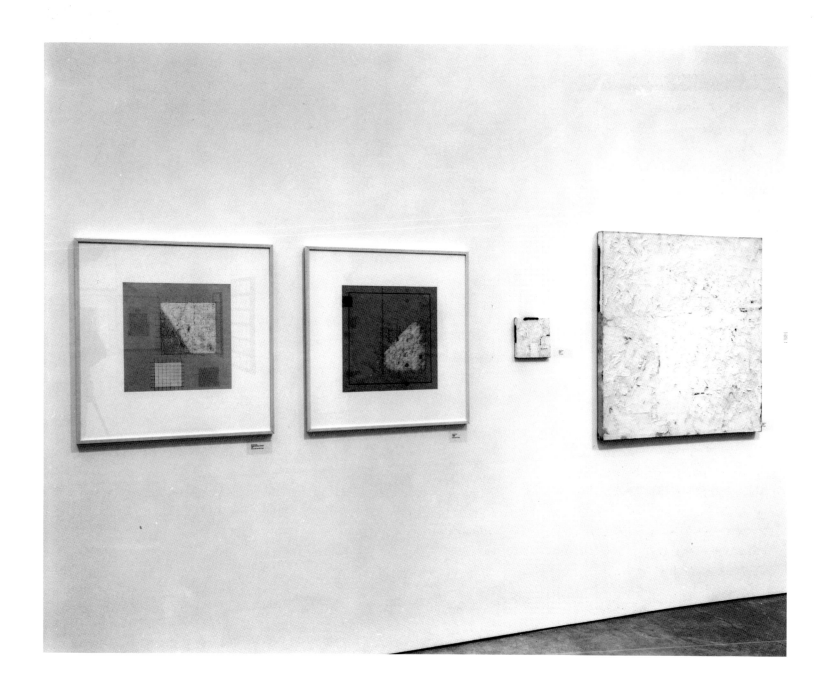

yearned for—since it was by becoming an artist (writer) that I had always imagined I might consummate my ambitions of upward mobility—and was troubled by, since, exactly because of these same class and cultural origins, I was bewildered by that world's insufficiencies in giving telling shape to where I came from. I remember saying to myself—still in monologue, not yet in dialogue—Hmmm. This is a jump that is needed, off the turret of the (white-washed) bourgeois art castle, to talk not about how form is good, pleasing, well done—a castle ornament—but, more radically, about how form in art signifies social imagination, how that castle has been made, as well as, perhaps, how it might be taken down. I remember thinking that I would like Lucy if I ever met her. I was also wondering how to make the aesthetic formal compositional ideas she was discussing a principle of democratic social practice—how to make culturally informed community-organizing a "medium" of artmaking.

I met Lucy in person in 1981, when she was connected with Bread and Roses,

CONTINUED

Whenever there is a women's show, or a Black artists' show, or any similarly "segregated" event, objections are raised on the basis that art is art and has no sex, no color. That's all very well, but artists do, and there has been considerable discrimination against artists of a certain sex and a certain color. A woman's show is no more arbitrary a manner of bringing together a group of artworks than a show of Czechoslovakian Art Since 1945 or Artists Under Thirty-five. When you open a magazine or enter an exhibition space, you have to look at what is there individually, no matter how vague or arbitrary the label under which it is hanging. If you can't enjoy good art because it is hanging with art by one political group or another, but you can enjoy art if it is grouped under the imposition of a movement or a theme or some curatorial whim, then you probably should think about why you are looking at art in the first place.

From the Center, p. 45, 1976

Most modern women lack the skills, the motive, and the discipline to do the kind of handwork their foremothers did by necessity, but the stitchlike "mark" Harmony Hammond has noted in so much recent abstract art by women often emerges from a feminist adoption of the positive aspects of women's history. It relates to the ancient, sensuously repetitive, Penelopean rhythms of seeding, hoeing, gathering, weaving, and spinning, as well as to modern domestic routines.

The Pink Glass Swan, pp. 134-135, 1995

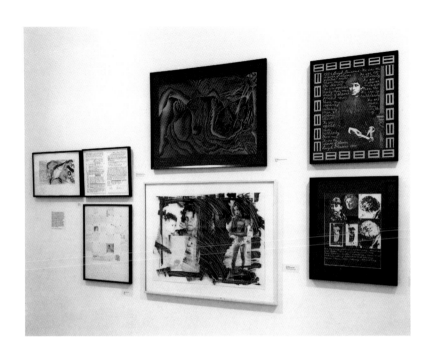

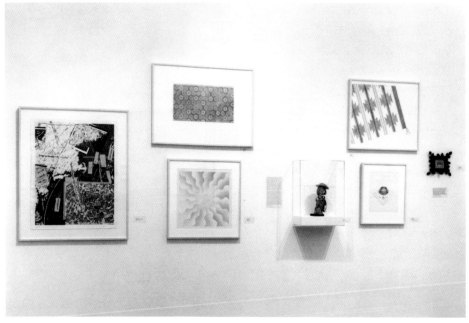

District 1199's cultural project. I remember we disagreed about a performance Bread and Roses was doing in the hospitals for the workers: I didn't know why Actors Equity performers were needed for a community musical performance. But I was proved right in what I had imagined from reading her essay. I liked Lucy. I thought we could be sisters. Then we intersected and worked together in activist art and cultural places through various organizations: PADD, Artists Call, and the Alliance for Cultural Democracy.

None of these organizations was (or could be) anything more than a tent thrown up in our nomad time in history (too many human tribes at war, too many assumptions of hierarchy—however often unconscious—prohibiting the possibility of truthfully mutual settlement). These places where we worked together were places to stop and do and tell, to meet people, make temporary gatherings and alliances—as well as permanent relationships; places to organize political and cultural action (this is a way to make art); places to exchange (hope) and barter knowledge (remaking

CONTINUED

Ethnocentrism in the arts is balanced on a notion of Quality that "transcends boundaries"—and is identifiable only by those in power. According to this lofty view, racism has nothing to do with art; Quality will prevail; so-called minorities just haven't got it yet. The notion of Quality has been the most effective bludgeon on the side of homogeneity in the modernist and postmodernist periods, despite twenty-five years of attempted revisionism. The conventional notion of good taste with which many of us were raised and educated was based on an illusion of social order that is no longer possible (or desirable) to believe in. We now look at art within the context of disorder—a far more difficult task than following institutionalized regulations. Time and again, artists of color and women determined to revise the notion of Quality into something more open, with more integrity, have been fended off from the mainstream strongholds by this garlic-and-cross strategy. Time and again I have been asked, after lecturing about this material, "But you can't really think this is Quality?" Such sheeplike fidelity to a single criterion for good art—and such ignorant resistance to the fact that criteria can differ hugely among classes, cultures, even genders—remains firmly embedded in educational and artistic circles, producing audiences that are afraid to think for themselves.

"Mapping," *Mixed Blessings*, p. 7, 1990

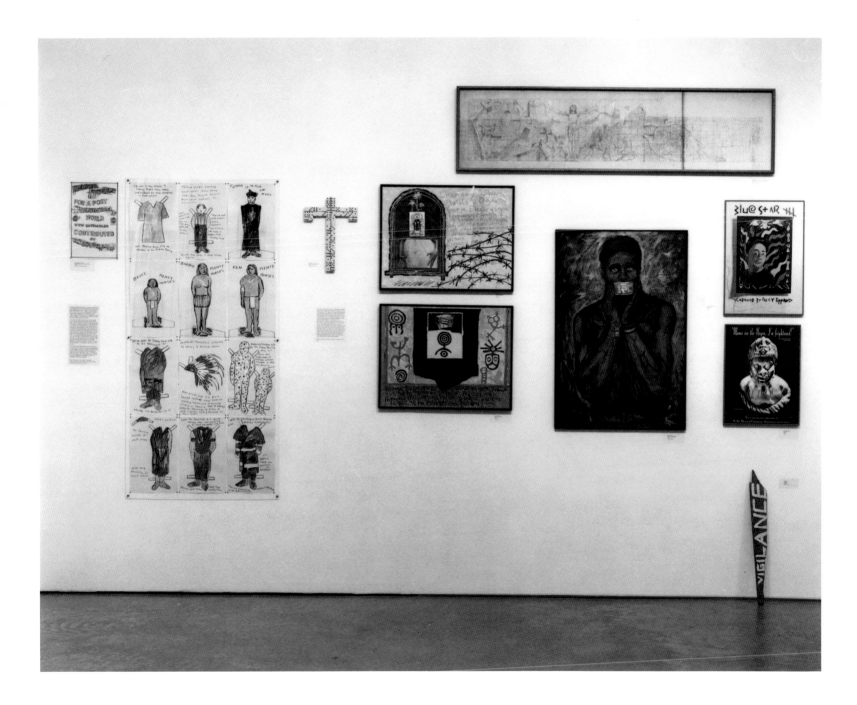

ourselves), understandings, images, re-sources, techniques of material and spiritual smelting and firing and joining and weaving: urns and baskets, masks and garments and banners, songs in new forms of call and response, stories which might (if all stories were told) make us re-member the dis-membered human community. But these places were still obligated to the class, race, and gender conditions that prevailed in the society at large. In art, the overriding form that was not yet fully able to be questioned was social/compositional, not aesthetic/compositional. The question of the multivocal authority of historical subjectivity was not truly on the table.

But there was a mix occurring: activist art, community art, art on the temporary terrain of political action (emblems of our mobilization), art in media performance, art attacking hegemonic images of sex and gender and class and race, art trying to remember that things weren't always this way, art demanding (from whom?) recognition of the unrepresented, the disenfranchised. In high-art discursive terms, this was still a warrior art (sometimes no

CONTINUED

From the late 1940s to the mid-1960s, even the notion of a socially concerned art had been smothered by the lasting effects of McCarthyism and the resultant art for art's sake. Institutional critiques and social consciousness from the civil rights movement onward finally broke the dam of self-imposed censorship, and by the end of the decade even traditionally isolated artists began to participate (or at least contemplate participation) in social movements. In the '60s, art became popular as a lifestyle and as a social theater, although high art remained on the margins while posters, psychedelia, guerilla theater, and music occupied the centers. Professional artists were often outflanked by amateurs in forming the new models of counterculture. The images most remembered from the Vietnam era rarely emerged from the art world.

But that world was in its turn much affected by political culture. The advent of body art and performance and video art can be partially attributed to the war. Conceptual art was an attempt to reintroduce life into art and indirectly reflected on political issues. That art which directly reflected the antiwar movement was often humorous, inventive, angry—and dependent on the media for its view of the war's realities. Probably the greatest effect the war had on high art was not in terms of style or content but was to educate the artists themselves about how much of their mythical freedom was real, how much their aesthetics and social effectiveness were determined by the institutions that decided their economic and/or public fates.

ICI Newsletter, Vol. 3, No. 2, p. 1, 1988

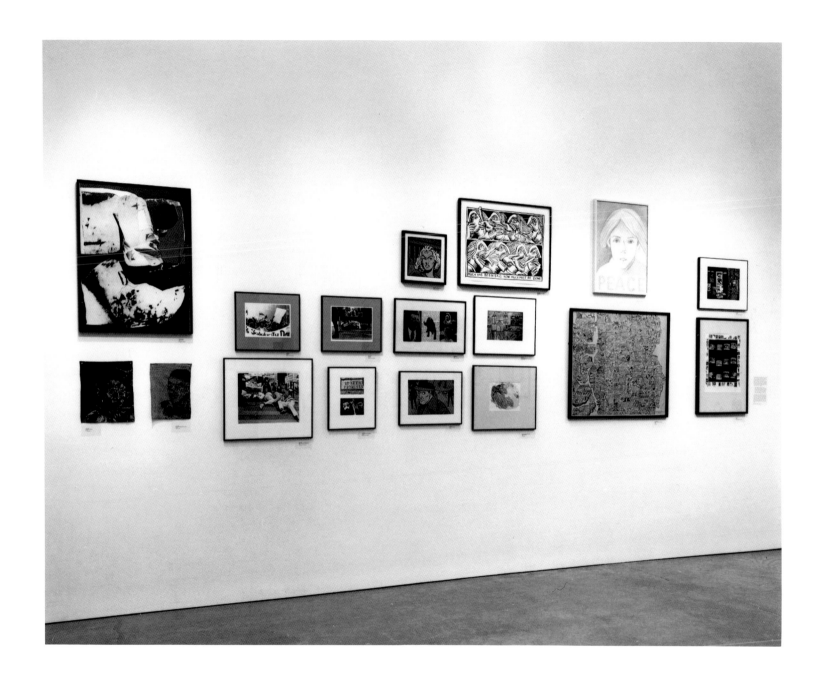

more than a bratty art), an oppositional art. It was not yet a griot art, where image and narrative might be crafted from a universal and egalitarian, material and existential security of possibility, from democratically and collectively sovereign proposals of the facts and purposes of human existence, and where the question of justice—material, cultural, and spiritual—would not be so much a challenge to a regime or a ruling class as, instead, a multivocal exploration of its possibilities, while within its immanence.

What I liked most about collaborating with Lucy (was Lucy) was that I trusted we shared a recognition that the work of art demanded more than craft(y) consciousness of form, medium, or even the subject appearing in the artifact, song, or story. The real work of art was to (re)build a communal culture within which individual works of art would gather to entrance and arrest attention, like the wave momentarily giving the water a shape: signifiers of the sensual, spiritual, narrative, collective and individual whole, not just inventions made significant, juiced by, the restless,

C O N T I N U E D

I became involved in the women's movement for endless reasons, but the most public one is the fact that, as a working critic for five years, I had been guilty of the same lack of seriousness towards women's work as the museums and galleries. Although I had once been an artist's wife, serving tea and smoothing the way for visitors, and had my own infuriating experiences in that anonymous role, I continued to go to men's studios and either disregard or matronize the women artists who worked in corners of their husband's spaces, or in the bedroom, even in the kitchen. I was, I think now, unconsciously responding to her sense of inferiority and insecurity as well as to my own (my "reputation" supposedly depended on male support and respect...).

Now, three years later, a lot has changed, but there is still an immense amount of changing yet to be done. One no longer hears as a matter of course comments from dealers like "I can't have a woman in the gallery, they're too difficult," or "Collectors won't buy women's work." Nor does the art press dare use the term "feminine" in a value-judgmental context, something that once caused many women literally to be afraid of using delicate line, sewn materials, household imagery, or pastel colors—especially pink. One well-known stain painter was accused in a review of "painting her monthlies." This won't happen any more; or, if it does, such a statement might come from an artist who, exploring her own experience, is doing just that!

Twenty Six Contemporary Artists, Aldrich Museum of Contemporary Art, 1971

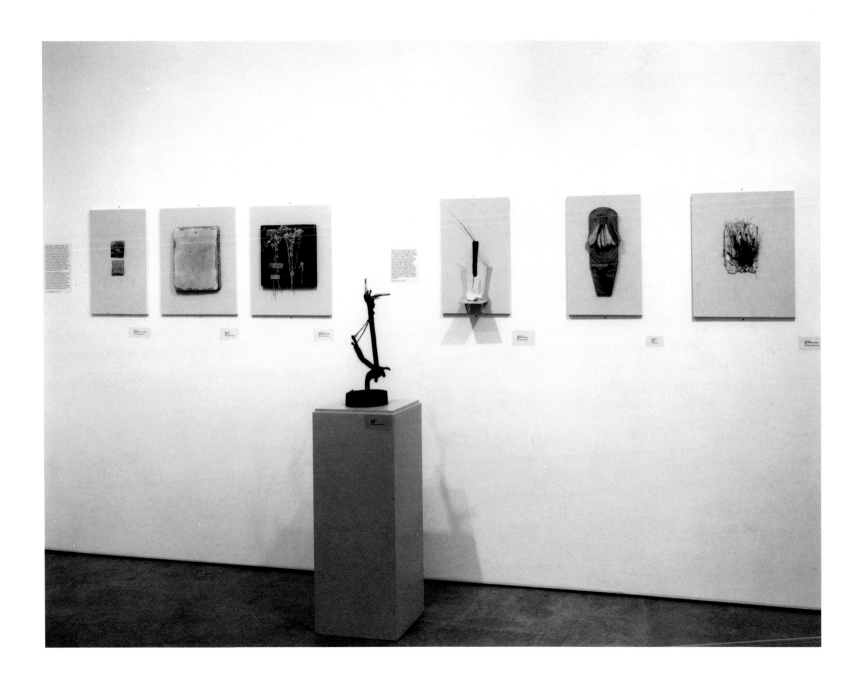

voguish attention of class/gender/race "empowered" (enforced) discourse….

From the mid '80s to the early '90s I worked among gay and lesbian Catholics, assisting the community struggle as we sought our wellbeing, among ourselves, in revolutionary presence in the Roman Catholic tradition, against the Church hierarchy and through the healing efforts of an AIDS ministry. My work was to use my art to facilitate and to shape voice for the community. I brought my poetry into living rooms as a way to give word to our bereavement, and some of the performance forms we crafted resulted in our being arrested inside St. Patrick's Cathedral in New York City. We also wrote Masses to perform on the street. I wrote eulogies as a public form of personal poetry.

Once during this time I wrote an essay as a testimony and witness to who we were as a community, our place in history, and what we felt and what we were enduring, our sorrow, our anger, our fear, our hope, what love and our bodies meant to us, who else we knew we were in communion with in history, how we were able to recognize ourselves

CONTINUED

During the 1960s the anti-intellectual, emotional intuitive processes of art-making characteristic of the last two decades have begun to give way to an ultra-conceptual art that emphasizes the thinking process almost exclusively. As more and more work is designed in the studio, but executed elsewhere by professional craftsmen, as the object becomes merely the end product, a number of artists are losing interest in the physical evolution of the work of art. The studio is again becoming a study. Such a trend appears to be provoking a profound dematerialization of art, especially of art as object, and if it continues to prevail, it may result in the object's becoming wholly obsolete. The visual arts at the moment seem to hover at a crossroad that may well turn out to be two roads to one place, though they appear to have come from two sources: art as idea and art as action. In the first case, matter is denied, as sensation has been converted into concept; in the second case, matter has been transformed into energy and time-motion.

"The Dematerialization of the Art Object,"
Art International, pp. 42-43, 1968

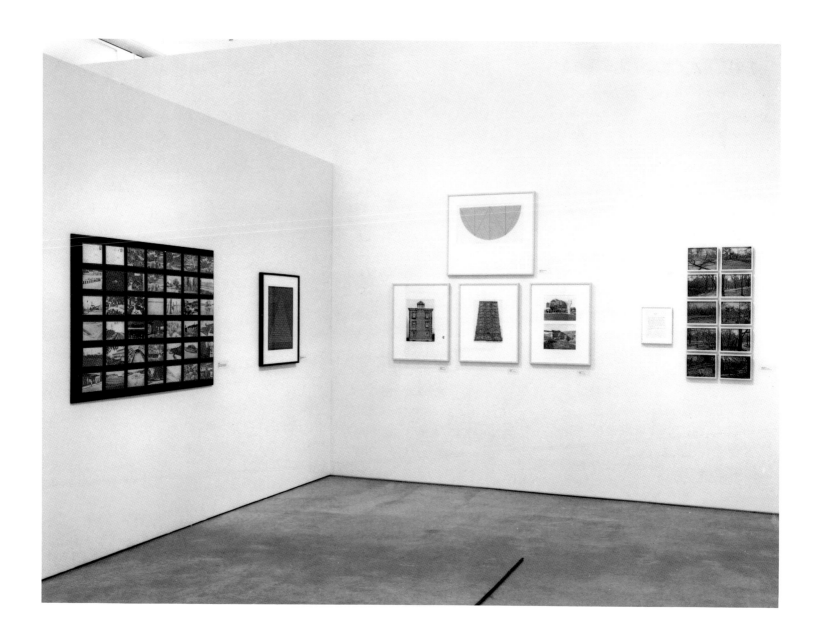

morally, spiritually, and even mystically, in the lore and ritual of our tradition, and how AIDS *had made us into such urgent prophets—why we must act. I wrote that essay, entitled "Gay and Lesbian People: A Human Identity of Love," as a work of literature, and I wrote it to be presented in court in the "form" of an affidavit as part of our defense during our trial after we were arrested in the Cathedral. This is what I mean by griot art: making art from the words we have to say, and alchemizing the crudest necessity into the most elegant forms.*

END

ARLENE GOLDBARD AND DON ADAMS

CALLING THE QUESTION OF CRITICAL STANCE

When we told Lucy we were looking forward to writing this little essay, she fretted a bit about the nature of our assignment. "It's not about me," she said, meaning, we supposed, that she didn't want to be a party to the sort of slavering

CONTINUED

In the case of a restless, multi-centered and multi-traditional people, even as power of place is diminished and often lost in modern life, it continues, as an absence, to define culture and identity. When history fails a community, memory takes up the task. If history comes from above and outside, from teachers and governments, stories are told from the inside at ground level. When governments and dominant cultures prove inadequate, grandmothers become the authorities. And the landscape triggers their memories, becomes symbolic, conveys different messages in different cultural languages.

"Around Here/Out There: Notes From A Recent Arrival," pp. 2-3.
Text adapted from a book in progress, *The Lure of the Local*, 1996

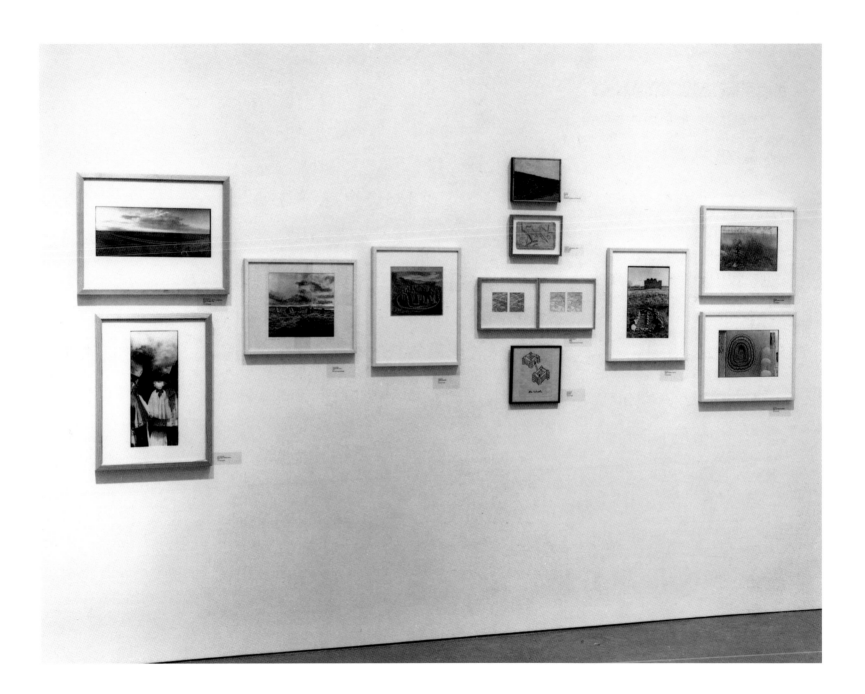

hagiography risked when ardent admirers such as ourselves are asked to submit a few hundred words. In deference to that wish, our stock of charming and revealing anecdotes will remain safely tucked away—save one. Lucy, you see, is one of those people who has managed so thoroughly to embody the concurrence of the personal and the political that the woman is the work and the work is the woman. So of course it is about her, and we hope she forgives us for saying so.

In the early '80s, the egregious Hilton Kramer had the bad taste to try to use Lucy as an object lesson. In the inaugural issue of his journal, The New Criterion, *he portrayed her as a casualty of the '60s, a once talented and promising critic who'd been engulfed and brainwashed by the tidal wave of feminism, multiculturalism, and just plain activism that coursed through that fluid epoch. She wasn't his main target, but he found her a handy tool in a larger job: assailing the Left's hegemony in cultural discourse and calling for an invigorated Right. It seemed possible that this assault might have left*

CONTINUED

REFLECTIONS ON A CURATORIAL PROCESS
Neery Melkonian

On a trip to Iraq in 1987, I went with a friend to visit the ruins of the ancient city of Hethra, located in a remote region midway between Baghdad and Mosul. I was astonished that this jewel-like site had no fence around it, no security guards, no entrance fee, no brochures or other kinds of literature. The curator (caretaker) of this national monument was a Bedouin man who lived on site with his family in a tent with no television, phone, or fax machine. As he walked us through the site he gave us an oral history of the place, occasionally illustrating his point by picking up (with his bare hands) a fragment off the ground, then carefully returning it to earth.

Curating means different things to different people. Similarly, "Sniper's Nest: Art That Has Lived with Lucy R. Lippard" is about many things, and the making of the show is irreducible to a single cohesive exhibition narrative. The idea of curating an exhibition out of Lucy Lippard's private collection came about in a rather organic way, much as the collection itself did. Lucy's and my positions in relation to the elusive terrain called the art world, our cultural and generational differences, and the circumstances surrounding our collaboration all contributed to the materialization of "Sniper's Nest" and helped shape its curatorial premise.

It was over dinner two Septembers ago in Santa Fe. Lucy and I had met to reconnect, as we periodically did when Lucy was in town. She mentioned that the interview I had done with her for *Artspace* was going to be reprinted in her forthcoming book *The Pink Glass Swan*. The news made me feel better, since I was unemployed and my departure from New Mexico, where I had worked and lived for the last six

Eva Hesse. Untitled (study for last sculpture).
1970. Ink on paper.
22 1/$_5$ x 26 x 1 3/$_8$".

Hannah Wilke. Untitled. c. 1973.
Chewing gum on paper.
13 x 10 1/$_2$ x 1 3/$_8$".

Lucy with one or two psychic bruises, due not to the accuracy of the attack (Kramer's aim was predictably wide of the mark) but to the sheer fury of his blows. Yet when we called to commiserate, Lucy was cheerful. "Isn't it great?" she said. "He makes us sound ten times stronger and more together than I ever could."

Kramer's was only the first shot off the bow, of course. Since his article, the cultural right's campaign has been joined by every first-class hypocrite and intellectual villain in the land, elevating its status from a mere art-world skirmish to what is widely seen as a full-fledged culture war. And Lucy Lippard has continued to come in handy as scapegoat and symbol, raising the obvious question: what is it about her that pisses these people off so much?

One thing must be her iconoclasm. She was admitted into the temple of high art—her early works demonstrated the craft and brilliance that unquestionably established her right to be there—and then she had the insufferable impertinence to pull the idols off their pedestals, draw back the velvet drapes, and wonder aloud whether the

CONTINUED

years, was imminent. We talked about the implications of the new wave of cultural tendencies that was pushing its way into an already fragile local art scene and economy. Lucy had told me earlier that she was in the process of permanently moving out of her SoHo loft, and that she still hadn't decided what to do with her "stuff," as she preferred to refer to her collection.

Being a diasporan, and having had the experience of dismantling too many homes in a lifetime, I knew too well what it's like to leave a place behind and to have to let go of objects whose meaning is attached to the memory of a particular place, group of people, and time. I suggested to Lucy the possibility of curating an exhibition of her "stuff" that same evening; she welcomed the gesture. I had not seen her collection yet, but details such as who and what was in it did not weigh much on our initial commitment to work with one another. My intuition told me that given the different art worlds this remarkable woman had known and made known over thirty years as a critic, activist, and feminist, her "stuff" was bound to offer valuable insights about contemporary cultures in America.

Lucy, for her part, was aware of my interest in the changing definitions of art criticism and the emergent role of the cultural critic. In fact I had recently attempted to organize an international forum on the topic. When that project fell through, curating this exhibition became an alternative way of raising some of the same issues, and in the process served as a vehicle to transform a negative experience into a positive one.

Lucy's rich career as a writer and cultural worker provided an ideal context for such a project. After all, she had been on the forefront of so many developments within the art world, starting with Pop, Conceptual, and Minimal art and moving on to

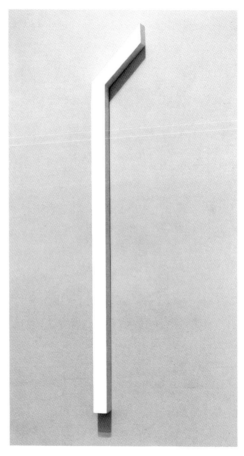

Sol LeWitt. Drawing for Hockey Stick. *1964. Pencil on paper.*
21 x 21 x 1 3/8".

Sol LeWitt. Wall Drawing (Hockey Stick). *1964.*
Wood and paint. 67 x 9 x 3".

whole place wouldn't be improved by a little fresh air. In this she (unfortunately) has no peer: she is the most conspicuous and successful heretic in the entire art world. Of course the sextons must try to drive her off, shouting "Unclean! Unclean!" Their livelihoods depend on it.

Another reason must be the depth and tenacity of her commitment to the cultural values she holds dear. It's hard to think of Lucy Lippard and E. M. Forster in the same sentence, but Forster's motto—"Only connect!"—could have been written with her work in mind. Establishment art criticism is one of the last places on earth where the phrase "objective standards" is taken as anything but an oxymoron. Lucy isn't writing for an audience of initiates in that cramped cant that is the shop talk of the art biz: her interest is in art that makes connections, that brings the unseen and unsaid into the foreground; and her writing proves the point. By making clear the particular brand of truth she is trying to tell, she has called the entire question of critical stance. The body of Lucy's work is characterized by boundless energy, openness to

CONTINUED

protest, feminist, and outsider art and the art of artists of color. Through her writings and actions, Lucy R. Lippard has been instrumental in defining new turfs and terms, taking positions and responsibilities that have shaped our understanding of art within the broader sociopolitical context.

> *... A work of art is a gift, not a commodity. ...works of art exist simultaneously in two "economies," a market economy and a gift economy. Only one of these is essential, however: a work of art can survive without the market, but where there is no gift there is no art....*

> *...Gift economies tend to be marked by three related obligations: the obligation to give, the obligation to accept, and the obligation to reciprocate.*

> —Lewis Hyde, The Gift: Imagination and the Erotic Life of Property

The thought of Lucy owning a "collection" may at first seem like a contradiction, but Lucy did not accumulate her objects with the intention of building a "collection." Most of these small works of art, photographs, artist's books, lithographs, and so on were given to her as gifts by family members, artists, friends, and lovers. The objects within our intimate environments define us beyond ourselves, and speak of the kinds of human relations that constitute a community and a sense of belonging. A rethinking of the meaning of notions such as "gift," "friendship," and "responsibility," then, acted as a guiding subtext in the making of "Sniper's Nest." The willingness of the Center for Curatorial Studies to invest in such a project, and the work of the writers who graciously agreed to contribute to this exhibition catalogue, are themselves further comment on the notions that make up our communal existence.

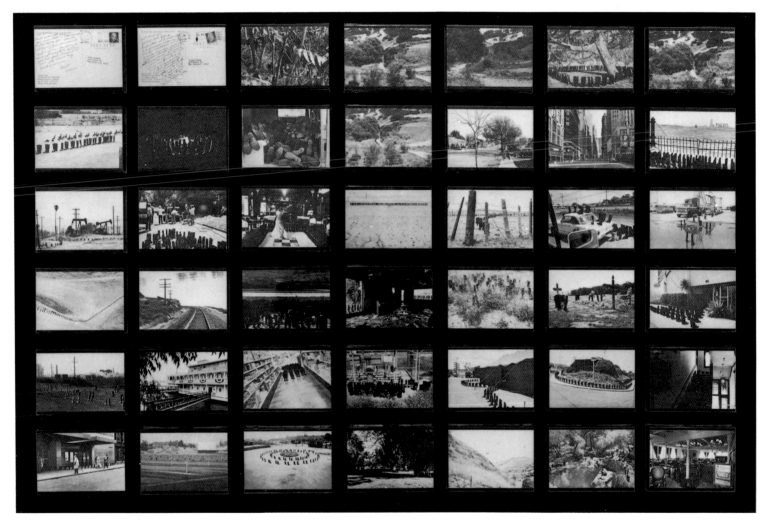

Eleanor Antin. 100 Boots. *1973.*
42 of 51 postcards forming a single work.
40 ³/₁₆ x 6 ¹/₂ x 2" overall; 4 ¹/₂ x 7" each.

debate, and a remarkable willingness to do what needs to be done, including pitching in to invent archives or organizations that channel energy and attention to the work of artists for whom, as for Lucy, engagement is as natural as breathing and disengagement as fatal as oxygen deprivation. It is typical of the optimism encoded in her writing that she has chosen to call her column in Z magazine (and hence, this exhibit) "Sniper's Nest." Someone more cowed by the presence of enemies might have chosen "Moving Target." Dauntlessness puts all other critical stances to shame. No wonder she gets their goat.

E N D

LEON GOLUB

Lucy Lippard has spoken up and spoken for an extraordinary range of art, for so many categories of New York, American, international, and out-of-phase or little-recognized social, political, or gender-oriented issues that they hardly bear listing.

C O N T I N U E D

It was generous and brave of Lucy to allow her private world into the public domain of cultural discourse, particularly when it was to be recontextualized from the perspective of someone like me, working from hindsight and as an outsider. But those who know Lucy would tell you it's very much in her spirit to cross borders and, in the process, to help others do the same. There is an element of vulnerability in most border crossings and acts of self-implication. Such vulnerabilities were integral in the making of "Sniper's Nest," since it aimed to be a site where things began processes of presence rather than marked closures. I think of Trinh T. Minh Ha's approach to documentary filmmaking, which a friend recently brought to my attention: "You are framing someone who had framed so many others and in doing so have framed yourself."

When I was a little girl growing up in the Middle East, Bedouin women from the nearby villages used to come on Fridays to offer their services to the city women. Having had six of her own daughters, my mother did not need much help, but, feeling sorry for these women, she would often ask them to tell the family fortune. With all of us sitting on the floor of the entrance of our house, the fortune teller would ask for a brass bowl of water, some salt, and a string. After chanting some songs, she would ask the youngest of the siblings (myself) to look into the water and report what she saw. To this day I cannot explain in scientific terms what I saw or heard. But I saw and heard things I had not encountered before.

Several years ago, while I was making a studio visit, something triggered a memory of that incident. Later I realized that the way I perceived my role as a critic and curator was similar to the little girl who acted as a translator of a language across time and culture.

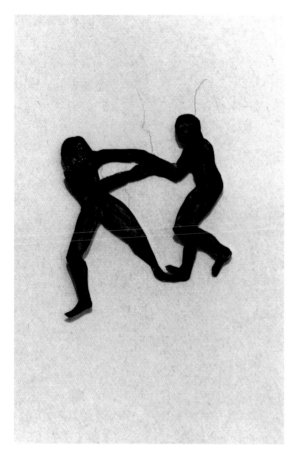

*Nancy Spero. (Couple). *c. 1980.*
Paint and collage on paper.
23 ³/4 x 19 ³/4 x 1 ³/8".

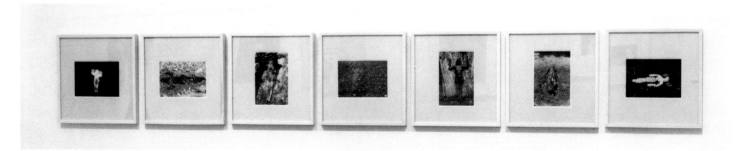

Ana Mendieta. Silueta series. *c. 1970-80.*
Seven color photographs.
19 x 19 x 1 ³/8" each.

REMINISCENCES

Lucy is a protean critical and cultural voice, often going against the trend and the grain and on the side of concerns largely ignored within New York power groupings and their squabbling claims for preeminence and priority. She is in it, with it, outside it, for it, and against it—"it" being whatever it is! Lucy has never been intimidated by art-world power moves, nor is she an intimidator, although she is certainly an initiator and a willing fighter on myriad fronts. Today's histories of art are inconceivable without Lucy's energies, interventions, and sympathies.

So Lucy has decamped to New Mexico. What is she doing there? Is this only a feint, a way of challenging art-world conventions from outside New York as she challenged them from within? Her focus is the future and the now, and she will continue to voice that unique invitation to join her in celebration. Salute!

END

Last August I visited Lucy in Georgetown, Maine, to interview her and go over the exhibition design. As she took me for a walk through the wooded paths near her family's summer home, Lucy told me stories from her childhood, the history of the place and its people. As she spoke, I saw a side of her that I hadn't known before: here was a woman with a strong sense of identity and place, yet one who chose a life of fighting in the trenches of the SoHo art world.

In installing the exhibition, I tried to avoid dividing artworks into rigid chronological or thematic categories, instead suggesting more fluid spheres of influence across time and cultures. In this context, the making of "Sniper's Nest" served as an arena to rethink and metaphorically rewrite the art history offered in textbooks such as Janson's *Art through the Ages*. For example, I placed certain posters, found objects, ornaments, political buttons, etc. in dialogue with "high art," revealing that a particular creative tendency is not fixed to a given medium, artist, period, or geography.

Lucy's collection contained representative works by artists who either helped form or perpetuated many of the artistic tendencies of the past several decades. It seemed natural, then, that the curatorial premise of "Sniper's Nest" would explore the relation of art-making to writing on art, and vise versa. As I began to arrange the works in groups—chronological (Minimalist, Conceptual), thematic (feminism, war/protest), by artist (Sol LeWitt, Eva Hesse), by medium (photographs, posters), and, sometimes in idiosyncratic combinations arising from the inherent qualities of the collection itself—the incorporation of passages from Lucy's writings throughout the exhibition seemed to be the most effective way to accomplish this objective. The texts I selected were chosen to give the viewer/reader examples of her different approaches

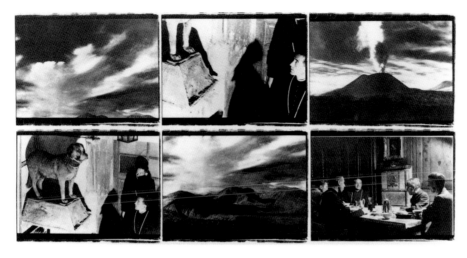

Caroline Hinkley. Death of the Master Narrative. *1990.*
Black and white photographs.
30 1/4 x 58 x 1 3/8"; unframed.

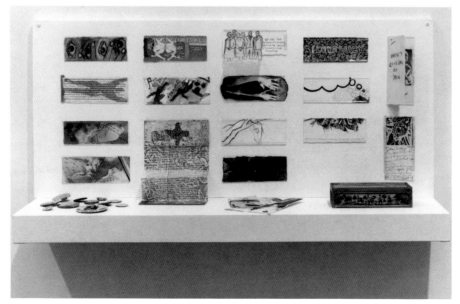

Heresies Box for Lucy, Dec. 1987.
Box of drawings, paintings, collages
by Heresies members on the occasion of
Lippard's resignation from "mother"
collective after eleven years.
Box: 2 x 4 x 9"; 17 works on paper.

HARMONY HAMMOND

It had to have been 1970 or '71 because I was living in a small loft on the corner of Spring Street and West Broadway. Most of the other lofts in the neighborhood sat empty, landlords unable to believe that people really wanted to live and work in them. There were a handful of pioneers—artists and writers (Lucy among them), a few galleries. That was it. For lunch you went down to the corner bodega, the Grand Union by NYU, or the rice-and-beans place. At night, nothing except Fanelli's. You had to go to the Village, Little Italy, or Chinatown.

Women artists were just starting to talk to each other within the context of the larger feminist movement. Complain, compare, share. Take their work and each other seriously. Word was out that this critic, Lucy Lippard, was curating a couple of museum shows on art by women, and was interested in looking at work. I called— too late to be considered for these exhibitions. But she came to my studio anyway, her son, Ethan, in tow. My daughter

C O N T I N U E D

to writing, and to (re)introduce the range of issues and topics she has treated during the evolution of her career. Also, to reference Lucy's contributions up to the present day, "Sniper's Nest" begins and ends with excerpts from the critic's current and forthcoming writings. Besides being quoted throughout the exhibition, Lucy's major books and catalogues, the sources for most of these texts, were made available in a living room-like section of the exhibition, where the viewer could sit down to read, or else watch her on a selection of videos.

As the juxtaposing of texts and artwork began to shape the overall "feel" of the exhibition, it became evident that criticism can be one with, not separate from, the art it speaks of, with, or about. The reproduction of the excerpted texts on clear paper suggested a placement directly on the "skin" of the gallery wall, as opposed to the more conventional, distancing, white exhibition labels. The living room section, which Lucy came to arrange two days before the opening of the exhibition, also included objects from her personal world: a quilt, a family portrait, posters and announcements, mementos, some of the rocks and artifacts that previously cluttered the desk area in her SoHo loft. The making of this room brought together the various aspects of her private and public personae; it was here that one most felt her spirit; as critic, mother, lover, activist, curator, and artist. In the text that she wrote on site for this section of the exhibition Lucy probes into her own roots and family history. It is as if, after all these years of lending her voice to others, the sniper finds rest in her own diasporic nest.

During that same visit to Iraq, one of the leading local artists, Ismail Fattah Al Turk, found out that I had never been inside a mosque, and offered to take me to one located about an hour outside the city of Baghdad. The place was known as an important pilgrimage site, and one could feel the power attributed to it

Louise Bourgeois. Femme pieu. *1970.*
Wax and needles with thread.
6 x 3 ¹/2 x 3".

Tanya, less than a year old, lay asleep in her crib.

I showed Lucy my work—bags made of rags recycled from women friends and the neighborhood sweatshops that turned out garments for the fashion industry. We talked about the work, its meaning, its relationship to women's lives, stitching and the needle arts. An aesthetic of survival. We were women, mothers, and art professionals. Multiple identities. No problem. To my surprise, Lucy bought a piece, my first sale in New York. That piece, Bag IX, is in this exhibition.

So Bag IX, which already embodied the lives of many women, traveled down the street to Prince and West Broadway, where it became part of Lucy's nest of books, art, broadsides, political posters, and furniture from the street. A sniper's nest woven of feminism, art, and politics. A gendered place for cross-fertilization, incubation, and hatchings. A place from which to view out in all directions, make change, fight back, defend, create. Writing goes on in the nest with forays into other worlds and back.

Since then we have worked together on

CONTINUED

from miles away as its golden domes hovered above the barren desert. In its enveloping courtyard, people from the surrounding towns had collected with their families, livestock, and produce to visit, exchange goods, and say their prayers. I was struck by the kind of public usage received by this opulent site, quite different in kind from, say, the hordes of tourists visiting St. Peter's in Rome. Once when I was inside the crowded interior, the heartbreaking cry of a woman caught my attention. As I got closer, I managed to understand that her anger and frustration were directed to God. She was asking why her son had been taken, when not too long ago her husband had been killed in the same war. What was she to do, since she didn't want to marry her brother-in-law? And how was she to feed her young ones? Again, I was struck by the sort of freedom to question authority, that this ordinary citizen was allowed at a religious site. Imagine someone protesting like that at the Cathedral of St. John the Divine without being kicked out, or dismissed as a lunatic. As I turned around to leave—before my emotions could reveal my foreign gaze from behind my borrowed veil—I heard the women nearby offering advice and comforting her. And I thought to myself, what a different form of group therapy!

I was first introduced to Lucy's writings in 1981, in a graduate seminar at UCLA. At one point during the discussion the Marxist-feminist-white-male visiting professor questioned my loyalty to the feminist "cause." Still embarrassed by my immigrant's "accent," I could not bring myself to tell him how wide the gulf was between us. This incident illustrates my peculiar and somewhat ambivalent attitude to various branches of Western feminism. There were moments, of course, where I appreciated and supported its efforts and accomplishments. But somehow I always felt a bit misplaced in relation to feminism, or most other "isms," perhaps because whenever I expected them to be nearby, they always seemed to be elsewhere.

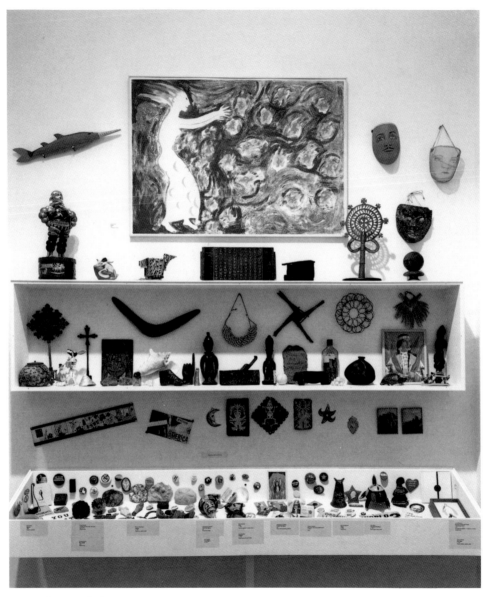

Lucy's collection of tchotchkes, natural objects, and political pins.

Heresies, hiked the high desert, shared work, ideas, feelings, and criticisms—trespassed many places where we were not welcome. What I have always respected about Lucy (aside from her critical eye and writing hand) is her subjectiveness and advocacy—her willingness to take a position, to be out there on a limb or on the line(s) learning from art, artists, and nonartists, sometimes being wrong or changing her mind, not being invested in one position. A willingness to question definitions, boundaries, categories. Many people would like to see Lucy stand still, in the same place, saying and doing the same old thing, year after year. But the position of the sniper is one of a moving target, and in any case feminism did not get turned in for political collaborative art, or multiculturalism. It is in Lucy's bones and woven throughout the nest. She can see the art in politics and the politics in art.

Fed up with the colonized, commercial neighborhood of SoHo and the system it represents (she is well aware of, and tries to minimize, her unavoidable role in the gentrification process), Lucy has moved on to other sites, and is building new nests.

CONTINUED

Rereading some of Lucy's writings made me recognize that the fragmentation and deterritorialization of my cultural experience carried traces of premodern and non-Western models of feminism, curatorship, art, and criticism. Working on "Sniper's Nest" enabled me to identify some of the resulting schisms and to ascribe new meaning to the other kinds of metaphors tucked away in my memory. In mediating the tension rising from such differences, I hope to extend a perspective from those other "in-between" places. ■

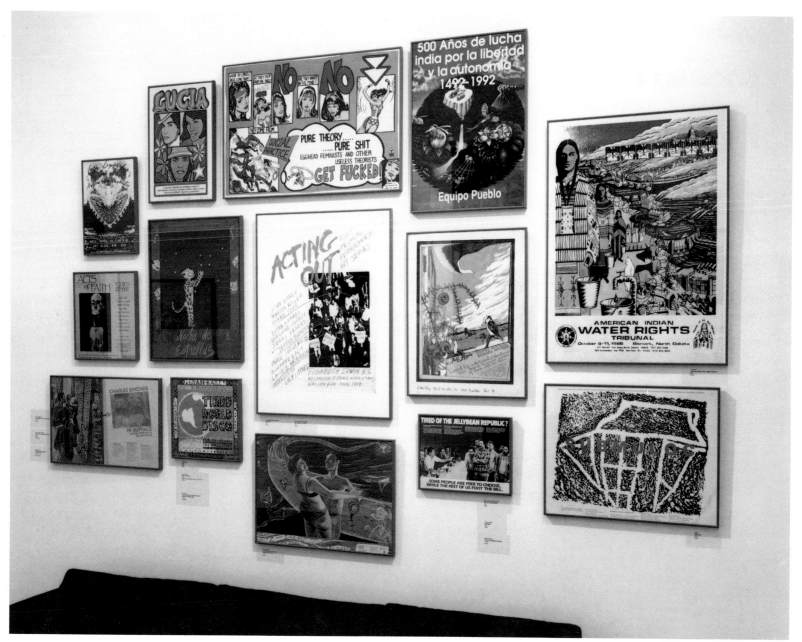

Posters from Lippard's collection.

But her early writing is still relevant. Now, twenty-four years later, Lucy's son Ethan is a musician. And my daughter Tanya is a fine artist in her own right. Lucy has bought a piece from her. Untitled *is in this exhibit (marking the first time my daughter and I have exhibited together). After reading* From the Center, *Tanya, the young artist of the '90s, who doesn't claim to be a feminist but assumes a lot of the feminism that Lucy, I, and other women fought for, pronounced with total conviction and passion, "It's a book every woman artist must read." I agree.*

END

JENNIFER HEATH AND JACK COLLOM

LUCY'S LIP-ERICKS

*While reading some Lucy Lippard,
I thought, "This isn't too hard;
Though it's very intense
It's just common sense—
Art's all over, just let down your guard."*

CONTINUED

LUCY LIPPARD INTERVIEW
with Neery Melkonian

(The interview with Lucy Lippard was conducted in Georgetown, Maine on August 18, 1995.)

NEERY MELKONIAN: The "stuff" you have lived with for so long in your intimate environment is being exhibited in a museum context. How does it feel?

LUCY LIPPARD: Well, I think if I had thought about it, I wouldn't have done it. It's your fault! You had this bright idea. But the actual thing is much more difficult. It's kind of like turning your life inside out, but I had already done that because I was moving anyway. Moving out of the loft after thirty years felt like dying and being reborn. I was going voluntarily, but it was like the end of one life; this is its closure.

NM: You said a little earlier that you really don't go back to read many of your writings.

LL: Now and then, I think, "Oh, isn't it funny that they found *that* interesting?" Or, "did I say that?" You come out of a long life of writing and thinking and talking, thinking you've said and thought certain things, and then someone says, "Well, that's not what you said." Then you look back and realize they're right. But I don't expect to have to deal with that in an exhibition, because it's mostly the art, after all….

NM: For you, it's more the art. I am interested in the text as much, or the relation between text and image.

LL: It's the art in context, and I'm the context, in a way. Yes, that's the way it is: my life is the context.

NM: That becomes especially true when one looks at the variety of the objects

in your collection and tries to see them in relation to your life as a writer and cultural worker.

LL: As I said in the exhibition catalogue essay, it would be a very easy way to write an autobiography: take any one of these pieces, and figure out your relationship to the piece and to the person. There aren't really that many anecdotes about the pieces. I mean, it wasn't a big thing when I got this, or a big thing when I got that. They were pretty organic in arriving. And I'm afraid I always took them for granted, because, never having valued objects tremendously, it didn't make this huge difference that I was given them either. I loved having them, but I don't think I exactly overvalued what I was getting.

NM: Nor undervalued.

LL: Well, maybe I did. The artists were giving me a little piece of their soul. Probably some of them would say I had undervalued the works—the ones that were stained, cracked, bent, and dented.

NM: But that happens to most unintentionally accumulated collections. Or even to collections that are maintained properly where people are hired to dust, polish, guard, etc.

LL: Even then, somebody dusts it wrong.

NM: What is the significance of the rocks, and other objects that are also part of your "collection?"

LL: They mean every bit as much to me as the art does, and I really don't differentiate. Sometimes they mean more to me than the art does. A lot of it is visual and sensual, and I can get every bit as much pleasure out of a rock as I can from a sculpture. They're three-dimensional things that you look at and feel. The whole cultural hierarchy doesn't mean that much to me. I love maps. I have maps and photostats of old maps. I get as much pleasure out of them as I do out of some artist taking that map and making a work of art out of it. (I wrote something about this in the early '70s, in

REMINISCENCES

In Little Italy, what'll we do
Without Lucy, our muscle 'n' glue?
I'm all in a fog—
Prince has shifted to frog
& the "Yo Ho!" of SoHo's turned blue.

How wonderful World Affairs
Might've been without snotty-snob airs.
If Chairman to Chairperson,
Higman to Higperson,
Had happened—hurray! By the hairs!

When nothing is stirring inside,
Then those "Outside Agitators" ride,
With street manifestos,
Recipes for pestos,
& justice flambé as a guide!

O them Wailing them Women,
* them Wailing*
WAC-ing, and Heresies sailing
Mixing It Up
In cauldron or cup
While the rest of the world's merely trailing.

CONTINUED

Well Lucy has helped my career
With her eye & her voice & her ear
Her tomes multicultural
& laugh supernatural
Bewilder the "suits" far and near.

The assignment of Damage Control,
When everything falls in a hole,
And Newts go a slimin'
With Rush 'n' Bush rhymin':—
To be fiery, primal, & droll.

Give us injustice or war,
Racism, ecocide, more…
Glass swans glimmer pink
In a sea of black ink
The feminist outrage and roar.

I tell you, it's all been "2 Much,"
Paintings, photographs, sculptures & such.
Get the Message? *my friend*
The World's at its End;
Don't bother to reach out & touch.

Galisteo—a tiny New World
Where conquistadors settled and hurled
The tongue Isabella
And Columbus, her fella—
Roll o'er for the Great Gringo twirl.

CONTINUED

Studio International). I like landscape painting but I prefer the actual landscapes. I like being in the space more. I'd rather have a rock than a styrofoam rock made by an artist. And I have friends who've made styrofoam rocks. Put in an art context they're really interesting, but in a direct, sensual situation, the rock itself is better.

NM: You once wrote that as a critic you were a " 'cog' in an intricate system that's incestuous socially, politically, sexually, professionally, intellectually, aesthetically." Do you still believe that?

LL: Yes, but now I'm less of a cog. Or I'm a cog who's rusted out or rolled off on its own or something. I said that in those days when I was really involved in the art world. I was extremely incestuous—I mean, look at this collection.

NM: But how can one avoid that, being in the art or any other small world?

LL: No, you can't. It's a very small world. It's an art village.

NM: Is writing about political art a political act in itself?

LL: Yes, entirely. And in a sense I consider it a collaboration with the artist. We're both trying to change the world, or how it's seen.

NM: Do you make a distinction between art criticism and journalism?

LL: No, but a lot of people do. I don't even like calling myself an art critic, as you know, because it makes it sound like you're going at the artist. I'm really interested in collaborating with artists to get their ideas out. Unfortunately, contemporary artists aren't trained to communicate brilliantly, although some do. Others make wonderful images, but there's a need for someone to do a little bridging… I'd like to think I've been able to do that. A lot of artists think they don't need anything in between the work and the audience, but I think that if they confronted their audiences more often, they'd find out that they do. They could bridge that gap better themselves, probably, but they don't, so….

NM: Perhaps that's why the art of recent years incorporates text more than ever before.

LL: Also artists who have always been able to talk clearly about their work. Others

just go off into theory, which is fine, but it's almost separate from the work.

NM: Could you comment on some major areas of activism in your life as they relate to the arts? Such as Central America, or censorship?

LL: Well, I was belatedly radicalized in '68 and joined the newly started Artworkers Coalition in January 1969. Everybody else was radicalized earlier.

NM: Even in the art world?

LL: Well, it's really too much to get into here. A few people like Ad Reinhardt, Rudolph Baranik, Leon Golub, Nancy Spero, and others. Even Don Judd, who was one of the organizers of Angry Arts Week in '67. I went to the events, but I wasn't directly involved. And then I finally realized I had a role to play—mainly from going to Argentina in '68, where for the first time I met artists who were truly radicalized, truly trying to put their art on the line. They were saying they weren't going to make art while the world was so fucked up. They were going to be out there in the world, not as artists, but as political activists; they were going to make art that was political work. I'd never heard artists saying that before. I mean, there *were* artists saying it, I just hadn't heard them.

So I went back home, and the minute I got back into town, Bob Huot, who was a Minimal artist, asked me to organize Paula Cooper's opening show with him and Ron Wolin, from the Socialist Workers Party, who was very interested in art and worked with Student Mobe. Ron played a large part in my radicalization, on top of the Argentine experience. Then, once I opened my eyes, everything was there. The next twenty years or so I organized with artists around a number of local and global issues.

NM: You joined the Artworkers Coalition in January 1969. What sort of things did the Artworkers Coalition do?

LL: Actions for artists' rights and against the war, against racism, and eventually against sexism. I worked with Tom Lloyd on one "de-centralization committee" to get art out into the neighborhoods and so-called ghettos, and on the "action com-

Lucy loves the New Mexico land
Dry silver, the sun is so grand
She walks the arroyo
With her archeo-boyo
Finding Indian paintbrush & sand.

 Old petroglyphs carved in red rocks—
 The rattlers sneak into our socks
 While we barefoot in mud,
 Learn the real from the dud,
 Observed by the sly desert fox.

Prehistory's history now,
The art critic's spiritual chow.
Since Overlay *piles*
And drives us for miles,
Dimension's been mentioned—and how.

 Her playhouse, in primary hues,
 Tomboy yellows and scarlets and blues;
 Plumped in immensity,
 Personal density,
 Shining like good-witch's shoes.

As the sun sets, we guzzle cheap wine
While the mesas turn red, and the line
Of horizon gets bright,
But we're planning a fight—
"Where's the paper? It's my *turn! No, mine!"*

CONTINUED

47

Give us your tired and your poor
The local with all its allure.
As for how to protest,
I'm doin' my best,
And Lucy dah Lip's bustin' Coors.

END

CAROLINE HINKLEY
GALISTEO

Between October and June of each year,
one is most likely to find Lucy Lippard
home-based in a 600-square-foot adobe
structure on a high plain in the village of
Galisteo, twenty-five miles southeast of
Santa Fe, New Mexico. This place is per-
haps the first Lucy has chosen as a "land-
ing": New York was necessary, Maine is an
ancestral site, Boulder was a stretching
site, but Galisteo is the site of settling-in-
while-taking-off—it is the high plain
where "dreaming from landing" will
happen. The Galisteo basin is also Pueblo
homeland, where, as Willa Cather
described it, "The sky is not so much the
roof of the earth as the earth is a floor for

CONTINUED

mittee" which was much more in-your-face. The last thing I remember AWC doing was protesting the censorship of Hans Haacke at the Guggenheim: his show there was canceled because of his absentee-landlord piece. Yvonne Rainer led a conga line around the circles of the Guggenheim and we yelled, "No more censor shi-i-p. No more censor shi-i-p." So that was one of the first censorship battles. "The Flag Show" was really the first, at the Judson Church, in '69.

And then feminism hit. After WAR (Women Artists in Revolution) we organized the Ad Hoc Women Artists' Committee and WEB (West East Bag). Then in '75, Rudolph Baranik, Hans Haacke, and I and some other people started Artists Meeting for Cultural Change, the antibicentennial thing. The Whitney Museum had decided to celebrate the bicentennial of the United States by showing the Rockefeller collection, which aside from being from the Rockefellers with all their history, like the Ludlow massacre, also had very few women and very few people of color in it.

NM: What's one of your favorite actions?

LL: When the Ad Hoc women protested the Whitney annual in 1970; we faked a press release and invitations to the show, we were there every Saturday, blocking the way to the Whitney, blowing whistles in the stairwells. That was Faith Ringgold's idea. And we raised the number of women in the Whitney annuals by something like 400 percent. The press release quoted the director of the Whitney saying something like, "*Naturally* the Whitney will be the first museum to have 50 percent women in its annuals, because the museum was founded by a woman, and a woman is the head of the board of trustees." We called a lawyer friend of ours and asked if we could go to jail for this. He said, "Oh no, it's just a hoax," and a hoax is a misdemeanor. But it turned out that you can't quote somebody *directly*, that's libel. We sent the press release out to all the media on the Whitney letterhead. We did their style really well. I mean, it really looked and sounded like a Whitney press release. Then we forged invitations to the opening, and the Whitney got onto it, so they had a machine at

the door to test the ink to determine if it was ours or theirs. We got over that by handing ours over to famous people who were going in. A lot of people supported us…. Then there was a sit-in inside the museum. And we were trying to show slides of women's work on the outside wall of the museum with a generator plugged into a nearby gallery….Luckily the three of us who did this had stayed very anonymous. The FBI came calling on us, and so forth, because the Whitney was furious.

NM: Those are amazing stories and bits of valuable history. What next?

LL: In 1976 a bunch of us, starting with me and Sol LeWitt, founded Printed Matter to distribute and sell artists' books. The same year I was in the group of women who started the Heresies collective. I've written a lot about that—a major event and influence for me. In '79, after I got back from living in England for a year, I did a little show at Artists' Space involving Conrad Atkinson, Margaret Harrison, Mary Kelly, Rasheed Araeen, and other British leftists. The announcement included a note to see if people were interested in starting an international archive of socially concerned art, and I gave my address and phone number. When people responded, we had a meeting at Printed Matter, and I said firmly, "This isn't about starting another organization, this is only about having an archive." By the time the meeting was over we had a goddamn organization. So that was how PADD (Political Art Documentation and Distribution) started. It was formalized about a year later after Jerry Kearns got involved, but we started meeting in '79. PADD was the most effective political art group I've been in. The second Sunday of every month, we did panels or performances or discussions at Franklin Furnace. We published a magazine called *Upfront* and a monthly guide to socially concerned art and theater in the city, called *Red Letter Days*. And we did big public art projects. "Death and Taxes" was the first one. "The Lower East Side Is Not for Sale" was another. Then in 1984 I helped start Artists Call Against U.S. Intervention in Central America and became the national coordinator. It was a huge project (thirty-three exhibitions in New York alone) that was in a way the beginning of *Mixed Blessings*. In the '80s I went to

the sky." The land is ringed with blue sacred mountains, the hogback ridges filled with mysterious petroglyphs, archives of an ancient culture but readable only through one's imagination. Rain and wind are capricious and unpredictable, like a Hopi trickster. Outside, at dusk, the light becomes violet and pink and orange, and the adobe stucture, lit with oil lamps and candles from the inside, becomes a glowing dot on the plain. As witness to the space, this also becomes the hour of wine and laughter and storytelling and imagination around objects bearing memories: sea rocks from friend and lover Peter, pictures of son Ethan, and various treasured debris from the rest of us.

Like mixed blessings, though, the genius loci of the Galisteo basin and of Lucy's place is a mixed bag. As with anything in New Mexico, this is a place of multilayered cultural and political dimensions and upheavals. Locally, for instance, neighbors in the village are wary of the further incursion of Anglos. For a year, Lucy ran her lights and computer off the battery of her all-wheel-drive Toyota Tercel. More

CONTINUED

globally, one of the roads to Lucy's house is known as the WIPP road, where radioactive waste might be transported by trucks to a permanent dump site in southern New Mexico. WIPP stands for Waste Isolation Pilot Plant, a complex of tunnels bored into salt beds some 2,150 feet beneath the desert. This nuclear highway would create an invidious straightaway, intersecting literally sacred land, mesas, and vistas and creating an unspeakable geometry of terror. The road also cues us to the advanced stages of cultural and environmental racism, where native people are duped, bought off, dumped on, and swallowed whole by the U.S. Government— providing a lot of work for steadfast cultural/political workers. Lucy understands the paradoxes and absurdities of living in this pristine desert, which has attracted so many of the "exiled," from crypto-Jews in the sixteenth century to atomic-bombmakers in the twentieth. Her little adobe may be a glowing speck on a huge plain, but contained within resides someone with immense wisdom, awareness, and vigilance.

END

China, El Salvador, Cuba twice, Nicaragua twice.

NM: What else was happening at the time?

LL: In 1979–80 groups like Group Material, CoLab, Fashion Moda, and ABC No Rio. PADD was the most straight-out leftist. It was a very exciting and lively time, the beginning of the Reagan era, when everybody was really all fired up. Artists were not just moaning about what was going on, or what they needed, but doing something about it.

NM: What happened to some of these groups?

LL: PADD stopped in '87. We almost made it a decade. People got tired and burnt out and went on to other projects Repohistory is a descendent of PADD. Group Material and No Rio are still going. *Heresies* is still publishing. CoLab is beginning to meet again.

NM: Who has influenced you as a writer?

LL: I always feel like such a dog-in-the-manger when people ask that kind of question, because I can never think of anybody. Maybe just *everybody* is the answer— mostly artists, but not one particular person. There are a lot of people who've brought amazing things to mind that I would never have thought of myself.

NM: How about your earlier writings?

LL: Well, Dore Ashton was a model—not so much for her writing, although she's a good writer—but because she was a well-known woman critic, the *only* woman critic who was really out there for contemporary art when I got out of college.

NM: How about before you began to write? What affected the way you view art, or the kind of art you appreciate?

LL: My parents, who both painted, and took me to museums, but they sort of stopped with John Marin, and I went on. They lived in New York for the first sixteen years of their marriage, and looked at a lot of art; they took classes at Cooper Union.

NM: Was *Pop Art* your first major breakthrough?

LL: It's hard to say. I don't know what the major breakthrough was. I never suddenly got rich, or suddenly got famous. I just kept doing things, and it adds up. I never made much money, that's for sure. I guess *Pop Art*, because Pop art itself was a lot more popular than the other things I was involved in, which were Minimal and Conceptual art, soon after that. The Evergood book, which came out at the same time—1966—certainly didn't make me famous. The art world being what it is, getting to know people, and people beginning to respect what I was doing, was more important than any single work.

Probably my *real* breakthrough was *Art International*. The editor, Jim Fitzsimmons, was a difficult character. Barbara Rose and Max Kozloff were writing the "New York Letter" pieces and doing wonderful stuff there. I was hired on in the fall of 1964 and I coexisted with them for a month or so. Then all of a sudden they both got mad at him, or he got mad at them, or something. Everyone else dropped out, and I *was* the "New York Letter." It was my first real writing job, and I was eight months pregnant. Luckily, Fitzsimmons was in Switzerland and he didn't know. I got everything done. I only missed one review, which was Anthony Caro. I wrote Fitzsimmons and said I was sorry but I just had a baby. "What, a baby? What a terrible idea." *Art International* at that point was *the* influential magazine. And I got to write these gigantic long articles every month. He assigned reviews, but I could also ask to do certain shows. I made the "New York Letter" into theme articles. It was a huge job but I just had a field day.

NM: How long were you there?

LL: A few years. I wrote for *ArtForum* very briefly right before that. Max Kozloff was the person who recommended me to both. But Phil Leider didn't like what I did. He didn't exactly fire me, because just at that point I got the *Art International* gig.

NM: What other publications have you enjoyed working with?

JERRY KEARNS
CASHING IN A WOLF TICKET

Hired by well-meaning art editors to manicure their mind fields for thirty years, Lucy R. Lippard is by now a known troublemaker who can't keep a good job. When looking over her employment record, however, I think first of Artforum *magazine, an excellent employment opportunity. Lucy in fact wrote regularly for the magazine from the mid-'60s on. Then, in 1981, Ms. Lippard messed up, caused trouble, and never got hired there again.*

Lucy and I coauthored "Cashing In a Wolf Ticket" for Artforum's *October 1981 issue (pages 64 through 73). Almost fifteen years later, our work, described by the editors as the merging of a visual project and an article, remains unique in the magazine's pages. We saw "Wolf Ticket" as an artwork. Producing it blurred the boundaries of our traditional roles; we repictured artist and critic. We stepped outside the cheerleader and adversary stereotypes. In collaboration we were cultural advocates and political activists.*

CONTINUED

*"Wolf Ticket" linked high culture (*Artforum's *readership) with grass-roots activism (a community's struggle against corporate culture), and drew connections between reel images and real political/economic power. At* Artforum *that mixture immediately scared a few people, stirring fear of libel suits.*

Editorial meetings involved us in discussions with Artforum's *lawyers nearly as often as with the editors. Ultimately, pushing into the printing deadline, we agreed to nine contested pages. The article would be preceded by a short editorial disclaimer, and we would provide three or four lines of text (since reclaimed in Lucy's book* Get the Message?*). As far as I know, our work is the only* Artforum *article in thirty years of publishing to carry a libel disclaimer:*

One of the authors of the following article was a member of the Committee against Fort Apache/The Bronx. *In reading this article, it should be recognized that the authors are advocates of their deeply held beliefs.* Artforum *is printing this article as an opinion of*

C O N T I N U E D

LL: *Art in America.* Betsy Baker is an old friend, and I immensely respect and like her, but I can't work with her. They overedit. I mean, one edit is enough if you can write at all. They tend to flatten everything out. I don't want to sound like everybody else, and I bet nobody else does either.

NM: How about the *Village Voice*? I have a whole stack of clippings that a friend gave me and I've enjoyed reading them .

LL: Yes. I loved writing my monthly column for the *Voice*, because it got out to so many people. That was very much part of my activist work. I was in touch with activist artists all over the country. I wasn't supposed to write about anything outside New York, but I could sift other stuff through New York stuff and let people know what was going on. I really enjoyed that part of it…

NM: I am one of those who also enjoys your early writings, say on Minimalist or Conceptual art. They help me to rethink some of those issues. And I view your subsequent work as more a continuum than a break.

LL: I know, it wasn't a break. Feminism made me rethink everything. But it wasn't like I suddenly stopped liking one kind of art and started liking another kind of art. Most of the feminist artists I first worked with were Minimally inclined. The excitement for me has always been in learning new issues or ideas. I have a short attention span. That goes for all of my life. I get excited, and I learn a lot, and I really get into something, then it leads to something else.

NM: Just as for your next book, *The Lure of the Local*, you are exploring issues related to the importance of place.

LL: Well, land use, culture, history, and how people look at what's around them. The *New Press* will publish it in winter '96–'97.

NM: So is the local everywhere?

LL: Yes, but it often isn't respected until it's generalized, or abstracted.

NM: Do you read other critics, Lucy?

LL: I read a lot, but can't say that criticism per se interests me much. Cultural critics opened a lot of windows for me, but, I often hate their obscure language. Sometimes I think, "Oh, what a wonderful idea," and then I unpack it and realize it's an idea that's been around for a long time, but it's been repackaged in a different language.

I read a tremendous amount, mostly books—a lot of fiction—but I can't quote it back at you. I often can't even remember what the last book I read was. I get stuff by osmosis. It sort of seeps in. I read *Art in America*. It's a good magazine as far as art magazines go. I subscribe to *Art Issues* and *Art Paper* from Atlanta. I don't read everything in them, but I really like what they're doing. But I spend a lot more time reading *The Nation, Z,* or *In These Times* and the local press. And *Crosswinds, The Reporter* and *The* magazine in New Mexico.

NM: The cultural wars that are going on—do you see them escalating or subsiding?

LL: Escalating. And at the same time, we're getting kind of resigned to them, taking them for granted. I mean, this society is polarizing like crazy, and it's inevitable that the privileged arts are going to end up on the elite side of the fence, because nobody else looks at them, or can afford them, or has time to see them. I want to be on the other side of that fence with the cultural activists. There are some artists over there too.

NM: Do you think that we are a visually literate culture?

LL: I think we're a visually *savvy* culture. We've been manipulated by images, and we've learned how to manipulate by images: we read what they tell us to read in the images. But we don't get under the surface much. I'm not sure that the art that does go under and analyze that imagery is getting across to enough people to make much difference. But at least it's teaching the rest of us something.

There have to be translators, which is one thing an art critic can't do, because

REMINISCENCES

the writers and as a matter of public interest affecting the arts.

—The Editors

"Wolf Ticket" retold the story of a committee of South Bronx activists and their two-year struggle against the production and distribution of the Time-Life film Fort Apache/The Bronx. *Starring in a remake of the famous '40s cowboys-and-Indians film, Paul Newman and Ed Asner played beleaguered cops/cavalry in a contemporary South Bronx police precinct. Once again, Hollywood changed history but not the story. Time-Life presented Asner, Newman, and their fellow cops as the heroic thin blue line of civilization in hostile territory. The Indians/savages were replaced by youth gangs, winos, junkies, pimps, hookers, maniacs, and cop killers. The police were the only people in the film with regular employment. The community was virtually empty of people who held jobs, went to school, had families, or did anything that would be considered normal or regular by most movie audiences.*

Newman's character, Murphy, delivered

CONTINUED

the film's perspective in a series of good-hearted-tough-cop one-liners. "These people are getting shit on every day. A little more or less won't make any difference" was a typical Murphy remark. To which community spokesman Richard Perez responded, "By showing us as animals, the film provides ideological justification for the neglect of the South Bronx by the rest of society; at the same time it legitimizes the killing of our people by cops and validates slum housing, the closing of hospitals and schools, and judicial inequality toward Black and Puerto Rican people. The film's unstated message is that since we are animals, we deserve what we get."

In the early '80s, most writing about art came wrapped in an objectivity flag. Shrouded in the linear poetry of Modernism, theory was composed in a transcendent script. Few art writers would have admitted to having an ideological ax, much less one to grind. The art world was not without racial prejudice but it was certainly above ideological bias. The scene was eight to ten years away from the market crash of the '90s. The mainstreaming (lower

CONTINUED

most art critics write for art magazines, and the people who read art magazines are not the ones who really need the translations. (Newspaper critics usually leave something to be desired, which is a pity.) There are people who can't really look at art until they've read the critics, which I find very annoying. They read criticism to find out what they think rather than to expand their ideas.

I'd like to be a kind of bridge or a catalyst that helps art reach more people and more people reach artists—a two-way bridge. It's not just "outreach," not the kind of patronizing "Lucky you, we've got some art for you… If you were just a little brighter you could understand it." It's really more about helping artists communicate with people than it is about helping people "appreciate" art. That need to reach, or speak to, and *listen to* people on a different level, has to come from the maker.

A lot of artists don't listen; the artist's ego is such a strange thing in itself. I mean, if you say to an artist, "That was an interesting public art piece, but I don't think anybody *got* it," they will get very defensive and tell you immediately about the three people who came up to them and said that they'd never been so moved in their lives. That's great, I'm only too happy that three people were moved, but probably there were three hundred people who walked by and said,"Hey, what the hell was that?" And maybe some of those people could have been moved too, and could have been moved to do something, and to think differently, and to change their lives by what they were encouraged to think about, if there had been a few more clues, a wider open window. I'd like my writing to facilitate that kind of exchange. Easier said than done!

NM: Are there shows that you'd like to curate?

LL: I usually curate one or two shows a year, and I haven't done one for over a year except to work with three other artist types on an "on-the-wall" show at The Center for Contemporary Art in Santa Fe. It's called "Up and Running" and it's

very lively. I was thinking the other day what I want to do in Galisteo and Santa Fe. I've got a couple of ideas and possible venues now, but what I'd really like to do is some kind of non-exhibition project where artists worked locally with people in the places they live, instead of always exporting their work. I'd like to see some support for artists looking around their own places, seeing what the issues are, what the problems are, what the history is, what people might want to know about, and so on.

NM: Site-specific?

LL: I'm using "place-specific" as opposed to "site-specific," which is more neutral. I think there are artists who would like to do that kind of thing, but somehow the tools aren't there, the models aren't there, the access isn't there, the knowledge isn't there, although of course there are exceptions.

NM: Have you tried curating around here in Maine?

LL: No, but I did a show based on *The Lure of the Local* in Colorado two years ago, and it included two Maine artists—activist Natasha Mayer and my partner Peter Woodruff. He did a piece that came partly out of the local history and archeology we're both into (and partly from a previous work he'd done with Ron Leax). Peter and I talk about how we'd love to get our hands on a historical society, to make it a work of art in itself—a way to make local history, and the way it's recalled and recorded, come alive.

I often think that after twenty-something years of talking about public art in almost exactly these terms, some day I should bite the bullet and try to collaborate on making some public art myself, instead of just bitching about it all the time. Because I've watched people do it, and I know how incredibly hard it is. ■

REMINISCENCES

prices in a down market) of multiculturalism, gays, and uppity women was not yet thinkable. Political correctness was not yet an idea, much less a danger.

In that climate our "Wolf Ticket" barked irritatingly about culture and politics beyond the art world; and we drew unsettling connections back to our home base. We pointed fingers, named names, and advocated positions. For their part Artforum wanted nothing to do with Mayor Ed Koch, Time-Life, David Susskind, Paul Newman, Henry Kissinger, Jesse Helms, or a host of others we went after in "Wolf Ticket." In several pressure-filled meetings Lucy and I battled the editors and lawyers, begrudgingly giving up a comma when they wanted to ax paragraphs. I was very impressed with her toughness. Her unflinching willingness to stand up for our words will forever stay with me.

Lucy Lippard is clearly not a candidate for permanent employment. She isn't even after a good job. She is on the grail trail where jobs are cocoons to be shed along the way. She has shed a lot of them... we call them books. Lucy is rarely a critic in the

CONTINUED

sense of someone who enjoys writing after the fact. Nor does she particularly like to criticize results. She would rather be there when the ground is wet and unstable. She is interested in the seeds of new ideas. She seeks out ideas before there are names or even words to describe them. Lucy exposes, uncovers, nurtures. Moving like a Louise Bourgeois spider, spinning threads behind her, leaving a trail. A network of articles and books result from her journey. I am proud of "Cashing In a Wolf Ticket" as one stop on the butterfly's flight.

END

SUZANNE LACY

PINK BLOUSE AND FALSE TEETH: ON "THE RELATIONSHIP OF ARTIST TO WRITER—REAL TO IDEAL"

This is the good thing about old friends, and also the bad: their memories are long, like an elephant's.

The first time I met Lucy was unremarkable, to me and I suspect to her, since neither of us seem to remember it particularly. It was sometime in the '70s at the

CONTINUED

At home in Galisteo workroom, 1995.

FRAGMENTS: HOMAGE TO A WOMAN WHO . . .
Maurice Berger

At the vortex of the political and the spiritual lies a renewed sense of function, even a mission, for art. The new fuels the avant-garde, where "risk" has been a byword. But new need not mean unfamiliar, or another twist of the picture plane. It can mean a fresh way of looking at shared experience. The real risk is to venture outside of the imposed art contexts, both as viewer and as artist, to live the connections with people like and unlike oneself.

—Lucy Lippard, "Mapping," in *Mixed Blessings: New Art in a Multicultural America*, 1990

ABSENCE: Lucy Lippard begins her essay for the catalogue of the "Information" show at the Museum of Modern Art in 1970 with this word, or rather with the complete entry for "absence" in *Roget's Thesaurus*. Perhaps she is alluding to the ephemeral, conceptualist aesthetic of the exhibition, a show in which objects are few and words abound. Lippard's use of this word is also dialectical, for many of the artists in the show directly challenge the ethos of absence in Modernist abstraction. Isn't the Symbolist notion of correspondence, after all, a system of physical absences in which abstract metaphors, similes, and synonyms replace physical things—a world where colors sound like music, or clouds smell like flowers? Lippard ends her entry with the words: **SEE ALSO PRESENCE.** She understands how the avant-garde movements of the '60s are committed to a shift to a new kind of presence in art, a shift from metaphor to concrete experience. The mute objects of Minimal art for the most part resist flights of the imagination; they are neither painterly nor anthropomorphic, neither representational nor expressive. "A cleaner break with the sculptural past has never been made,"

Woman's Building in Los Angeles, contextualized perhaps by the Women's Caucus for the Arts conference. I, no doubt, was busy securing a lamb cadaver from a local slaughterhouse and getting into my old woman's prosthetic face for a performance; she, no doubt, was preoccupied with the delivery of a seminal essay on feminist art.

But the second meeting is emblazoned on my memory as an image of a shocking-pink short-sleeved blouse, one she purchased impulsively (on sale, to be fair) at the elegant and expensive Bonwit Teller during a long afternoon shopping spree filled with compulsive giggling. I admit that it was I who instigated the foray, in order to buy a beige linen blazer for the opening of Judy Chicago's Dinner Party *at the San Francisco Museum of Modern Art. I even admit I egged Lucy on to buy that blouse. Actually, it inspired my introduction to her talk that night at the San Francisco Art Institute. It was then I first discovered how to pull Lucy's chain, when I announced how much fun we had had at Bonwit, and how much money she had spent there. Her swift and sure response*

CONTINUED

was to trace the origins of her attire that evening, most of it acquired for under five dollars on Canal Street.

So far all was going well, and I remember other times, though many of them blur together: running away, with a delicious sense of the illicit, from our politically correct and on-purpose tour of Cuba to explore Havana at night; camping out in SoHo (this was the only way to stay in Lucy's loft—with combat boots for house slippers, to protect from the layers of dirt and splinters on a floor she was proud of never washing); climbing a mountain above Moira Roth's house in Berkeley; meeting across microphones on innumerable panels around the country; talking about political performance into a tape recorder at a restaurant in Los Angeles; climbing a mountain in Boulder; hiking across an expansive tidal flat in front of her house in Maine during Moira's sixtieth-birthday gathering; laughing wickedly at everything imaginable; arguing over the effects of class on behavior, hers and mine.

And one time during all these times I remember it coming up, perhaps early on,

CONTINUED

Lippard writes of them. In keeping with this idea, she refuses some of the standard critical terms for this art: Minimalism, Primary Structures, ABC art. Rather than seeing this work as reductive in the Modernist sense, she sees it as "rejective." Thus Rejective art, in all the aesthetic and political meanings of the phrase, becomes her name of choice. (See also **PRESENCE**)

ABSTRACTION, ECCENTRIC: The works of such post-Minimalist sculptors as Eva Hesse, Robert Morris, Bruce Nauman, Keith Sonnier, Richard Serra, and others—aesthetic objects that waver between literalness and allusion, order and chaos, chance and control—represent both a departure from and a continuance of the Minimalist or Rejective sensibility of the mid-'60s (see also **ABSENCE**). Perhaps least understood is the psychosexual dimension of this work, which, to one degree or another, challenges the purity and aloofness of Minimal art (and even the formalist painting and sculpture to which Minimalism was, in part, a reaction). This subtle confrontation is accomplished through the most disparate of strategies—from the lush sensuality of Morris's unraveled felt pieces to the formal integrity of Hesse's suggestive objects. Yet this psychosexual aspect eludes the puritanical, formalist methodologies of most critics of the period. Lippard, on the other hand, wonders whether the 1966–67 art season will be the "Erotic season"—an answer to the Pop, Op, and Primary Structure seasons past. "For at least two years," she writes, "rumors have been rife of wickedness stored up in the studios waiting for the Trend to break." (See also **DUCHAMP, MARCEL**)

Lippard herself explores this idea in "Eccentric Abstraction," an exhibition she organizes in 1966 at the Fischbach Gallery in New York. The show considers the "emotive or 'eccentric' or erotic alternatives to a solemn and deadset Minimalism which still retained the clarity of that notion." It includes Louise Bourgeois's erotic latex

membranes, Alice Adams's "giant chain link womb form," Don Potts's undulating wood-and-leather sculptures, Hesse's sausagelike objects, as well as works by Gary Keuhn, Bruce Nauman, Sonnier, and Frank Lincoln Viner. Lippard's understanding of eroticism is neither iconographic nor simplistic; instead, she sees it as a continuation of the body-oriented phenomenology of Rejective sculpture, where objects insert themselves, dumbly yet provocatively, into the viewer's space. "Evocative qualities or specific organic associations are kept at a subliminal level," she observes. "Ideally a bag remains a bag and does not become a uterus, a tube is a tube and not a phallic symbol. Too much free association on the viewer's part is combatted by formal understatement, which stresses a non-verbal response and often heightens sensuous reactions by crystallizing them."

ACTIVISM: The U.S. involvement in the Vietnam conflict infuriates Lippard and many of her compatriots in the avant-garde. She is not afraid of activism. (In 1995, she describes herself not as an art critic but as "a writer and activist, much to the annoyance of the universities where I lecture.") The cool conceptual edge of the "Information" show (see also **ABSENCE**) does not dissuade her from speaking her mind; thus, in her decentered and fragmentary contribution to the catalogue (see also **NARRATIVE**), she includes the following admonition and exercise: "Show no films glorifying war. Ask the American artists in the exhibition to join those willing on the museum staff in compiling and signing a letter that states the necessity to go A.W.O.L. from the unconstitutional war in Vietnam and Cambodia; send it to 592,319… men at armed forces bases in each state of the U.S.A. (If this is impossible, to fifty-six major newspapers.)"

> (For further reference, see **LIPPARD, LUCY R.**, *Get the Message? A Decade of Art for Social Change*, New York: E.P. Dutton, 1984, and **LIPPARD**, *A Different War: Vietnam in Art*, New York and Seattle: Real Comet Press, 1990.)

as Lucy was first formulating her ideas about the relationship of the writer to the artist, when she remarked testily to me (in a tone Lucy's close friends have all come to love and ignore), "Why do all those artists think they are writers?" I remember how, with the self-righteousness of a good friend, I pointed out to her that she herself had recently taken to doing performance. This brought to mind all those other would-be artists/writers—like Moira Roth, who kept trying to horn in on my performances by proposing fictional characters she might assume, and Arlene Raven, who offered her participant writing to my postcard Travels with Mona.

Now I'm pondering this critical issue of artists and writers in the midst of another memory, this one inspired by a photograph from the performance site of The Crystal Quilt. *Lucy, Moira, and I are looking like three muses or perhaps witches within the purview of what has been affectionately called the "male gaze" (of Larry Fink, the photographer, which in this case isn't on us). The image she evoked, with which she ended her article "Some of Her Own*

CONTINUED

59

Medicine," was peculiarly Lucy: "The ultimate image: when everyone had left after 'The Crystal Quilt' (in which some participants were in wheelchairs and one was 'plugged in' to a sustaining device), there remained on the tables a set of teeth." Now that's as idiosyncratic a perception as any artist might have. One wonders if she planned it.

Here's a present to you, Lucy, another shocking pink blouse, this one with black pinstripes and long sleeves. Pink is out of vogue this season according to my friend Jill, who gave it to me, so it ought to please you as it does me that it is well-made, as blouses go, but also free.

END

YONG SOON MIN
UNFINISHED BIZNESS

Lucy Lippard is uniquely positioned to bridge the wide gap between '70s feminism and '80s multiculturalism. No other art historian of her stature has delved so wholeheartedly into the feminist art move-

CONTINUED

BARTHES, ROLAND. *Mythologies.* Trans. Annette Lavers. New York: Hill & Wang, 1957/72:

There is at least one type of speech which is the opposite of myth: that which remains *political.* Here we must go back to the distinction between language-object and metalanguage. If I am a woodcutter and I am led to name the tree which I am felling, whatever the form of my sentence, I "speak the tree," I do not speak about it. This means my language is operational, transitively linked to its object; between the tree and myself, there is nothing but my labor, that is to say an action. This is political language.

CRITICISM: Throughout the late '60s and early '70s, Lippard pushes the envelope of cultural writing by challenging the methodologies of art criticism. Sometimes she ignores theoretical methodologies that might in the end have sharpened her understanding of the complex relationship between representation and ideology. But Lippard has something else in mind. "I should like to create a fragmentary criticism of cross-references," she writes. "Instead of setting up more of the name-able theoretical thickets that exist around experience, I should like to cut away some of the transitional undergrowth to expose more clearly the irregular tempo of art in 1970." Lippard takes her critical mission seriously. For her, the writer must exercise three talents at once: intellectual rigor, a "good eye," and a "solid foundation" built on looking at many kinds of art. From this, she argues, the critic can form "his own ideas of recent history before the historians have their 'distance.' " (See also ABSENCE, HISTORY, NARRATIVE, PRESENCE)

DUCHAMP, MARCEL. Quoted in Pierre Cabanne, *Dialogues with Marcel Duchamp.* Trans. Ron Padgett. New York: Viking Press, 1971:

I believe in eroticism a lot, because it is truly a rather widespread thing throughout the world, a thing that everyone understands. It replaces, if you wish, what other

literary schools called *Symbolism, Romanticism. It could be another "ism," so to speak.* (See also **ABSTRACTION, ECCENTRIC**)

ERRATA: In her essay for the "Information" catalogue, Lippard strikes an ironic note: "Provide errata sheets... where visitors can correct any inaccurate information, spelling, etc., in the material on view or in the catalogue. Edit out facetious comments and publish as a review of the exhibition in an art magazine." Is she describing the death of the author (critic), to paraphrase Barthes? Lippard clearly understands how the Minimal and Conceptual styles of the '60s and '70s reorient the object/viewer relationship. Is the ideological basis of this change even more political than we have thought? Could it have contributed to certain aesthetic and philosophical shifts in artmaking of the past two decades: from form to politics, mind to body, phallus to gender, whiteness to race? (See also **ACTIVISM, CRITICISM, GENDER, RACE**)

FORMALISM: In an essay written in 1967, "Change and Criticism: Consistency and Small Minds," Lippard scrutinizes the art-for-art's-sake mentality of formalist criticism. She intrinsically understands that formalism per se isn't entirely bad. It has a major drawback—its tendency to concentrate on the evolution of stylistic and aesthetic concerns rather than on broader social or cultural factors—but its "specificity did a good deal to clear the air." In other words, even the most socially or politically oriented criticism should back its assertions through an analysis of or at least a respect for the art object itself.

GENDER: Lippard becomes the first art critic to place feminist issues in the center of her practice and to advocate the centrality of women's issues in leftist politics. Her *From the Center: Feminist Essays on Women's Art*, published in 1976, represents

ment and multicultural advocacy, or "propaganda." I take it as a personally resonant symbol of the meeting of our different activist communities and histories that the Asian American Arts Alliance, a cultural organization that I helped to build, initially shared office space in downtown Manhattan with PADD, the political arts organization Lucy was instrumental in establishing. That PADD was in its waning years (it officially disbanded by the decade's end) while the Alliance was just beginning to grow, was also a sign of the times. I spent hours in the PADD archives on the other side of that office, catching up on activist history.

So I thought of Lucy when I participated this past summer in the Fourth World Women's Conference in Huairo, China, the site of the NGO Forum. As a delegate of the U.S.-based Women's Caucus for Art (WCA), I was thrilled to be a part of this immense global gathering of women, all seeming there to make a difference. I attended illuminating sessions about such issues as education and legal protections for female migrant laborers, the closing of

CONTINUED

U.S. military bases in Okinawa, and the struggle for justice for the mostly Korean but also Filipino, other Asian, and Dutch "comfort women" who survived the sexual slavery perpetrated by the Japanese government during its military expansion in Asia roughly fifty years ago. However, aside from an extensive and effective program of panels, performances and exhibitions organized by the WCA, the nearly one hundred daily events at Huairo included virtually no presentations about women in the contemporary arts.

And so this conference served once again to heighten the sense of split in my identity between activist and artist. While I was happy to be among other progressive activists in the sociopolitical arena, I hungered for a similar engagement in the arts on the part of women from other parts of the world. Aside from traditional arts or crafts, the arts were generally relegated to the sidelines, considered nonessential next to such bread and butter or rice and beans issues as how the World Bank's structural-adjustment programs have increased the poverty of women in the southern sphere. I

CONTINUED

yet another important shift in the focus of her criticism: from the mostly male Minimalist and Conceptualist circle of the '60s and '70s to the women's art of the same period and beyond. (Sometimes there is overlap: Hesse and Adrian Piper, for example.) Lippard gets accused of many things: both the old-line avant-garde and the new-era theoretical artists and critics deem her activities irrelevant and even self-destructive. Hard-line feminists question her open-minded brand of feminism. And more recently, with yet another shift on Lippard's part, to the work of artists of color, white feminists think she's sold out the cause of women altogether. ("Bemused by the notion that the Third World was perceived as all male," she writes, "I was also annoyed and alarmed at such a narrow definition of feminism.") Still, feminism changes her "entire outlook on the world."

Once again Lippard serves as a kind of critic/prophet: the women's art she champions in the early '70s—Hesse, Piper, Faith Ringgold, the cultural protest groups Ad Hoc Women Artists' Committee and WASBAL (Women Artists and Students for Black Art Liberation)—have by the '80s and '90s become central influences for feminist and activist artists and groups. Her writings at the time are nurtured in another important cultural forum of the mid-'70s: The Heresies Collective and *Heresies* magazine, founded in 1976 by a group of women (including Lippard) who want to create a forum for cultural self-examination and intellectual and emotional growth. Through the '80s and '90s, Lippard advocates a continued alliance between feminist artists and the activist left. Despite the centrality of these issues to the art world, she remains as much at edges of this world as she does at its center: "I have spent the last decade and a half," she writes in 1995, "on the 'margins' of activism and cross-culturalism, and I have moved from New York City to rural New Mexico and Maine." (See also ACTIVISM; CRITICISM; RACE; WALLACE, MICHELE; WORD)

HISTORY: In *Overlay: Contemporary Art and the Art of Prehistory* (1983), Lippard writes a kind of archaeology of contemporary art (see also **MORRISON, TONI**) by looking at a new generation of artists who have appropriated the images and styles of prehistoric monuments. She examines a range of aesthetic phenomena—from the megalithic monuments of Stonehenge to the ancient art forms that reappear in Ana Mendieta's Cuban site art. Lippard writes the book under the premise that "art has social significance and social function." She argues that a truly effective art "offers a vehicle for perceiving and understanding any aspect of life, from direct social change to metaphors for emotion and interaction, to the most abstract conceptions in visual form," she continues: "The social element of response, of exchange, is crucial even to the most formalized objects or performances. Without it, culture remains simply one more manipulable commodity in a market society where even ideas and the deepest expression of human emotion are absorbed and controlled."

What is perhaps most radical about *Overlay* is its refiguring of history as "monument." Her work recalls Michel Foucault's *The Order of Things* and *The Archaeology of Knowledge*, writings of the mid-'70s that dramatically challenge the linearity of the historical narrative. The historian, Foucault reasons, is charged with a new responsibility: to constitute events synchronically in relation to the "monuments" that defined them in their own time. The new history must be liberated from traditions that impose an often artificial causality on a given period's complex meanings; it should establish a network of discontinuous events and monuments rather than a linear narrative driven by the overarching sweep of historical convention. As Lippard suggests, such a conception of history is recuperative rather than passive— a history that, to quote Foucault, facilitates "the discovering or constituting [of] meaning in the inertia of the past and the unfinished totality of the present."

REMINISCENCES

came home from this event, as from many similar situations in the past, wondering what my role in these struggles is.

Recalling that Lucy Lippard had also travelled to China and several other third world countries with an arts group, I wondered what strategies she might bring to bear to help me integrate activism and the arts. Lucy always seems to have a knack for making fruitful connections, of bringing people together, of "mixing it up." The Pink Glass Swan *encapsulates a history of writing and activism that is a testament to her inclusive and border-crossing practices.*

A second involvement has also sent me to Lucy recently—my participation with a group of Los Angeles-area women, predominantly in the arts and architecture fields, on a project to revisit Womanhouse, a seminal feminist art project of 1972 that transformed a dilapidated house in L.A. into a "feminist environment." Like its predecessor, the new project entitled Womanhouse emphasizes collaboration among feminists and "seeks critical reexamination of the house and its spaces that address the domestic situation of women in

CONTINUED

the 1990's." One radical departure is that the new Womanhouse space will be virtual: it will take the form of a World Wide Web site with its own page. A public presentation of this project is scheduled to coincide with the spring opening of Judy Chicago's Dinner Party *at an L.A. Museum, in the hopes of generating a dialogue between two generations of feminists.*

While the project is both timely and well conceptualized, its one glaring shortcoming seems to be the lack of genuine inclusion and diversity. Although the new participants may be equipped with enough consciousness to avoid a repeat of the unfortunate painting of the initial Womanhouse kitchen walls a pinkish color as a way to refer to the skin of women in general, the participants and organizers include few participants of color. One might have expected that after a decade of struggles against racism among women, a greater mix would be a reality. Equally disheartening is that the issue of diversity has not even been openly raised. I'm tired of constantly raising this red flag. So the project offers another marker showing how

CONTINUED

The cultural or discursive practices that Lippard discusses in *Overlay* present history dynamically, allowing memory, sensation, and emotion to help shape its meaning. Evoking the monument, a remnant of a distinct cultural and social moment that exists as a kind of silent ruin, they ask us to renegotiate our relationship with the present as they present us with fragments of our ruined past. Rather than allowing us to fall back on a passive interaction with the formalist or conceptual object, these historically oriented works exist simultaneously as sites of painful absence and sensual presence.

MORRIS, ROBERT. "Aligned With Nazca." *Artforum* **(October 1975):**

Whatever the intentions of these forms on the desert, they are morphically related to certain art we see today. If Nazcan purposes were lost in the past, they can nevertheless throw our present art context into helpful relief. (See also ABSENCE, HISTORY)

MORRISON, TONI. "The Site of Memory." In Russell Ferguson et al., eds., *Out There: Marginalization and Contemporary Cultures.* **Cambridge, Mass., and London: The MIT Press, 1990:**

I can't tell you how I felt when my father died. But I was able to ... imagine not him and not his specific interior life, but the world that he inhabited and the private or interior space of the people in it... Like Frederick Douglass talking about his grandmother, and James Baldwin talking about his father, and Simone de Beauvoir talking about her mother, these people are my access to me; they are my entrance into my own interior life. Which is why the images that float around them—the remains, so to speak, at the archaeological site—surface first, and they surface so vividly and so compellingly that I acknowledge them as my route to a reconstruction of a world ... to the revelation of a kind of truth. (See also HISTORY)

NARRATIVE: With the publication in 1973 of *Six Years: The Dematerialization of the Art Object from 1966–1972*, Lippard makes a radical break with the traditions of the critical narrative. "Radical" is perhaps the wrong word; it doesn't quite capture Lippard's ability to grasp (and sometimes presage) the zeitgeist. Belief in the master texts of Modernism, as well as in the notion of a univalent, omnipotent critical voice, had already been subject to intense scrutiny. This is the *full* title of the book as it appears on the cover:

> *Six Years: The dematerialization of the art object from 1966–1972: a cross reference book of information on some esthetic boundaries: consisting of a bibliography into which are inserted a fragmented text, art works, documents, interviews, and symposia, arranged chronologically and focused on so-called conceptual or information or idea art with mentions of such vaguely designated areas as minimal, anti-form, systems, earth, or process art, occurring now in the Americas, Europe, England, Australia, and Asia (with occasional political overtones), edited and annotated by Lucy R. Lippard.*

The book consists of a pastiche of text fragments. Leafing through its pages, the reader stumbles on a myriad of annotated sources: a transcript of a radio interview program (appropriately titled "Art Without Space"); a list of films shown at Radio City Music Hall in 1937 and 1947; excerpts from artist's treatises; critical and art-historical writings; photographs of earthworks, book leaves, and instructions for Conceptual art pieces; dance notations; and critical commentary by Lippard herself. Little order (besides the year-by-year chronological grouping) is imposed; readers glide over and into the texts, deciding when and where they wish to concentrate. The book in effect re-creates the structural and intellectual core of the avant-garde movements it documents. The

far we have come in the women's art movement in some aspects, and how much farther we still need to go.

Involvements like these have me wishing that I could turn back the hand of time to the late '80s and early '90s, when Lucy and I were living in the same city (at least a good part of the year) and I could drop by her SoHo loft and get some choice feedback from her, or at least check out the latest good read among the heap of magazines and books that passed for a coffee table. I miss the camaraderie of those years, especially her dinner parties and soirées, which enlivened and enlarged my world. Lucy was about the only prominent art figure I knew then who not only talked the political talk but walked the walk, in the "trenches." I remain grateful and amazed that despite our vastly different levels of experience and knowledge, Lucy always made me feel validated and respected.

END

JOLENE RICKARD

SILENCE AND VOICE

Lucy Lippard is one of the few people in the art world interested in the issues of Indigenous people; her expertise has been not to be an expert on them. Yet her interest has created a space for issues concerning Indigenous or Aboriginal people in a crowded, competitive cultural arena. This is perhaps an overstatement—this interest on the part of the monolithic art world is marginal, and a direct reflection of where Indian people fit into the American memory. It's not like people wake up and think, "I am living in Seneca territory and in violation of a treaty." Americans mostly don't know which Indians lived on the land they now occupy. A vague mist settles in the mind whenever Indians are mentioned, forever trapped by Hollywood's mythmaking machine.

The popular idea is that Indians are at peace with poverty, environmental and health degradation, and economic and intellectual subjugation in our tax-free reservation communities. So pervasive is

CONTINUED

dematerialization of the art object has now led to the dematerialization of the critical narrative. (See also CRITICISM)

With this fractured narrative, Lippard questions many of the assumptions about authorship that critics and historians take for granted. One myth shattered is the idea that representation is ideologically pure, that it seamlessly summons up truth or reality. The realist text has long been seen as a kind of "window," setting up a stream of denotations that correspond directly with things in the world. Roland Barthes, however, in *S/Z*, reminds us that the text does not copy reality itself, but constitutes a pastiche of things already seen, read, done, experienced—things, in essence, "already-given-within-a-culture." The system of codes that make up the text is actually a compounding of stereotype, cliché, and other such elements. As such, even the most "objective" critical narrative carries with it the underlying biases and ideologies of the writer and, more important, of the culture in which the writer writes. It is in this sense that Lippard maintains in 1969 that "criticism, like history, is a form of fiction." And so she foregrounds the ideology of an avant-garde seemingly without ideology, setting the stage for the links she would later draw between the Minimalist and Conceptualist continuum of the '60s and early '70s and the approbations of race, gender, sexuality, multiculturalism, and class in the artmaking of the '80s–'90s.

PIPER, ADRIAN: Quintessential Lippardian artist. From forays into the cool stylistic and intellectual sensibilities of Minimalism and Conceptualism in the mid-'60s to the reinterpretation of these idioms in the political work of the past two decades, Piper's installations, performances, drawings, and videos have challenged the viewer in radical and sometimes surprising ways. "More than any other contemporary artist," writes Lippard, "Piper has consciously explored the genre of social transformation through the self." More than any other artist, Piper has also bridged the gap

represented by the conceptual and intellectual trajectory of Lippard's criticism: from a cool, ideologically charged Minimal/Conceptual aesthetic, to a more assertive voice uncompromisingly addressing issues of race, gender, power, and the ways all of these mitigate and shape our hearts, our souls, our bodies. (See also ABSENCE, GENDER, RACE)

PRESENCE: *Occupancy, occupation, attendance.*

> *Diffusion, permeation, pervasion, dissemination, 73. . . .*
> Adj. *Present, occupying, inhabiting, etc., moored, at anchor, resident, residentiary.*
> *Ubiquitous, omnipresent.*
> Adv. *Here, there, where? every where, aboard, on board, at home, a-field, etc.*
> —*"Absentee information" arrived at by chance from the entry for "presence" in the New Roget's Thesaurus, 1989 edition*

The philosophical and stylistic framework of Lippard's writing introduces a new level of presence, or at least of presentness, in critical discourse. The fracturing of the text in *Six Years: The Dematerialization of the Art Object*, or in her essay for the "Information" catalogue, constitutes a new critical realm, a continuum of words that keeps the reader at the text's surface, continually traversing its idiosyncratic appropriations. Lippard writes, "Fragmentation can be a highly effective artistic or critical approach to much new art. It is closer to direct communication than the traditionally unified or literary approach, in which all sorts of superfluous transitional materials are introduced. Interpretation, analysis, anecdote, judgement, tend to clog the processes of mental or physiological reaction with irrelevant information, rather than allowing a direct response to the basic information." (See also ABSENCE, CRITICISM, NARRATIVE)

this projection of Indian experiences in the Americas that Congress ignores treaties by taking away chunks of money from Indian health and education, and blatantly dangles nuclear carrots cloaked as economic development in the face of our leaders while the states slap our gaming, cigarette-stamping, gas-pumping hands. But it goes too far when Disney animates Pocahontas in the shape of Barbie and nobody hears the foul cry. So the minor debate about Indian art that simmered for two seconds in SoHo sometime in the '80s concerning "identity" does not even scratch the surface of the scars.

Our art, the expressive cultural statement of Indigenous people, speaks but is rarely heard. Thinking people in the Americas are certainly capable of understanding the work, so what can account for the ongoing dismissal of Indigenous makers? Perhaps it's the message's journey to acceptance. Indian people mark our continual survival by making art. Often this work negotiates space from a "sovereign" perspective; to borrow Vine Deloria's term, we think of ourselves as "nations

CONTINUED

within nations." The Iroquois defended Indigenous autonomy in every treaty they negotiated. I am always reminded that the U.S. made treaties with the Iroquois because it had to in order to survive as an emergent nation. Indians lost a war, not to bullets but to germs. Does that give the surviving nation the right to dominate based solely on numbers?

This issue of glossing the experience of Indigenous peoples must run deeper than acknowledging our political autonomy. Artwork from Indians consistently calls for the viewer to deal with multiple constructions of reality. Acceptance of the various world views of Indigenous people represents the big hurdle in the Americas or the "West." And should one make the jump, I would focus on understanding Indian philosophies about the "living" world. Indian people formed cultures based on a continuous relationship with the universe, and last I checked those ideas are still critical and valid. Knowledge systems of Indigenous people are not recognized equally in "intellectual" spaces like theory, but this does not mean our

CONTINUED

RACE: In the '80s, Lippard concentrates on the issue of race, or, more accurately, on those communities and artists of color mostly ignored by mainstream culture. The contemporary art world, while a somewhat "rebellious satellite of the dominant culture," shows little interest in the work of African-American, Latino, Asian-American, and Native American artists. The presumed radicality and open-mindedness of this art world are often an aesthetic illusion created by those who control the markets and institutions. In other words, the upper-class white patrons of the mainstream art museum and art galleries—as well as the dealers and curators who serve them—for the most part couldn't care less about artists of color. The art critic and the art historian are often no less complicitous. When it comes to the issue of race, theoretical sophistication is not enough. Many of the problems associated with the relationship between marginalized artists and mainstream institutions also plague the various disciplines of art history, criticism, and critical theory: the tendency to ignore cultural producers of color, the impulse to reduce racist behavior or representations to intellectual abstractions, and, most important, the inability of writers and scholars to engage in any substantive degree of self-inquiry. As long as they are silent about their own racism, and as long as they refuse to question their own authority to speak, the white voices that speak for the dominant culture, no matter how liberal or thoughtful, continue to subjugate people of color. (See also GENDER; WALLACE, MICHELE; WORD)

In 1990, Lippard attempts to redress this problem with the publication of *Mixed Blessings: Art in a Multicultural America*. Rather than creating a "nice, seamless narrative" that follows the dictates of traditional art writing, Lippard attempts to create a "syncretic book that simultaneously reflect[s] the enormity and instability of its subject, to lay out a patchwork of images." She has returned, in some

sense, to the writerly sensibility of *Six Years: The Dematerialization of the Art Object*: stylistically, the text of *Mixed Blessings* is fractured, as images are joined with extended captions and the main text is interrupted by boldface sidebars; conceptually, the writer refuses to force a coherence she does not see; and politically, her text shatters into a multitude of voices from different racial, ethnic, and economic backgrounds. (See also ABSENCE, CRITICISM, NARRATIVE)

RAINER, YVONNE. "Film about a Woman Who..." (film script), *October* no. 2 (Summer 1976):

She tries to reconstruct the passage from the novel that had so impressed her. The best she can do is: "All is finally clarified. It is unspeakable, but clear." (See also NARRATIVE)

WALLACE, MICHELE. "Reading 1968 and the Great American Whitewash." In Barbara Kruger and Phil Mariani, eds., *Remaking History*. Seattle: Bay Press, 1989:

"Where is tomorrow's avant-garde in art and entertainment to take on the racial bias of the snowblind, the sexual politics of the frigid, and the class anxieties of the perennially upper crust?" When I asked this question a few months ago, I was trying to make light of something that is not light at all. As ridiculous as it may seem, a white cultural avant-garde, here and abroad, has always believed it possible to make an oppositional art without fundamentally challenging hegemonic notions of race, sexuality, and even class. (See also ERRATA. GENDER, NARRATIVE, RACE, WORD)

WORD: As in the last word. How ironic. The protectors of the various critical canons of the past thirty years often overlook Lippard. Once at the margins, she now represents a central, multicultural position in the art world. The canon has caught up with her, acknowledging as it sometimes does that race, gender, and sexuality are not irrelevant to culture and that the Minimalist/Conceptualist movements of the past three

REMINISCENCES

thoughts are less significant. The conflation of these knowledge systems would be a start in creating a dialogue of equity—assuming, of course, that one realizes what is gained in a society by making room for real diversity, not manufactured difference, like the art world's version of identity politics.

The question I have is, Who is going to be interested enough in the issues of Indians to make space in their dialogue in the future? Lucy Lippard has done her part, well.

END

A LETTER TO LUCY R. LIPPARD FROM MOIRA ROTH

August 7, 1995
Berkeley, California

My dear Lucy,
Yesterday—the 50th anniversary of the U.S. bombing of Hiroshima—I returned from Honolulu, where I had visited Margo Machida's exhibition "Asia/America: Identities in Contemporary

CONTINUED

Asian/American Art" and its accompanying conference. In Hawaii I thought, as I so often do when traveling in my mind or geographically, about your ideas and beliefs. The conference's fare of history, politics, and culture was heady, the language was fresh, and the moods swung back and forth from argumentative to celebratory— just Lucy's cup of tea, I kept saying to myself. I also kept remembering (they were so relevant to the day's discussions) your chapter headings for Mixed Blessings: New Art in a Multicultural America: *"Mapping," "Naming," "Telling," "Landing," "Mixing," "Turning Around," and "Dreaming."*

Dreaming? I've always enjoyed the fact that you dream as well as act. Indeed I remember conversations with you in various places—New York, Maine, Colorado, Texas, and California—in which you described your actual dreams. Wonderful, lively dreams, sometimes having to do with flying, always full of strange presences and magical occurrences, and, so often, containing advice for your waking life. You take these dreams of yours seriously, as

CONTINUED

decades are *rejective*, both of the mythologies of modern life and of the art-world status quo. Lippard's writing is always startlingly open-minded, incisive, and prescient. "Flexible ideas… contribute directly to change by their openness," Lippard writes in 1967, words that aptly sum up her own formidable contribution to American culture. ∎

"Damage Control" (Five Women Over 40), street performance group hitting on the Gulf War in Boulder, Colorado, 1991.

THE "ACCIDENTAL" COLLECTION

Elizabeth Hess

Art critics are not born. They are constructed by a series of social manipulations that sometimes turn into jobs and, for better or worse, careers. Lucy R. Lippard is having an unconventional career. She began in the early '60s as a devotee of the art object, placing her finger directly on the pulse of the art-historical moment. But instead of continuing up the academic ladder, writing scholarly tomes and preaching the gospel, Lippard veered off to the left, perfecting a craft of advocacy criticism. It was a period of apocalyptic turmoil: the civil rights movement was marching, the Vietnam war was raging, and the consciousness of women's liberation was beginning to rise. Lippard adamantly rejected the erudition of her (largely conservative, largely male) peers, leaving Modernism and its groupies behind. She joined the revolution.

Coming to the conclusion that art is inextricably linked to social reality, Lippard began to write on art from an engaged perspective rather than a removed one. Many of her colleagues were either confused or outraged. Charged with a variety of crimes, the critic was labeled a leftist and considered a serious threat to the establishment. In 1982, looking back at the decade, the perversely conservative critic Hilton Kramer wrote, "There was every reason to believe that a writer of this quality would one day become one of our leading historians of the modern movement. Yet in the Seventies Miss Lippard fell victim to the radical whirlwind…. This, to be sure, is an extreme case. The descent into straightout political propaganda is not usually so crude."

Lippard considered this red-baiting attack a badge of honor; controversy has never scared her away. Fully understanding that her status as a critic would change, she

you should. Indeed I think of your life as guided by left-wing radical politics, New England traditional morality, and mystical dreams.

But it is not only this Honolulu visit that has recently brought you so vividly to mind. On July 24, two years ago, I celebrated my sixtieth birthday at your house in Georgetown, Maine. You had told me I could invite a group of seven women friends for what I conceived (I am sure this will make you cringe, but there it is—my English background speaking) as a sort of house party: a gathering of friends, many of them yours as well as mine. After the initial shock of finding you had neither a fax machine nor the sort of phone that could retrieve people's home-telephone messages, we settled down. You took us sailing on your small boat. We went for long walks on the beach: sometimes talking intensely and plotting for the future, sometimes walking solitary and gathering shells. Then we would return hungrily to your house, to feasts that you had spread out. (Perhaps not everyone knows what a good cook you are, as well as a most loving,

CONTINUED

71

loyal, and energetic friend.) Our stay seemed to go on forever, although, in reality, it was just a few days. Later we talked among ourselves about the visit—-a moment of rare peace and intimate community in a rural world. It was a remarkable present for all of us, not just me.

Over the years I have traveled to visit you, as you have to see me. So often, too, I sense your presence on my journeys into feminism and into cultures other than my own. When I write, I frequently turn my head to consult you as I do when I foray out into the world to act. You are, so to speak, one of my main fellow travelers. Not always, I might add, a totally comfortable companion, for there are times when I have the urge to lapse into wishy-washy comfortable liberal stances, and I remember, nervously, that these do not sit well with you. But I like the way you sit. I like the way you stand. I like the way you act and the way you dream. You are, Lucy, for me as for so many of your friends, a much admired as well as much loved traveling companion in this mobile world of ours.

Aloha

END

went off to find new venues for her writings. *Artforum* had not been ready to legitimize the notion that art and propaganda were inextricably linked, while *Art in America* was intent on maintaining the bedrock of art-historical tradition. Lippard continued to write for such publications, but she could not express herself fully there. Editors became the bane of her existence as they pulled apart her sentences, claiming that their rewrites were purely stylistic. Lippard suddenly found herself generating texts that were more publishable in left and feminist publications than in the centrist art magazines she had been contributing to for years.

Lippard's columns began to turn up in unexpected progressive journals and newspapers, including *The Village Voice, The Guardian, Z* magazine, *In These Times, The Nation,* and *Seven Days,* a left-leaning biweekly where, working as an editor, I first encountered her. It was 1975. The idea that art was an inherently ideological practice was not a novel premise in radical circles outside the art world. Lippard became a regular columnist in *Seven Days,* covering avant-garde art from an overtly polemical perspective.

At the time, not many realized how subversive art would come to be in America. It was the '70s; the National Endowment for the Arts was a healthy, respectable institution, and Robert Mapplethorpe was hanging out on the Lower East Side with Patti Smith. Fourteen years later, Mapplethorpe's retrospective would be censored in Washington, D.C., and we would all—as a country—rethink the question of art's political agenda. Lippard was way ahead of us.

The average critic in the average newspaper is hardly a radical visionary. While some of her best friends might be critics, Lippard has always rejected any personal identification with them as a group, choosing instead to align herself with artists. Critics

have demonstrated a range of attitudes to the artist/critic bond. Some refuse to form personal ties with artists, while others enjoy their company in bed. In the '50s, during the height of Abstract Expressionism, art, sex, and booze were virtually synonymous. In the days before feminism, women artists frequently slept their way into the commercial art world; it was the only way in.

Lippard has always made her passion for artists clear. She was married to Robert Ryman for eight years, as he painted white on white; she then lived with sculptor Charles Simonds for nine years, as his fantastic miniature cultures were unearthed in the oddest places. She went on to have several affairs with both prominent and unknown artists. Lippard's personal life has not been uninteresting. I find myself mentioning it right away, because it is the most obvious subtext in this private collection: reading through the list of artists in this exhibition is like reading through the critic's diary. Sexuality, of course, is not a subject that Lippard, or any other feminist, has neglected. And as most women have come to know, sex is most dangerous when kept secret. But I raise this contentious theme primarily to demonstrate that Lippard, unlike most critics, has never been alienated from artists or viewed art from the outside. Moreover, she seems to operate more like an artist than a critic.

Alternatively, in the art-critical world, Lippard has been viewed as an outsider, more an advocate for certain ideas and artists than a hard-nosed (i.e. "objective") writer. "I am occasionally 'accused' of being an artist," she remarked in the prefatory note to *Get the Message?*, a shrilly titled collection of her writings from the '70s and '80s. "I used to deny this adamantly… since I am primarily a writer… Now, having urged everyone else to break out of their boundaries, I find myself wandering in a well-deserved no-one's land." (Notice her insistence on politically

REMINISCENCES

NANCY SPERO

Lucy Lippard has great personal integrity and a strong sense of fair play and loyalty. To me her convictions carry a great deal of credibility—she champions artists whose messages and art practices might otherwise not be heard and seen.

I worked with Lucy in the early '70s in the Ad Hoc Women Artists' Committee, an open coalition of women artists and writers whose work and ideologies varied greatly. We investigated the art world and the "real" world. Lucy was crucial as a powerful and principled voice. This was an exciting and revelatory time.

Lucy continues her "revolution," one of the precursors in opening up the art world.

END

MAY STEVENS
FOR LUCY

Inside the Sniper's Nest over the years, the changing arrangement has charted the proceedings of a life: friends, books,

CONTINUED

articles, causes, symposia, countries, ethni-cities. Three of my heroes have come to sit on these walls: Rosa Luxemburg and Alice Stevens, from my series "Ordinary/ Extraordinary," and the eponymous Lucy Parsons, anarchist/activist ancestor of the Sniper herself.

Art[ifacts] spill from walls to floor to doors, contiguous surfaces are ablaze with memos, chores, postcards, little yellow notepad stick'em pages, seed pods, tools, implements, photos, posters, oddities of all sorts. Piles of bricks and clay block the floorways, as magazines, books, and flyers fall off chairs and coffee tables. The cat for-ages. The Sniper, in precarious control, knows where everything is.

To witness the growth and falling off and to mark the continuous redefining— the appearance of ingested foreign matter, coloring adjacent organs—is to watch a lifetime. From the early leftism (Evergood) to Dada and Surrealism, to Pop art, to Minimalism and Conceptualism, to activism, to ancient history with its rocks, and then, after the European hiatus, the great divide—feminism, a sea change,

CONTINUED

correct language.) Still, Lippard's wanderlust resulted in seventeen books on art, which cover more of it than many working critics see in a lifetime.

As her books popped out like toast from a toaster, Lippard began to develop a voice that was distinctly political. For a generation of progressive artists who needed their thoughts and actions organized, she became a hero, an activist model. Lippard wrote from her own experience as a woman, a feminist, and a socialist, always allowing her biases to drive her thoughts. Her books and articles crossed over into the mainstream (once defined as any body of water deep enough to drown in), picking up an audience beyond the art world. But as the '80s muddled along, the polemicist became more and more disenchanted with art-world resistance to activism. Teaching a seminar off and on for nine years at the University of Colorado at Boulder, she began to wean herself from SoHo politics. A shift in her interests and in her writings became evident as she began to veer off once again in a new direction.

This time she would leave the New York art scene behind. Breaking free from the tyranny of her profession, the critic metamorphosed into a cultural explorer, opening herself up to write broadly about "places" and "things" that many of her art-world peers might dismiss. Just the fact that she has given up ownership of the art in this extraordinary collection is telling. Like a monk shedding material objects in a ritual of purification, she has embarked on a new journey. This exhi-bition marks its beginning.

Having built a one-room house in a small village in New Mexico, Lippard is immersing herself in a new landscape, one that is raw and relatively undeveloped. In her book *Overlay* and in various articles, she has written extensively on artists

inspired by the earth and other natural events. Now, Lippard herself is digging in the ground, foraging and hunting for petroglyphs and artifacts buried beneath the surface of what we see. Bringing a critic's eye to an archaeologist's task, she is writing about her own search for a natural history long since covered up by the economics of a homogenized, racist culture. Physically and intellectually, Lippard has moved to the West (although she is still devoted to Georgetown, Maine, where her family has summered for eight decades), and she is not bringing New York—or the collection in this exhibition—with her. She is making room, cleaning house.

In a sense, Lippard's desire to give up these objects follows her own developing position on the entire project of making art. Over the decades, she has grown less and less sympathetic to artists still producing objects geared to the commercial-gallery system of buying and selling at increasing prices. She has become most interested in social-issue art, made by artists working in the particular environments where they might affect community consciousness or local politics. (The problem, of course, is how to show, sell, or maintain this form of art; the solution, frequently, is to let the piece wither away—not a natural process for most artists.) Much of the activist work that Lippard has supported was created in contexts where there was a need for social reform.

Today, many painters and sculptors (especially those public sculptors who make what she calls "Plunk Art") hold little interest for Lippard. Instead, she is attracted by objects and projects that *no collector* could possess. She has also developed a fondness for things that anybody can have for the taking; she long ago began collecting rocks, for example, during her forays into the mountains or through desert terrain. Lippard writes, "I've never collected art the way I've collected rocks." Most of her rocks are not in this exhibition because she is actively thinking about them—not about fine art.

and women's work washes up on the shore. Now amongst the Spanish words and Native American faces, the land comes back, the petroglyph, the shard, the first stone. And a pattern, a deep underlying logic, shapes itself... not so varied, not so erratic, after all.

END

MICHELLE STUART
LUCY

There are questions of memory in the beginning.

Is there an entrance to memory, and how does it represent the interior? Has memory a map of its own, like the old Paris métro—touch a destination button and the subway stops light up? And do we make up its reality anyway? And do we change memory according to both chance and desire? Can this interpretive map be shared?

Should it have a boundary... and if so... where should that edge lie? Should the map illuminate Maine... Spain... Ireland... Mexico... Colorado... New

CONTINUED

Zealand... Australia... New York... Central America? Should a woman with a child in hand and a book be painted on the adoptive edge?... INTEGRITY... INTELLECT. Should the sheep dog companion of walks in Devon be there too? ... LOYALTY... prancing with the light? Why does the latter seem like my own memory?

Why is the imprint on my memory of postcards with little x's like a nest or a crown above a name so particular, so personal ... so lovingly imperious?... Would there be a defined path on this map or could one meander without limits?... Would there be rebels behind the standing stones ... in St. Michael's Woods or San Miguel de la Selva? Does the path unfold to release a hand-painted carte-de-visite of a Native American, or just roll out indefinitely until death parts... or until one reaches Sayreville, New Jersey...?

Sometimes memories wander inside and outside of one's self, and one doesn't know to whom they belong... being without matter... thoughts shared...

CONTINUED

The 200 objects in "Snipers Nest," organized by Neery Melkonian, were never deemed a "collection" before this show. Over a period of months, the "stuff" in Lippard's New York home has been transformed into a respectable and valuable exhibition. It's an exquisite irony. As Lippard exits an art world ravaged by a decade of greed and a corrective recession, her own accumulation of art becomes a prized commodity. Nevertheless, the public is well served by this predicament.

What is this collection of objects? Should we even call it a collection? Should critics, ethically, even collect art?

The works in this exhibition map Lippard's political adventures, aesthetic biases, and friendships during a tumultuous time in New York. Before this moment, when the objects were not numbered, dated, framed, or even dusted, they lived a different but equally engaged existence in her loft. As you can see from the breadth of the selection, Lippard views art through a wide-angle lens. Her goal has always been to be inclusive, almost to a fault. The one question that Lippard, unlike many of her colleagues, rarely asked is: But is it art? She kept (and cherished) everything—postcards, rocks, tchotchkes—regardless of the sender's intentions.

Since most of the works in this collection were gifts to the critic, we must wonder about the artists' intentions. The premise of "Sniper's Nest" begs us to ask: were there strings attached to these presents? Did the artists want to tighten the knot that tied them to Lippard? Does it matter? Bribery is too crass a term to describe how these works came to be in this show. Nevertheless, behind every piece in "Sniper's Nest" lies the complex relationship between critic and artist. Clement Greenberg once demanded payment in the form of an artwork after reviewing an artist's exhibition. Lippard was quite the opposite: she has always

been reluctant to accept gifts of art. Still, the gifts came. And when Lippard continued to write about the artists whose work she then owned, the value of her "collection" went up, at least in theory. Did Lippard ever consider the economic value of her collection? This was never her concern.

Even if the objects in this show have now been born again into a world where economic value is an overtly significant index, the installation encourages us to consider the meaning of these works in their previous context, where they were unburdened by any commercial order, or by the layers of meaning inherent to a museum show. The "show" in Lippard's loft was always changing, like a revolving or living installation. As she received new gifts she would display them and remove something else. Though she did buy art—one of the first pieces she ever purchased, Harmony Hammond's *Bag IX*, is included in this exhibition—she did so rarely. The numerous paintings, photos, sculptures, and unpredictable items surrounded the critic/performer in a space that was frequently the site of dramatic public meetings, workshops, and social events. The art looked vital in the critic's home; the objects seemed almost to belong to us all, the coterie around the critic, as well as to Lippard and her son, Ethan Ryman, a musician inhabiting a mysterious darkness toward the back of the space.

Most people don't give away their art collections until they die. Initially, the fact that Lippard could dispose of these works so easily was distressing. It was as if she were rejecting art altogether at a moment when artists need all the support they can get. There was something verging on morbidity about her sudden dispersion. The sadness around her exodus from New York remains, but as the massive task of weeding through her art began, and the layers of dust lifted, Neery Melkonian began to put together a view of Lippard we had never before seen. Every collection has a story to tell, and this one belongs to Lucy.

ideas exchanged… The thought of all the materials both hard and soft that define a relationship… stones enclosed in bamboo binding from China, pink stones wrapped in a pink stone box from somewhere… India? The color and texture that represent a territory reminiscent of Canyon de Chelley or Chaco, a worn map of New Mexico that was used, but at a different time and place.

I am not sure if I imagine fantastic gardens where they are hanging like ripe tropical fruit… but… earrings, loud and Latina, figure in the reverie like a cultural wind chime… the tinkling sound masking distant gunshots… scenes of passion and injustice… Why does the latter again seem like my memory?… Es como un espeyo… la memoria… a shared revelation in a frame that people invent together to satisfy the reflection.

END

SUSANA TORRE

THE MOVING TARGET

In Argentina during the mid- and late '60s I used to translate Lucy Lippard's essays in Art International *for my artist friends. To us, hers was the most inquisitive, polemical voice, and we relied on her writings to learn about work being done outside the circle of Clement Greenberg's critical and artistic protégés, which dominated most English-language art publications. Most intriguing was the wholly undogmatic assertiveness of her criticism, and the fact that she seemed to be just as passionately interested in Minimalist art, with its emphasis on series and its denial of the hand's role in production, as in work that represented materiality and sensuality in both attractive and repelling forms. For these latter works she used the term "eccentric abstraction." In retrospect, this would seem to reveal her conceptual consistency as a self-defined "moving target," and her tropism toward ex-centric positions.*

Although the struggle to expand the boundaries of institutional recognition to

CONTINUED

This seemingly casual assemblage of objects describes the precise period of time, from Minimalism to multiculturalism, in which Lippard was writing and reviewing in New York. While the art in the show literally pays homage to the critic, it would be incorrect to assume that these "gifts" are less significant than the few items the artist kept. By referring to them as "gifts," I do not mean to demean their authenticity or power; there are major works in this collection, as well as minor ones that other collectors or museums might kill for. These artists understood that without Lippard, their entire production might well have been sentenced to a life of invisibility. They were genuinely grateful. There are also gifts from friends who are not particularly exceptional artists, but the issue of "quality" has always been riddled with conflict for Lippard. It's not that she has had a problem with the term, but that many of her peers took issue with her definition. (One person's pornography is another's art.)

When put on the spot in a lecture, Lippard once defined art simply and clearly as a medium of communication that is primarily visual. The work must have something to say, a raison d'être. It can be as abstract as a Robert Mangold, as didactic as a Guerrilla Girls poster, as polemical as a photograph by Jerry Kearns, as gorgeous as a collage by Michelle Stuart, or as perplexing as a Jimmie Durham sculpture. If the work of art spoke to Lippard, she frequently ended up writing about it and, sometimes, befriending the artist.

There was a clear point for Lippard (post-*Overlay*) when she seemed to become more interested in what an artist was making than in judging the "quality" of that particular work. Her book *Mixed Blessings*, for instance, covers the work of hundreds of artists without much critical assessment of their art. This aspect of her approach was debated by some of the artists included in the book, and also by

some of Lippard's adversaries, who refused to accept her unwillingness to rank artists according to the latest theories on art. Over the years, however, Lippard has become more critical of artists for their lack of independence, and for their inability to control their own production, than for their aesthetics. She has even lost interest in following contemporary art closely, in part because she had been there before.

Feminism is the big issue in this exhibition. During her most militant stage, in the '70s, Lippard was a founding member of the editorial collective that published *Heresies: A Feminist Journal on Art and Politics.* She had already written a dozen books, and was beginning to reassess her ideas and to enter a revisionist period. *Heresies* offered her an analytic forum: a motley group (writers, artists, anthropologists, filmmakers, journalists, etc.) of women, all insistent on deconstructing an art world that was totally subjugating the woman artist, especially if she wasn't white or heterosexual. The magazine was started (I too was a member of this group) because no other art journal on feminist art and ideas existed. Artists too wanted a place to write, because critics were doing such a painfully inadequate job of articulating their work.

The Heresies Collective was determined to annihilate the myth of the genius (i.e. male) artist. Lippard had the ability to spotlight unknown artists—women artists—in her writings and in the shows she was curating around the country. Six years before the inaugural issue of *Heresies*, she had already organized her first major all-women show in a museum (at the Aldrich Museum, Ridgefield, Connecticut, in 1971). The show included twenty-six women (Alice Aycock, Mary Heilman, Howardena Pindell, Adrian Piper, Merrill Wagner, Jackie Winsor, and Barbara Zucker among them) who were all, at the

REMINISCENCES

include women artists and artists of color was a collective effort, Lucy's commitment as a critic was uniquely important. Her colleagues in the art establishment looked on in disbelief as she joined artists in picketing museums to protest their exclusionary practices. Surely this risky crossing-over would mean forgoing the kind of recognition usually given to what Hilton Kramer called a "writer of this quality." She came to define part of her identity as author in terms of the power to authorize work at the margins; in turn, much of the work she focused on, including political activism, eventually came to be regarded as a legitimate subject in the dominant cultural discourse. Hence the paradox of someone who has defiantly embraced the moniker of "marginal" in well-established political tradition, although her writings have created multiple critical "centers."

When we became friends and neighbors, in 1968, she was, intellectually and emotionally, the most self-reliant and independent person I had ever met. I think this independence must have been crucial in developing her original approach to theo-

CONTINUED

rizing art from within its own production, and to originating critical discourse in the work itself. It is fitting, then, that those pieces in this exhibition not related to her familial heritage are mostly related to investigations pursued in her writings. In this regard, the Sniper's Nest may contribute to deconstructing the dominant concept of what constitutes a great collection. Class, taste, and money—those key ingredients—could never acquire such an incomparable cluster of artifacts, nor could they represent the integrity and specificity of anybody else's life. For Lucy, ideas have never been expressed in black and white, but in biting shades of purple and yellow.

END

ANNE TWITTY

RETRACING HER STEPS

In a dream: *art center: large blowups mounted on free-standing forms, record of a trip Lucy and Peter have taken along the roads of Georgetown Island, unrolling backward toward the starting place:*

CONTINUED

time, unknown. Soon after, a separatist curatorial practice became the focus of a significant debate among feminist and gay artists. Now we have a different problem: museums do huge group shows of women, or of a particular ethnic group, but refuse to show these artists as individuals, retrospectively, or in smaller, more complex shows.

Throughout the '70s, as Lippard moved away from Minimalism and Conceptualism, she was the single New York critic regularly championing women's work. She had already put a high percentage of women in "Eccentric Abstraction" (1966), including two little-known sculptors named Eva Hesse and Louise Bourgeois. Lippard knew that women were going to be the ones, finally, to give Modernism a kick in the groin. "Sniper's Nest" is by any standards a feminist beehive of activity. Consider a partial list of the talent included: Alice Adams, Eleanor Antin, Judy Baca, Louise Bourgeois, Josely Carvalho, Judy Chicago, Mary Beth Edelson, Hammond, Bessie Harvey, Hesse, Ellen Lanyon, June Leaf, Ana Mendieta, Howardena Pindell, Faith Ringgold, Lorna Simpson, Jaune Quick-to-See Smith, Joan Snyder, Nancy Spero, Pat Steir, May Stevens, Stuart, Kathy Vargas, Cecilia Vicuna, and Hannah Wilke.

While any number of these artists might star in this and other contexts, their general status, judging by the usual museum standards, is not so high. Some of them remain unrepresented by commercial dealers, and most have not had a major museum retrospective, despite their (forgive me) age, experience, and accomplishment. Wilke, an innovator who documented her own demise, died of cancer without ever seeing her works in a major museum exhibition. Her fame catapulted after her death, but women artists, like male artists, would like the privilege of witnessing their own success, of meeting their audiences.

The two women artists whom Lippard championed early in their careers—Mendieta and Hesse—both died young, becoming stars posthumously. Mendieta fell or was pushed out of a window, and Hesse died of a brain tumor. Mendieta's husband, Carl Andre, was accused of murdering his wife, and Lippard was tied up in knots for a time over the young artist's shocking death. She had known Andre longer than Mendieta, and had been influenced by his concepts on Minimal art and his application of Marxist politics to his flat sculptures. The case against Andre was dismissed in court—but not by a number of people in the art world.

The bad news, obvious to most readers of this catalogue, is that there is still little justice in the art world for women. Just ask the Guerrilla Girls. The group itself may have become an institution, but it gets more attention than the individual women artists behind the masks. While we no longer isolate the condition of women artists from that of artists of color (an unfortunate term), we still need to ask what happened to the feminist art movement of the '70s. Despite a current miniresurgence of interest, as far as most art historians are concerned it seems to have slipped through the cracks. Why was that movement so isolated, and so unable to sustain any momentum?

While there are still flurries of feminist activity in the art world, the movement itself seemed to hit a dead end when leading feminist artists became so rigid that their cadre had to move away to gain enough freedom to make art. By the early '80s, there were fresher art movements that seemed equally or even more vital. Many of the feminist artists who emerged in the '90s, none of them represented in this exhibition, intentionally disconnected themselves from '70s feminists, whom they viewed as authoritarian. *Heresies* became a dull politically correct journal that was edited by consensus; articles and interviews published in mainstream art publications were far

REMINISCENCES

SOUND: *tape recordings: words said as they drove past each scene.*
Movement. In motion. The wind of it blows the words away.

Carboneras: *a crumbling cliff overlooking the Mediterranean. Two figures, women, each edged into a hollow. A bottle of wine between them/us. Looking out over the sea as clouds take form, billow, against late-afternoon pastels. Ethan and Gerardo, smaller then, sent off—escaped—somewhere into landscape.* SOUND: *slap and mutter of small waves, hollow clank and bobbing tinkle, soaring calls. Goatherd with evening animals, a herd of them and then another following, spreading earth browns, blacks, white splotches in rhythm down the beach.*

Devon: *Hard driving down from London in the rain. What were we looking for, which address, anyway this wasn't it, this lane between hedgerows we headed down by map mistake, halting just before the big gray farmhouse, to the right in front a gray stone cottage, in front of that a pond. Water birds sailing purposefully across it, at cross-purposes. The cottage in the foggy*

CONTINUED

mist. Something not quite here nor there. Have the roads that led us here rolled up behind? Lucy, go ask if it's for rent. It became, already was: Ashwell. Headquarters for expeditions along drenched Dartmoor rows, down Penzance way to stone circles among the dun, green, gold of tussocky Cornwall fields, sprawl/crawling through Men-an-tol, memory of a farm horse rubbing its back against a menhir, unselfconsciously.

Maine: *front deck: Lucy reading, her feet propped up, a day when sailing wasn't right, or the boat had already been wheeled up for the winter. Slow retreat and advance, a thin line of silver slipping in across the bay. Calculating the tidal hour for a walk across to visit Nan.* ODOR: *distant salt, opened mollusc, pungence of mosquito rub. Feet anticipate:* FEEL: *splinter of worn mussel shells, bristle of reeds, cold channel suck, yield of bladderwrack.*

Home loft: *The old rocker slanting among seats clustered around a (now white) table Sol made for her some time ago. Holding point: the back middle partition at Prince Street. Blanket stripes*

CONTINUED

more relevant to women artists. Neither the Heresies Collective nor the publication could make the transitions that would have allowed them to keep up with current concerns, nor could they find the finances to publish quarterly. The magazine became a period piece.

Though this is not the place to debate the progress of the feminist art movement, Lippard's collection raises the issue. (Don't miss the Heresies contribution, a small box, filled to the brim with treasures, that was given to Lippard when she left the collective.) As the primary critic behind many feminist artists, Lippard is as familiar with their agonies as with their work. "Sniper's Nest" allows us to see some of their most private and formative pieces—an early collage by May Stevens, for instance, which developed out of a page piece for *Heresies*, from her well-known series "Ordinary/Extraordinary," about the theoretical relationship between her aging mother, Alice Stevens, and the German revolutionary Rosa Luxemburg.

While I have written about many of the women artists in this collection, I was surprised by the number of men included, and by the range of their works. I must begin with Lippard's coffee table, which, once upon a time, was just that. In the old days we went so far as to set our feet and our wine glasses right on its painted surface. That same table is now "The Sol LeWitt Table."

Though I find it somewhat difficult to consider this innocuous piece of furniture as an aesthetic object, the table nevertheless leads us to consider the significance of the long-term friendship between LeWitt and Lippard. (Lippard had so many LeWitts in her collection that Melkonian could not display them all.) One might presume that this hermetic abstract artist and our cranky ideologue would be an unlikely match, but this is far from true. As Lippard considered the perplexing

and contrary relationship between politics and abstract art, she was immersed in a dialogue with LeWitt that has never stopped. LeWitt, also committed to progressive politics, never allowed his rage to enter his work formally. Like Rudolf Baranik, another long-term intimate of Lippard's, he maintained his commitment to abstraction and poetics apart from his political activities (though Baranik's dark canvases are far more emotional than LeWitt's geometric fantasies). LeWitt built Lippard a necessary table, then went on to draw 1,000 delicate wiggly lines on her wall, which have been re-created for this exhibition. He knew how to please both sides of her, and never saw them as schizoid.

For Lippard there was never an intellectual conflict between her passion for art and her insistence on political activism. Meeting after meeting was held beneath the shrine of a brushy, yellowing Robert Ryman (white) canvas, for years the center of Lippard's home. Meanwhile Papo Colo's black-and-white cross made of dominoes cynically blessed Lippard's stereo, a shrine to the amount of faith and luck every artist needs. I had admired Colo's cross for years before coming across this artist/curator in person; this was the case with a number of pieces in Lippard's loft. Walking through the exhibition, one should check the dates of every work; there are numerous early objects by artists who became established long after their due. Lippard was in their studios first. At the time, little did she know (or probably care) that where she went, others would eventually follow.

While Lippard is constantly accused of having abandoned art and artists for her own more anthropological field trips, this is not the case. The more interesting question is what Lippard has come to mean by "art" over the years, as she has moved out of the art world's protective shell into the more brutal world of social realities. There's no short answer. "Sniper's Nest" offers several narratives to follow, but Lippard's

REMINISCENCES

thrown over an original worn beige partly visible behind a shape: Lucy, her hair exasperated, wrapped in something hastily, China cat a sinuous black question mark across her lap.

Galisteo: a walk that trails past the old cemetery, up and then along the basalt ridge to petroglyphs, rays bursting, arrowmouths, then down through scrub juniper and blinding distances. A long arc, sunheaded, cool bare feet slurring through shallows of the fading creek that leads back under the bridge and home. Not far away: Harmony's old wool shed made beautiful. Afternoon advancing into twilight. Sitting out on the porch with Nancy. The triangle, arrowhead shape of the garden, pointing toward a setting sun that seeped over silver-gray and orange-red flowers, anonymous. Later, we seize the wheelbarrow and sail it into the back of the Toyota. While dinner cooks, a wild and whirling dance on the stained cement of the new house, boot heels stomping to the sound of local radio.

Crestone: Buffalo burgers at the Roadkill Cafe. Peering along graveled roads, no signposts anywhere, oh, there's one small

CONTINUED

horizontal reading: Carmelite Monastery. That's not it. The Temple of the Universal Mother? Where among cottonwoods, across descending streams, under the clouds and hanging snow-peaks behind this sidesprawl of a place can it be? We drive, finally, by a car: a red-faced Texan: Sure, I think it's up that way. Just follow me. And we do, up a rutted road, to an adobe shape, gleaming golden spiral topping the dome. Inside, in front of white Saraswati, her hands presenting imagery, we each take a cushion from the stack and sit a while, stop time. Neither first nor last in the stream of time.

Gioia's Byrdcliffe House: *eclipse dream: Lucy has brought back a woven shirt from New Mexico. I look at the stamped tin figure on the front.* Lucy, *I say,* that's Saint Francis. Oh no, *she answers,* it can't be. Yes, *I insist, looking closer.* You can see the belt around his robe and the bird circling his head. And *(I take another look),* Saint Francis always has the traveler and the magician with him. See— there they are. *Invented iconography: two figures, one of them elongated, his head*

CONTINUED

current journey is unpredictable. On an aesthetic track, this show moves from Minimalism to some sort of crazy Maximalism, where art is not determined by pre-conceived definitions or necessarily bound by any commercial system—yet. Remember: where Lippard goes, we all follow. At the moment, a part of this show has a seriously kitschy edge. Lippard may have moved from trained objects to untrained ones, but the rocks she gathers must be labeled through an entirely different set of criteria. Where are they from? Did they serve a purpose? What are they made of? I suspect Lippard will consider the identities of those who have held these stones before she came along and reached down into the dirt. Finders keepers? ■

Hanging Ariadne's work at "Both Sides Now" exhibition of women's art, Artemesia Gallery, Chicago, 1979.

small as a statue's seen from the ground. Behind him, the juggler. THE TRAVELER AND THE MAGICIAN. TRAVELING COMPANIONS. ON YOUR WAY.

END

KATHY VARGAS

Lucy and I still don't quite agree as to exactly what I was watching on television the Sunday she called. She keeps insisting that it was soap operas, and I keep telling her that if it had been soap operas she would have had a much harder time prying me away to go look at murals. Luckily for both of us it was only an old rerun of Jaws, *which I gladly gave up to go meet Lucy Lippard— and without knowing it, a host of marvelous women I'm still just meeting.*

One letter and several postcards later, Lucy and I met up again in New York. She cooked dinner and invited some people she thought I should meet. Yong Soon was there, and later came to Texas for a women's exhibit the Guadalupe presented. At a "Mixing It Up" conference in Boulder

CONTINUED

85

in 1990, I met Lorna and Jean and remet Hung. We did some truly inspired shopping. Every time I see or talk to Hung we congratulate each other about the great deal she got on the gorgeous serpent necklace she acquired. During those same four days I met several of Lucy's friends: Anna, who's doing some incredible work now; Lucille, who got married a couple of years ago; Annie, who I'm so glad got a grant for her photography in 1993; and Jennifer, who curated a spectacular velvet-painting exhibit. We've managed to keep in touch somehow, and when I talk to Lucy these days I ask "How is Jennifer?" or "Have you seen Jean?"

Two springs ago I saw Elizabeth again— Elizabeth whom I'd also met at Lucy's dinner table. Before a very trying panel discussion on censorship, it was great to talk with her about my exboyfriend, her great taste in earrings, and other absolutely essential topics. And I can't forget May, who made me feel welcome during my sojourn in New York while Lucy was away. Just last January I sat down to dinner with Jolene and Tere and Theresa: bright, busy, energetic friends

C O N T I N U E D

In December of 1994 I met Lucy Lippard in her Prince Street home in SoHo, New York. I was there as a registrar to review an inventory of Lucy's collection, and to plan the shipping of it to the Center for Curatorial Studies. Lucy was in the process of packing her belongings for her move to New Mexico, so the collection had been consolidated in the main living area. We sat among the stacks of frames and boxes to discuss the logistics of our project and to review each work of art. Lucy knew, without a moment's hesitation, the name of each artist and when she had received the work. She matter-of-factly related the occasion of each gift, or the relationship she had to the artist. At the close of our meeting, I had already begun to understand how Lucy, with her easy manner and spirited laugh, could acquire such a variety of objects primarily as gifts from artists and friends.

On the ride back from New York and during the next weeks I kept thinking about the truckload of "stuff" we had just packed, and about how it was acquired. I kept thinking of the difference between an old world connoisseur's collection and that of a more contemporary buyer on the art market. For some time I harbored the notion that because Lucy may not have made deliberate choices in acquiring these works of art, they were not a "collection." It was an odd notion but something was getting at me, probably because I was still trying to make sense of the objects' physicality. They were for the most part not

matted or framed in any particular manner. Many were unframed, housed in portfolios or cardboard. Some very clearly were showing their age. They had lived in New York City, many for twenty to twenty-five years. By museum standards they had been through hell. But by historical standards they had lived a rich life, and they had survived.

Once I began working with the "collection" back at the Center I had the opportunity to get to know individual artworks from both a registrarial perspective and a human perspective relating to Lucy. Our task began with unpacking, checking inventory, and recording physical condition, dimensions, and framing specs. Next came the cleaning of existing frames and glass, and sorting works into bins and portfolios for storage. The inventory list tallied over two hundred paintings, prints, photographs, small sculptural objects, and posters. Computerizing that list and assigning loan numbers were really the first steps in thinking of all of these objects as a collection. I spent additional days at the computer recording information on over two hundred artist's books, as well as one hundred natural objects and tchotchkes. Each task was a building block in the process that revealed the collection to me.

During all this time I had anecdotes in my head that I had heard from Lucy in my two meetings with her, and I began to tell them as if they were my own stories. It was very early on that I remarked that Lucy did not just

collect objects, she collected people and, more important, people who were friends. It wasn't until July of 1995, however, that I realized that whether or not Lucy chose these works of art, or paid money for them, she did in fact save them, keep them, live with them, and value them not just as art or mementos from friends, but as evidence of history. The work tells that those friends range from art world veterans to students. It traces Lucy around the country and in and out of eras. It is a chronicle of her writings. And it is in this way that I see Lucy's "collection" as different from that of a connoisseur or contemporary collector, whose focus may be limited or dictated by trends.

These works have been matted, in bright white, and framed, in smooth unobtrusive wood, I have started to feel that Lucy is being taken out of the collection. And while as a registrar I cannot handle these works of art in any manner other than a professional one (seeing to their wellbeing and preservation, that is), I hope that the essence of each work as Lucy might pin it up on the wall can be remembered by those who know her and her Prince Street home.

Our task—to create an exhibition that illustrated the soul of the collection and further exemplified the evidence of Lucy's life—was gradually being realized by summer's end. When we finally moved the now transformed two hundred objects into the CCS Museum galleries, their new physical similarities, a result of uniform framing, and their placement against the egret white walls, further stripped away most of

the personal references declared in the stories and inscriptions, and began to isolate concepts and art movements, as well as to reveal the collection's cohesive nature. The installation of galleries two (Earth, Body, and feminist art) and three (Pop, Conceptual, and Minimalism) was fairly straightforward and linear. Gallery one, however (war and protest, people, places and things from all times), felt more like my first experience at Prince Street, brimming with visuals, objects, and information. Lucy participated in the installation of this part of the space. She chose the placement of the onehundred or so natural objects, mementos, trinkets, tchotchkes, and artist's books in the cases and on the surrounding walls. In this simple but effective way her spirit again enlivened the collection.

"Sniper's Nest: Art That Has Lived with Lucy R. Lippard" has been my connection to artists Carolyn Fijalek, Papo Colo, Cara Jaye, Florence Isham Cross, Juan Sanchez, Caroline Hinkley, Luis Jimenez, Elizabeth Layton, Regina Vater, Ana Mendieta, Marta Maria Perez Bravo, and Eva Hesse, to name a few. And of course to Lucy Lippard. The project has involved long hours, people and resource management finesse, and planning strategy, and has been not only a learning experience but a richly fulfilling one. Its final chapter, which includes the exhibition tour, will no doubt further my connection with Lucy and her collection.

—*Marcia Acita, Registrar*
Center for Curatorial Studies

who were friends because somewhere along the line Lucy, or other friends of Lucy's, made sure we intersected. And as we all meet we bring other friends into the circle. Often I get calls from—or I call—the greatest women; we introduce ourselves with the refrain "Lucy said I should call you." Immediately the ice is broken and we can laugh, share resources, compare notes, and exchange insights in complete confidence and comfort. The conversation shifts back and forth from the intensely political to the very personal; from the victories to the doubts and disappointments.

To me, Lucy's collection of art and Lucy's collection of friends have much in common. Both are open and accessible aggregations, each person/each object unique, different from the rest, yet obviously gathered together by the same mind and heart. All elements acting as complementary entities, engaging each other the minute they connect. The need for variety is obvious in the differences, yet both art and friends are unified by the spirit of the collector.

END

All 2-D dimensions are framed. * *Not traveling.*

Artworkers Coalition Poster Committee (Irving Petlin, Jon Hendricks, Frazier Dougherty). *Q. And Babies? A. And Babies.* 1969. Poster. 29 x 40 1/8 x 1 3/8".

**c. 7500.* Wall label for travelling exhibition of women's contemporary art. 1974. Poster on board. 34 5/8 x 12 1/4 x 1 1/8".

Certificate from La Universidad de El Salvador. 1984. Printed paper. 9 1/4 x 9 1/2 x 3/4".

Collection of tchotchkes, natural objects, political pins.

World War 3, #5. Comic book. Published by Seth Tobocman, Peter Kuper, Christof Kohlhofer.

Anonymous. *Anciennes fortifications de l'Ohio (Indian mounds).* 19th century. Paint and print on paper. 7 1/2 x 10 1/2 x 1 3/8".

*Anonymous. *George Washington Welcoming Abraham Lincoln to Heaven.* n.d. (c.1865). Postcard. 19 3/4 x 14 x 1 1/4".

Anonymous (Cross/Isham family). *Crazy Quilt.* Dec 25, 1883. Fabrics. 68 x 58".

Anonymous. *San Juan Pueblo.* 1930s. Black and white photograph. 11 1/4 x 45 1/4 x 3/4".

Anonymous. *Gardens...some metaphors for a public art.* 1980. 14 1/2 x 21 x 3/4".

Anonymous. *Stones: a feminist view of ancient images in contemporary art.* c. 1980. Poster. 15 x 9 1/2 x 3/4".

Anonymous (Salvadoran child's drawing). *Niños de Preparatorio.* c. 1984. Crayon on paper. 20 1/4 x 24 1/4 x 1 3/8".

Anonymous. *Female Ibeji figure (Yoruba).* n.d. Wood with bead/string necklace. 9 1/2 x 3 x 2".

Anonymous. *Male Ibeji figure (Yoruba).* n.d. Wood with beads. 10 x 3 1/2 x 2".

Anonymous. *Untitled (megaliths).* n.d. Page from a book. 21 x 17 x 1 3/8".

Alice Adams. *Adams House.* 1979. Etching. 23 1/4 x 30 3/4".

Carl Andre. *Beam Ends.* 1970. Steel I-beams sections. (4) at 4 x 5 x 6" each; 24 x 4 x 5" overall.

*Carl Andre. *21 Queens Tube Run.* 1971. 22 rusted steel pipe laid end to end. 3 1/2 x 1/2" each.

Carl Andre. *Steel Track Meander.* 1971. Steel. dimensions variable, c. 180" length.

Carlos Anrien/Equipo Pueblo. *500 años de lucha india por la libertad y la autonomia 1492-1992.* 1992. Poster. 24 3/4 x 18 1/4 x 3/4".

Eleanor Antin. *100 BOOTS.* 1973. 42 of 51 postcards forming a single work. 40 3/16 x 6 1/2 x 2" overall; 4 1/2 x 7" each.

Ida Applebroog. *You What?* 1979. Artists' book.

*Takeshi Asata. *Untitled.* c. early 1960's. Pencil on paper. 18 x15 x 1 3/8".

Terry Atkinson. *Map of an area of dimensions.* 1967. Print. 26 x 26 x 1 3/8".

Atlatl. *Submuloc.* 1992. Poster. 18 1/2 x 24 x 3/4".

Judy Baca. *Study for Olympic Mural of Woman Runner.* 1980. Blueprint drawing. 18 3/4 x 73 x 1 3/8".

Rudolph Baranik. *Attica/Vietnam.* 1973. Photographic collage. 29 1/2 x 37 3/4 x 1 3/8".

Christina Beach (Mrs. Joseph Giles Isham [1820-1904]). *Sampler.* 1827. Fabric and yarn. 10 1/8 x 10 1/8 x 1".

Hilla and Bernd Becher. *Untitled.* c. 1967. Black and white photograph. 28 1/2 x 23 1/2 x 1 3/8".

*Hilla and Bernd Becher. *Untitled.* c. 1970. Black and white photographs. 28 1/2 x 22 1/2 x 1 3/8"

Hilla and Bernd Becher. *Untitled.* c. 1967. Black and white photographs. 28 1/2 x 23 1/2 x 1 3/8".

Max Becher. *Cantalope.* c. 1980. Black and white photograph. 15 1/4 x 18 1/4 x 3/4".

Gene Beery. *Death in Family Painting.* c. 1963. Paint on masonite. 25 5/8 x 26 1/8".

Ron Benally (Navajo). *Untitled.* 1994. Pen and ink on paper. 27 x 31 x 1 3/8".

Vivienne Binns. *"Full Flight" Community Arts Committee Project.* Central Western Australia. 1982. Poster. 24 X 19 x 3/4".

Marc Blane. *Abandoned Buildings.* c. 1981. Photograph in glass bottle. 8 1/2" high.

Louise Bourgeois. *Femme pieu.* 1970. Wax and needles with thread. 6 x 3 1/2 x 3".

Marta Maria Perez Bravo. *Serie "Mujer Sola en Rio Camaco."* 1984. Black and white photograph. 25 x 20".

Marta Maria Perez Bravo. *Serie "Aquas, La Habana, 1984."* 1984. Black and white photograph. 25 x 20".

Sheila Levrant de Bretteville. *"Pink."* 1974. Poster. 26 3/4 x 21 x 1".

Beverly Buchanan. *(shack).* 1984. Painted clay. 6 1/2 x 6 1/4 x 3 1/5".

Beverly Buchanan. *Tea cup.* 1987. Painted foamcore with glitter. 6 x 8 x 3".

Rudy Burckhardt. *Astoria.* 1940. Black and white photograph. 9 x 11 1/4 x 1".

Rudy Burckhardt. *Have a Coke.* 1948. Black and white photograph. 11 1/4 x 9 x 1".

Werner Buser. *Untitled.* 1958. Ink on paper. 15 x 18 x 1 3/8".

Donna Byars. *Untitled.* c. 1975. Mixed media. 22 1/2 x 14 1/2 x 2 1/2".

*Ivan Canas Boix. *(Cuban Couple).* c. 1985. Black and white photograph. 18 1/4 x 13 1/4 x 1".

Anne Carlisle (image). *Divisions, Crossroads, Turns of Mind: Some New Irish Art.* 1986. Poster. 18 x 12 x 3/4".

Josely Carvalho. *Broken Dreams/Ripped Wings.* 1983. Silkscreen and mixed media on paper. 36 5/16 x 47 5/16 x 1".

Don Celender. *ArtBall Trading Cards.* Boxed set 1 of 5 (20 cards per set) with sugarless gum. . .

Enrique Chagoya. *Kicker/El Rey.* 1985. Mixed media in glass-fronted box. 5 3/8 x 8 1/2 x 2 5/8".

Judy Chicago. *Red Flag.* 1971. Lithograph. 29 x 33 x 1 3/8".

Judy Chicago. *Great Ladies 2.* 1972. Airbrush on paper. 29 x 29 x 1 3/8".

Judy Chicago. *The Rock Cunt as Portal . . .* 1974. Painted china relief. 6 x 6 x 2".

Judy Chicago. *Dinner Party*. 1979.
Poster. 54 1/4 x 19 3/4 x 3/4".

Judy Chicago. *The Creation from a Different Point of View*. 1985. Screenprint. 30 x 40 x 1".

Papo Colo. *Dominoes [sic] Dominant*. 1982.
Dominoes and wood, 7/25. 16 x 1 x 3/4".

Florence Isham Cross. *Shell*. 1903.
Ink wash on paper. 18 x 15 x 1 3/8".

Rick Danay (Caughnawaga Mohawk). *Big Ben*.
1986. Enamel on plastic. 17 x 7 x 7".

Hanne Darboven. *Untitled*. c. early 1970? Twenty-four pages, pen and ink on paper. 11 3/4 x 9" each.

Agnes Denes. *From the Philosophical Drawings Series, Dialectic Triangulation: A Visual Philosophy; Symbolic Logic #1*. 1970. Lithograph. 31 x 26 x 1 3/8".

Dentures Art Club. *(Stan Kaplan and Joan Giannacini)*.
Dancing Reagan. 1982. Mixed media collage on music box.

*Christos Dikeakos. *The Only Real Canadian Art*.
1969. Altered postcard. 6 x 9" actual size.

Marcel Duchamp and Jacques Villon. *after La Mariée for La Boîte-en-Valise*. 1936? Aquatint. 26 1/2 x 20 5/8 x 1 1/4".

Jimmie Durham. *Armadillo*. 1982.
Painted armadillo skull, shell, agate. 2 1/2 x 4 1/2 x 2 1/2".

Jimmie Durham (image). *Acts of Faith: Politics of the Spirit*.
1988. Poster. 14 x 12 1/2 x 3/4".

Mary Beth Edelson. *Up From the Earth*. 1979.
Black and white photographs. (3) at 21 x 21 x 1 3/8" ea.;
21 x 62 1/2 x 1 3/8" overall.

Mary Beth Edelson. *Venus*. c. 1980. Print on chiffon. 12 x 7".

Philip Evergood. *Charles Edward Smith on the Subway*.
1934. Pencil on paper. 26 1/2 x 20 5/8 x 1 1/4".

Lauren Ewing. *The School*. Late 1970's.
Etching on paper, A/P. 10 1/2 x 10 5/16 x 1".

Oyvind Fahlstrom. *Sketch for World Map, Part I, Americas Pacific*. 1972. Lithograph. 36 x 42 x 1".

*Carolyn Fijalek. *Untitled*. c. 1989.
Tempera on paper. 14 1/2 x 17 1/4 x 1".

Carolyn Fijalek. *Statue of Liberty*. c. 1989.
Tempera on paper. 12 1/4x 17 1/4 x 1".

George Freeman. *Family Portrait of Mr. and Mrs. Joseph Giles Isham and their children*. 1854.
Oil on ivory. 14 x 12 1/2" .

Su Friedrich. *Untitled (mannequin)*. c. 1979.
Black and white photograph. 18 x 15 x 1 3/8".

Mike Glier. *Vigilance*. c. 1982.
Paint on wood. 29 1/2 x 2 1/4 x 3/4". Actual size.

Eunice Golden. *Body Works Series III, #1*. 1976.
Color photographs. 31 x 28 1/2" x 1 3/8".

Leon Golub. *Vietnamese Prisoner*. c. 1973-74
Acrylic on linen. 15 3/4 x 10 3/4.

Leon Golub. *Vietnamese Woman Under Torture*.
c. 1973-74. Acrylic on linen. 15 3/4 x 13. Actual size.

Peter Gourfain. *Much Has Been Said, Now Much Must Be Done*. 1980. Silkscreen. 26 1/2 x 34 x 1 3/8".

Peter Gourfain. *Necklace*. c. 1981.
Glazed terra cotta and leather. 7 x 2 x 3/4".

Peter Gourfain. *Plane*. c. 1984.
Carved wooden carpenter's plane. 7 1/2 x 2 1/2 x 5".

Francisco José de y Lucientes Goya. *Nohubo Remedio*.
1799. Engraving, plate 24 from Capricios.
23 11/4 x 17 1/2 x 1 3/8".

Nancy Graves. *National Air and Space Museum*.
1975. Screenprint. 46 x 39 x 1/2".

Harmony Hammond. *Bag*. c. 1970.
Paint on cloth. 61 x 19 x 4".

Tanya Hammond. *Untitled*. n.d.
Four leaves and fabric string. 81 x 18 x 2 1/4".

Lyle Ashton Harris. *"Mama see the Negro, I'm frightened!"*
Poster for exhibition. 1993. Poster. 23 x 18 x 3/4".

Bessie Harvey. *The Rider*. Late 1980's.
Wood, paint and mixed media. 22 x 8 x 8".

Marty Heitner. *Bill Gordh and His Father*. 1984.
Black and white photograph. 26 x 22 1/2 x 1 3/8".

Heresies #9; Power, Propaganda,and Backlash. 1980.

Heresies Box for Lucy, Dec. 1987. Box of drawings, paintings, collages by Heresies members on the occasion of Lippard's resignation from "mother" collective after 11 years. Box: 2 x 4 x 9"; 17 works on paper.

Eva Hesse. *Untitled*. 1961.
Brown ink and pencil on paper. 26 x 22 1/2 x 1 3/8".

*Eva Hesse. *Untitled*. c. 1963.
Crayon, pencil, ball-point on paper. 22 1/2 x 26 x 1 3/8".

Eva Hesse. *Untitled*. 1967. Inkwash on postcard.
26 x 22 1/2 x 1 3/8".

Eva Hesse. *Untitled (cover of Lippard's Hesse book)*. 1967.
Ink wash on museum board. 26 x 22 1/2 x 1 3/8".

Eva Hesse. *Whole Shelled Clams, Atlantic*. 1967.
Pen and ink on paper. 22 1/2 x 26 x 1 3/8".

Eva Hesse. *Untitled (study for last sculpture)*.
1970. Ink on paper. 22 1/5 x 26 x 1 3/8".

Caroline Hinkley. *Death of the Master Narrative*. 1990.
Black and white photographs. 30 1/4 x 58 x 1 3/8".

Douglas Huebler. *Duration Piece #5, New York*.
April, 1969. Ten black and white photographs and text.
7 1/2 x 9 1/2" each, text 12 1/2 x 10 1/2".
Overall installation 43 1/4 x 36".

Alexis Hunter. *Untitled*. 1982.
Lithograph. 30 1/2 x 43 1/4 x 3/4".

Robert Huot. *Lucy's Lolly*. 1968. Alkyd on canvas. 20 x 20".

Patrick Ireland. *Untitled*. 1967.
Ink on paper. 34 x 29 1/2 x 1 3/8".

Yvonne Jacquette. *Belfast*. c. 1975.
Pencil on paper. 9 1/2 x 11 7/8 x 1".

Yvonne Jacquette. *Belfast*. c. 1975.
Colored pencil on paper. 9 1/2 x 11 7/8 x 1".

Cara Jaye. *Untitled (Southern Colorado) (grave by water)*.
1993. Chromogenic color print. 17 x 21 x 1 3/8".

Cara Jaye. *Untitled (Southern Colorado) (church and stones)*.
1993. Chromogenic color print. 17 x 21 x 1 3/8".

*Cara Jaye. *Nicho with Virgin of Guadalupe*. 1993.
Chromogenic color print. 17 x 21 x 1 3/8".

Noah Jemisin. *Ball*. 1984.
Birch wood and string. 20 x 20 x 20".

Chris Jennings. *Callanish II, Lewis*. 1976.
Black and white photograph. 16 1/4 x 20 1/4 x 1 3/8".

Luis Jimenez. *A Gaulope*. 1993.
Lithograph. 31 x 37 x 1 3/8".

J. Johnson. *American Indian Water Rights Tribunal*.
1986. Poster. 32 x 23 x 3/4".

Poppy Johnson. *I Think It Is Only Immortal Longings–
That's All*. 1972. Stones, lead. 5 1/4 x 19 x 2".

Alex Katz. *Peace (Portrait of Ethan Ryman for Collage of
Indignation II)*. 1970.
Pencil on paper. 30 7/8 x 23 3/4 x 1 3/8".

*Alex Katz. *Peace (portrait of Ethan Ryman)*. 1970. Pencil
on paper (study for poster, Collage of Indignation II).
12 x 9 x 1 3/8".

Alex Katz. *Ada*. c. 1970. Lithograph. 36 7/8 x 28 7/8 x 1 3/8".

On Kawara. *I Met*. 1968.
Seven pages, type on paper. 12 1/2 x 9 1/2".

On Kawara. *I Got Up.... 1969-75*.
Fifty-seven postcards. 3 1/2 x 5 1/2" each.

Jerry Kearns. *Broken Promises/Active Resistence*. Late 1970's.
Black and white photographs. 18 1/4 x 15 1/4 x 3/4".

*Jerry Kearns. *(Police Line)*. late 1970's.
Black and white photograph. 16 1/8 x 19 1/8 x 3/4".

Jerry Kearns. *Solidarity*. 1983.
Black and white photograph. 16 1/4 x 19 1/8 x 3/4".

*Jerry Kearns. *Untitled (man with hat)*. 1984.
Screenprint. 16 1/4 x 22 1/4 x 3/4".

Jerry Kearns. *Untitled Triptych*. c. 1984.
Paint on printed acetate. 16 1/4 x 25 1/4 x 3/4".

Jerry Kearns. *Female Trouble (Portrait of LRL)*. 1987.
Paint on printed acetate. 14 1/4 x 14 1/4 x 1 1/2".

Rita Langlois. *Untitled*. early 1980's.
Pen and pastel on paper. 18 1/4 x 12 1/4 x 1".

Nancy Wilson Kitchel. *The Face My Mother Gave Me*.
1974. Black and white photographs + xeroxed,
handwritten texts. (15) at 12 x 9" each.

Joyce Kozloff. *Untitled*. c. 1985. Lithograph. 29 x 40 x 1 3/8".

Suzanne Lacy. *Rape*. 1972. Artist's book.

Ellen Lanyon. *Mount St. Helens May 18, 1980*. 1981.
Lithograph, hand-tinted 1993. 26 x 22 1/2 x 1 3/8".

Elizabeth Layton. *Hope is my Sailboat*. 1985.
Colored pencil on paper. 31 1/4 x 23 3/4 x 1".

Elizabeth Layton. *"Her Strength is in Her Principles"*. 1992.
Poster. 23 1/4 x 29 1/4 x 3/4".

June Leaf. *Untitled*. 1963.
Charcoal on paper. 30 x 40 x 1 3/8".

June Leaf. *A Thing Made...(portrait of LRL)*. 1970.
Pencil and acrylic paint on paper. 31 1/2 x 43 x 1 3/8".

Michael Lebron. *Tired of the Jellybean Republic*. c. 1984.
Poster. 11 1/2 x 15 x 3/4".

Joanne Leonard. *Celebration*. 1975.
Mixed media collage on paper. 23 3/4 x 19 3/4 x 1 3/8".

Jack Levine. *"This is a Revolution Emma Goldman would
like" — Lippard, Barrio Jonathan Gonzalez, Managua*.
1983. Black and white photograph. 17 x 21 x 1 3/8".

*Sol LeWitt. Table. c. 1964.

Sol LeWitt. *Drawing for "Hockey Stick."* 1964.
Pencil on paper. 21 x 21 x 1 3/8".

Sol LeWitt. *(Hockey Stick)*. 1964.
Wood and paint. 67 x 9 x 3".

Sol LeWitt. *Untitled 9 (cover of Lippard's book* Changing*)*.
1969. Pen and ink on paper. 21 x 21 x 1 3/8".

*Sol LeWitt. *Untitled*. 1970. Color etching. 21 x 21 x 1 3/8".

Sol LeWitt. *Untitled*. 1970.
Color etching, Artists' Proof 19. 21 x 21 x 1 3/8".

Sol LeWitt. *Untitled*. 1970. Color etching. 21 x 21 x 1 3/8".

*Sol LeWitt. *Wall Drawing #73*. First installed March
1971 on a rough bricked wall at 138 Prince Street, New
York City. "Lines not touching, drawn at random, uni-
formly dispersed with maximum density, covering the
entire surface of the wall." Pencil on white wall (executed
at Bard by Sarah Granett).

Sol LeWitt. *3 x 3 x 3*. 1979.
Painted steel. 11 x 11 x 11".

Nancy Linn. *Ellenita*. 1982.
Color photograph. 29 x 43 1/4 x 1".

*Nancy Linn. *Father and Child*. c. 1983.
Color photograph, altered. 5 x 7" in plastic standup frame.

Lucy Lippard and Jerry Kearns. *Acting Out*. 1981.
Poster. 23 x 19 x 3/4".

Margaret Isham Lippard. *Florence*. c. 1949.
Watercolor on paper. 17 x 17 x 1 3/8".

*Vernon W. Lippard. *Bay Point*. 1950.
Watercolor on paper. 27 x 31 x 1 3/8".

Vernon W. Lippard. *Spiral Staircase, Fort Popham*.
c. 1952. Oil on board. 18 3/4 x 24 3/4 x 1/2".

Eileen Little. *Denver Protest*. 1986.
Black and white photograph. 22 3/4 x 26 1/4 x 3/4".

Allan Ludwig & Gwen Akin. *Bonzo*. 1985.
Black and white photograph. 21 x 25 x 1".

Muriel Magenta. *Lucy Lippard at Arizona State University*.
c. 1976. Poster. 16 x 11 x 3/4".

Robert Mangold. *1/2 Manila Curved Area Series W*.
c. 1968. Ink on manila paper. 29 1/2 x 34 x 1 3/8".

Raul Martinez. *Lucia*. 1968. Poster. 19 x 13 x 3/4".

Raul Martinez. *Untitled*. 1981.
Paint on black and white photograph. 18 x 23 x 1 3/8".

Marucha (Maria Eugenia Haya). *(couple in car)*.
c. 1985. Black and white photograph. 17 x 21 x 1 3/8".

*Mayito (Mario Garcia Joya). *(confessional)*. c. 1984.
Black and white photograph. 17 x 21 x 1 3/8".

Mayito (Mario Garcia Joya). *Caibarien*. c. 1985.
Black and white photograph. 17 x 21 x 1 3/8".

Ana Mendieta. *Silueta series*. c. 1970-80.
Seven color photographs. 19 x 19 x 1 3/8" each.

Ana Mendieta. *Rites and Ritual of Initiation*. March 1978.
Burned grass and paper. 22 1/2 x 18 1/2 x 2 1/2".

Ana Mendieta. *Pot ("my revolutionary soul")*. c. 1983. Ceramic. 5 x 6 1/2 x 5".

Shiko Munakata. *Untitled*. 1958. Woodcut on rice paper. 20 5/8 x 26 1/2 x 1 3/8".

Eadweard Muybridge. From *Animal Locomotion, Plate 154*. 1887. Black and white photographic reproduction from book. 21 x 25 1/4 x 1 3/8".

Anne Newmarch. *200 Years: Willy Willy*. 1988. Screenprint. 31 x 23 1/2".

Christine Oatman. *Personal Landscape Fantasies*. 1981. 12 postcards in plastic folder.

Alejandro Obregón. *Untitled*. 1950's. Color intaglio. 20 5/8 x 20 1/2 x 1 3/8".

*Doug Ohlson. *Red Balls*. 1969. Acrylic on canvas. 8 x 8 x 1".

Cesar Paternosto. *Untitled*. 1981. Acrylic emulsion and marble powder on paper, mounted on masonite. 11 1/2 x 11 3/8 x 1".

Howardena Pindell. *Untitled*. 1973. Ink on paper on graph paper. 26 x 29 1/2 x 1 3/8".

Larry Poons. *Untitled*. late 1960's. Screenprint. 34 x 34 x 1 3/8".

*José Guadalupe Posada. *"Sra. Calavera Catrina."* c. 1912. Engraving on paper. 18 1/2 x 24 1/2 x 1 1/4".

José Guadalupe Posada. *Calavera*. 1913. Engraving. 18 5/8 x 23 5/8 x 1 3/8".

Poster Collective (Australia). *"Pure Theory."* 1977. Poster. 21 x 31 x 3/4".

Robert Rauschenberg. *Poster for Drawing Exhibition at Dwan Gallery*. 1965. Offset lithograph. 31 x 33 x 1 3/8".

Odilon Redon. *Les Bêtes de la mer, rondes comme des outres*. c. 1888. Engraving. 23 5/8 x 19 5/8 x 1 3/8".

*Odilon Redon. *(Head with Zodiac Ram)*. c. 1895. Lithograph on paper. 18 x 15 x 1 3/8".

Ad Reinhardt. *Untitled*. Late 1960's. Screenprint, published by Wadsworth Atheneum. 34 x 29 1/2 x 1 3/8".

Barbara Jo Revelle. *Untitled (children against city skyline)*. c. 1993. Color photograph. 22 1/2 x 26 x 1 3/8".

Jolene Rickard. (Tuscarora) *Grandmother at Niagara Falls*. 1992. Photographic collage on paper. 23 x 29 x 1 3/8".

Faith Ringgold. *White Lady*. 1976. Fabric and mixed media. 13 x 8 x 5".

Tim Rollins & KOS. *No Heat*. 1982. Paint on found brick. 8 x 3 1/2 x 2 1/2".

Rachael Romero. *Gregory with Dollar Bill*. 1985. Acrylic on paper. 44 x 30 x 1".

Antoinette Rosato. *Mourning Picture*. 1994. Velvet and mixed media. 10 1/2 x 10 x 3/4".

James Rosenquist. *John Adams Rosenquist, heir apparent*. Sept 25, 1964. Screenprint. 26 x 22 1/2 x 1 3/8".

James Rosenquist. *For Love*. 1965. Silkscreen. 35 3/8 x 27 x 1 3/8".

Ethan Isham Ryman. *Hamburger with Bug*. c. 1974. Poster paint on paper. 24 1/2 x 36 1/2 x 3/4".

Robert Ryman. *Untitled*. 1959. Oil on canvas. 8 1/4 x 8 1/4 x 1".

Robert Ryman. *Untitled*. 1959. Oil on canvas. 44 x 44 x 2".

Robert Ryman. *Untitled (birthday drawing)*. 1963. Pencil, chalk and ink on paper. 34 x 34 x 1 3/8".

*Robert Ryman. *Untitled*. c. 1963. Mixed media on paper. 34 x 34 x 1 3/8".

Juan Sanchez. *La Lucha Continua*. 1986. Silkscreen. 22 x 30 x 1".

Juan Sanchez. *Recoge Tu Destino*. 1986. Silkscreen. 22 x 30 x 1".

David Sandlin. *I Could Waltz Across Sinland With You In My Arms*. c. 1991. Poster. 17 1/2 x 24 x 3/4".

William Short. *Le Tri Dzung, Artist, Veteran of the Vietnam War, NVA 1971-78*. 1989. Black and white photograph. 19 x 19 x 1 3/8".

*Charles Simonds. *(Little Books)*. 1970's. Mixed media.

*Charles Simonds. *Artpark 75*. 1975. Poster. 20 x 28 x 3/4".

*Charles Simonds. *In Buffalo*. c. 1975. Poster. 14 x 22 x 3/4".

Charles Simonds. *Growth House*. 1978. Lithograph and mud. 28 x 32 1/4 x 1 3/8".

Charles Simonds. *Strassenwelten, Kunstmuseum Bonn*. 1978. Poster. 19 1/2 x 21 3/4".

Charles Simonds. *Home for Wayward Little People*. c. 1978. Clay.

Lorna Simpson. *Untitled (street photograph)*. Early 1980's. Black and white photograph. 23 x 28 x 1 3/8".

Lorna Simpson. *III (Norton Family "Christmas Card")*. 1994. Mixed media multiple.

Jaune Quick-to-See Smith (Flathead/Salish). *Paper Dolls for a Post Columbian World*. 1991. Watercolor and pencil over photocopy paper. 71 x 35 3/8 x 1/4".

Kristine Smock. *Deer Rattle*. 1993. Painted clay.

Carl Smool. *Third World Disco, Cultural Workers and Artists for Nicaragua Today*. c. 1985. Poster. 13 3/4 x 13 3/8 x 3/4".

Joan Snyder. *Pink was Flesh....* 1975. Etching. 16 3/8 x 23 5/8 x 1 3/8".

Nancy Spero. *Spitting Fire*. 1966. Ink and paint on paper. 43 x 37 x 1 3/8".

Nancy Spero. *Text by Lucy Lippard for Nancy Spero's Torture of Women exhibition at A.I.R. Gallery*. 1976. Type and rubber stamp on paper. 16 3/4 x 20 3/4 x 1 3/8".

Nancy Spero. *Sheela Na Gig*. c. 1980. Paint, collage, print on paper. 35 x 29 x 1 3/8".

*Nancy Spero. *(Couple)*. c. 1980. Painted cutout on paper. 23 3/4 x 19 3/4 x 1 3/8".

*Frank Stella. *Untitled*. c. late 1960's. Screenprint. 34 x 29 1/2 x 1 3/8".

May Stevens. *Rosa Luxemburg*. 1977. Collage. 28 1/2 x 23 x 1".

May Stevens. *We are the Slaves of Slaves: Lucy E. Parsons*. 1980. Acrylic on xerox. 28 1/2 x 23 x 1".

Michelle Stuart. *Untitled*. April 14, 1975. Earth on muslin-backed paper. 22 1/2 x 18 1/2 x 2 1/2".

*Michelle Stuart. *Towncreek Mound, N.C. (near Gilead).* c. 1979. Color photograph and bag of dirt. 22 1/2 x 14 1/2 x 2 1/2".

Michelle Stuart. *Avebury, Wiltshire, England.* 1980-81. Black and white photograph: earth on muslin-backed paper. 11 3/4 x 12 1/4 x 1/2".

*Michelle Stuart. *Brookings Herbarium LXIV.* 1988. Encaustic, pigment and plants. 22 1/2 x 18 1/2 x 2 1/2".

Alex Sweetman. *Dress Shop, Tuluum, Mexico.* 1991. Color photograph. 26 x 20 x 1 3/8".

Alex Sweetman. *Peña Boulevard at Denver International Airport, Looking West.* 1994. Color photograph. 20 x 26 x 1 3/8".

*Yves Tanguy. *Untitled.* 1953. Print after a painting, 48/50. 26 1/2 x 20 5/8 x 1 1/4".

*Carlos Ugalde. *Managua, Nicaragua.* 1981. Color photograph of a drawing by a Salvadoran child (Alicia Cruz Zaldano). 18 1/2 x 23 1/2 x 1 3/8".

Rembrandt van Rijn. *Self Portrait with Saskia.* 1636. Etching, later printing. 19 3/4 x 14 x 1 1/4".

Kathy Vargas. From *Oración: Valentine's Day/Day of the Dead Series.* c. 1990. Hand colored photograph. 30 1/4 x 24 1/2 x 1".

Kathy Vargas. From *Oración: Valentine's Day/Day of the Dead Series.* c. 1990. Hand colored photograph. 30 1/4 x 24 1/4 x 1".

Regina Vater. *Untitled.* c. 1984. Photographic collage mounted on board. 34 x 24 x 1 3/8".

*Cecilia Vicuña. *"Ichu" (New York-Titicaca).* 1989. Bone, wood, grass and paint. 12 x 4 x 1".

Lawrence Weiner. *Statements.* 1968. Artist's book.

Lawrence Weiner. *Arctic Circle Shattered.* 1969. "Back in the bush Larry creased a rock with several shots of a .22 (The Arctic Circle Shattered)." (From *Changing.*)

Mac Wells. *Landscape.* 1964. Paint on wood. 7 7/8 x 9 7/8 x 1".

Hannah Wilke. *Untitled.* c. 1973. Chewing gum on paper. 13 x 10 1/2 x 1 3/8".

Grace Williams. *Working Women...(self portrait).* 1981. Mask with sequins, feathers and glitter. 7 x 7 x 2".

Peter Woodruff. *Underwater.* c. 1992. Color photograph. 12 3/8 x 16 1/2 x 3/4".

Peter Woodruff. *Underwater.* c. 1992. Color photograph. 12 3/8 x 16 1/2 x 3/4".

Melanie Yazzie (Navajo). *The U.S. Government Will Never White Wash My Grandparents.* 1992. Screenprint. 23 1/2 x 31 1/4 x 1".

"Headlines, Heartlines, Hardlines." In *Cultures in Contention.* Eds. Douglas Kahn and Diane Neumaier. Seattle: Real Comet Press, 1985. First published January-February 1984, See Part IV of this bibliography

*Melanie Yazzie (Navajo). *Indian Boy Art Project.* 1993. Screenprint. 23 1/2 x 31 1/4 x 1".

Terry Ybañez/Janis Kay. *Blue Star III.* 1987. Poster. 19 x 26 x 3/4".

*Terry Ybañez. *Noche de Estrellas.* 1992. Poster. 22 x 17 x 3/4".

Kestutis Zapkus. *Ulster Study.* 1981. Pencil on paper. 18 1/2 x 23 3/4 x 3/4".

*Kestutis Zapkus. *Embers (Children of War).* 1985. Screenprint. 25 5/16 x 36 x 3/4".

BIBLIOGRAPHY

Compiled by Natalie Frigo

December 1995

Due to limited time, space, and resources, this bibliography is not complete, but it is the first attempt to catalogue Lucy Lippard's thirty years of full-time freelance writings.

The bibliography is divided into eight sections, all but one organized chronologically: "Books by Lippard"; "Contributions to Anthologies and Other Books"; "Monograph Articles and Solo Catalogues" (ordered alphabetically by artist); "General Articles"; "Exhibition Catalogues"; "Catalogues for Exhibitions Curated by Lippard"; "Interviews with Lippard"; and "Fictions and Visual Work."

Essays reprinted in one of Lippard's four anthologies are indicated by the abbreviations C (*Changing*), FTC (*From the Center*), GTM (*Get the Message?*), and PGS (*The Pink Glass Swan*).

Works about Lippard (consisting mostly of book reviews and newspaper articles) are not included.

—N.F.

NOTE

I have kept no bibliographical records at all over the years, and Natalie Frigo had to start from scratch. I am immensely grateful for her good work and good humor under chaotic circumstances.

—*Lucy R. Lippard*

I: Books by Lippard

The School of Paris: Paintings from the Florence May Schoenborn and Samuel A. Marx Collection. With Alfred Barr and James Thrall Soby. New York: Museum of Modern Art, 1965.

The Graphic Work of Philip Evergood: Selected Drawings and Complete Prints. New York: Crown Publishers, 1966.

Pop Art. With contributions by Nicholas Calas and Lawrence Alloway. New York: Praeger Publishing, 1966.

Surrealists on Art. Editor. Englewood Cliffs, N.J.: Prentice Hall, 1970.

Dadas on Art. Editor. Englewood Cliffs, N.J.: Prentice Hall, 1971.

Changing: Essays in Art Criticism. New York: E. P. Dutton, 1971.

Tony Smith. London: Thames and Hudson, 1972. Also published in German by Verlag Gerd Hatje, Stuttgart, 1972.

Six Years: The Dematerialization of the Art Object from 1966 to 1972. . . . New York: Praeger Publishers, 1973. An annotated bibliography, chronology, and anthology.

Eva Hesse. New York: New York University Press, 1976. Reprinted in 1992 by Da Capo Press, New York.

From the Center: Feminist Essays on Women's Art. New York: E. P. Dutton, 1976.

What Do You See? Think? Say? Private and Public Responses to Art. Editor, with Williams students. Williamstown, Mass.: Williams College, January 1976.

Cracking/Brüchig Werden. Cologne: Verlag der Buchhandlung Walther König, 1979. An artist's book with Charles Simonds. Text in German.

I See/You Mean. Los Angeles: Chrysalis Books, 1979. A novel.

Ad Reinhardt. New York: Harry N. Abrams, 1981.

Overlay: Contemporary Art and the Art of Prehistory. New York: Pantheon Books, 1983.

Get the Message? A Decade of Art for Social Change. New York: E. P. Dutton, 1984.

A Different War: Vietnam in Art. Seattle: Real Comet Press, 1990.

Mixed Blessings: New Art in a Multicultural America. New York: Pantheon Books, 1990. An excerpt, "Mapping," reprinted in *Modern Art and Society*, 1994. See Part II of this bibliography.

How to '92: Model Actions for a Post-Columbian World. Coedited and cowritten with Kirsten Aaboe, Lisa Maya Knauer, Yong Soon Min, and Mark O'Brien. Minneapolis: Alliance for Cultural Democracy, 1992.

Partial Recall: Photographs of Native North Americans. Editor. New York: The New Press, 1992.

The Pink Glass Swan: Selected Feminist Essays on Art. New York: The New Press, 1995.

The Lure of the Local: Land, History, Culture, Art, and Place. New York: The New Press, forthcoming 1996–97.

Hot Potatoes. The Netherlands: G&B Arts (an imprint of G&B Arts International), forthcoming 1996. Selected essays by Lippard, response by Laura Cottingham.

II: Contributions to Anthologies and Other Books

[Several entries.] *Encyclopedia of World Art.* New York: McGraw Hill, 1959.

"Eros Presumptive." In *Minimal Art.* Ed. Gregory Battcock. New York: E. P. Dutton, 1968.

[Contributions to] *Open Hearing* and *Documents.* Co-editor. New York: Artworkers Coalition, 1969. Volumes of statements and protest documents; Lippard one of many coeditors.

"Alex Katz Is Painting a Poet." In *Alex Katz.* Eds. Irving Sandler and Bill Berkson. New York: Praeger Publishers, 1971.

"The Artworkers Coalition." In *Idea Art.* Ed. Gregory Battcock. New York: E. P. Dutton, 1973.

"The Dilemma." In *The New Art.* Ed. Gregory Battcock. New York: E. P. Dutton, 1973.

"Letter to a Young Woman Artist." In *Anonymous Was a Woman.* Valencia: California Institute of the Arts/Feminist Art Program, 1974.

"Centers and Fragments: Women's Spaces." In *Women in Architecture: A Historic and Contemporary Perspective.* Ed. Susana Torre. New York: Watson-Guptill Publications, 1977.

"The Pink Glass Swan." In *Feminist Collage: Educating Women in the Visual Arts.* Ed. Judy Loeb. New York: Teachers College, Columbia University, 1979. PGS

"To the Third Power: Art and Writing and Social Change." In *Voices of Women: 3 Critics on 3 Poets on 3 Heroines.* Ed. Cynthia Navaretta. New York: MidMarch Arts Press, 1980.

"Fire and Stone: Politics and Ritual." In *Seven Cycles: Public Rituals by Mary Beth Edelson*. New York: Mary Beth Edelson, 1980.

"Breaking Circles: The Politics of Prehistory." In *Robert Smithson: Sculpture*. Ed. Robert Hobbs. Ithaca: Cornell University Press, 1981.

"Foreword" to *Käthe Kollwitz: Graphics, Posters, Drawings*, by Renate Hinz. New York: Pantheon, 1981.

"Book Art: A Conversation among Jamake Highwater, Richard Kostelanetz, Lucy Lippard, and Paul Zelevansky." In *American Writing Today* vol. 2. Ed. Richard Kostelanetz. Washington, D.C.: USIS, 1982.

"Foreword" to *Mary Kelly: Post-Partum Document*. London: Routledge & Kegan Paul, 1983.

"Long-Term Planning: Notes toward an Activist Performance Art." In *Performance as Social and Cultural Intervention: A Special Issue of Open Letter*. Ed. Bruce Barber. Toronto: Coach House Press, 1983. GTM.

"Up, Down, and Across: A New Frame for Quilts." In *The Artist and the Quilt*. Ed. Charlotte Robinson. New York: Alfred A. Knopf, 1983.

"Trojan Horses: Activist Art and Power." In *Art after Modernism: Rethinking Representation*. Ed. Brian Wallis. Boston and New York: David R. Godine/New Museum of Contemporary Art, 1984. Also in *Art, Theory, and Criticism*, 1991.

"Foreword," "Forbidden Fruits," "Art Against Displacement," and "Artists Call," "Artists Call is Heard" (with Daniel Flores Ascencio). In *ABC No Rio Dinero: The Story of a Lower East Side Art Gallery*. Eds. Alan Moore and Marc Miller. New York: ABC No Rio/Collaborative Projects, 1985.

"Headlines, Heartlines, Hardlines." In *Cultures in Contention*. Eds. Douglas Kahn and Diane Neumaier. Seattle: Real Comet Press, 1985. First published January–February 1984. See Part IV of this bibliography.

"Wearable Political Statements" (with Seth Tobocman). In *The Art of Demonstration*. New York: Cultural Correspondence, 1985.

"American Landscapes." In *Markings: Aerial Views of Sacred Landscapes*. New York: Aperture, 1986. Text for book of photographs by Marilyn Bridges.

"Feminist Space: Reclaiming Territory." In *The Event Horizon*. Ed. Lorn Falk and Barbara Fischer. Toronto: The Coach Press, and Banff: Walter Phillips Gallery, 1987. PGS.

"Give and Takeout: Toward a Cross-Cultural Consciousness." In *The Eloquent Object: The Evolution of American Art in Craft Media since 1945*. Eds. Marcia Manhart and Tom Manhart. Seattle: University of Washington, 1987.

"Foreword" to *Marks in Place: Contemporary Responses to Rock Art*. Ed. Rick Dingus and Charles Roitz. Albuquerque: University of New Mexico Press, 1987.

"Conspicuous Consumption: New Artists' Books" and "The Artist's Book Goes Public." In *The Artist's Book*. Ed. Joan Lyons. Rochester, N.Y.: Visual Studies Workshop, 1987. The second of these articles originally published 1977. See Part IV of this bibliography.

"Captive Spirits." In *Multiethnic Literature*. Ed. Cordelia Candelaria. Boulder: University of Colorado, 1989.

"Moving Targets/Moving Out." In *Art in the Public Interest*. Ed. Arlene Raven. Ann Arbor: U.M.I. Press, 1989. Compendium of four Lippard articles from *The Village Voice* and *Z* magazine: "Mixed Messages from Public Artists," 1984; "One Foot Out of the Door," 1986; "Sniper's Nest: Moving Target," 1988; and "Drawing the Battlelines," 1988. See Part IV of this bibliography. The last of these articles later appeared in a revised version as the introduction to *World War 3 Illustrated*, see immediately below. .

"Introduction." *World War 3 Illustrated*. Eds. Peter Kuper and Seth Tobocman. New York: Fantagraphics Books, 1989.

[Excerpts from] "Towards a Post-Columbian World." In *Affirmative Actions: Recognizing a Cross-Cultural Practice in Contemporary Art*. Chicago: The School of the Art Institute of Chicago, 1990. A longer, related text appears in *Ethics of Change, Multicultural Issues: Conflict or Cooperation*, 1992. See below.

"Thinking about the Rosenbergs" and "Hanging onto Baby, Heating up the Bathwater." In *Reimaging America: The Arts of Social Change*. Eds. Mark O'Brien and Craig Little. Philadelphia: New Society Publishers, 1990. A much revised version of "Sniper's Nest: Of Babes and Bathwater," 1988. See Part IV of this bibliography.

Excerpt from the Foreword to *Käthe Kollwitz. Worlds of Art*. Ed. Robert Bersson., Mt. View, CA: Mayfield Publishing Co., 1991.

"Trojan Horses: Activist Art and Power" (1983). In *Art, Theory, and Criticism*. Ed. Sally Everett. Jefferson, N.C.: McFarland & Co., 1991.

"Andres Serrano: The Spirit and the Letter." In *Culture Wars*. Ed. Richard Bolton. New York: The New Press, 1992. Excerpt from article of the same title, 1990; see Part III of this bibliography.

"Toward a Post-Columbian World," and "Panel Discussion." In *Ethics of Change, Multicultural Issues: Conflict or Cooperation*. Ed. Elmer B. Fetscher. New Smyrna Beach, Fla.: Atlantic Center for the Arts, 1992. Transcribed lectures and symposium with Harvey B. Gantt, Richard Rodriguez, and Lippard.

"Foreword" to *Other Visions, Other Voices: Women Political Artists in Greater Los Angeles*, by Paul von Blum. Lanham, Md.: University Press of America, 1994.

"In Search of Cutural Amnesty." In *Skijin Ao Whaa (Indian Time); Contemporary Indian Art*. Odense (Denmark): Kunsthallen Brandts Klaedefabrik, 1994.

"Mapping." In *Modern Art and Society: An Anthology of Social and Multicultural Readings*. Ed. Maurice Berger. New York: Icon Editions/HarperCollins, 1994. Excerpt from *Mixed Blessings*, 1990; see Part I of this bibliography.

"Passenger on the Shadows." In *David Wojnarowicz: Brush Fires in the Social Landscape*. New York: Aperture, 1994.

"Crossfires." Preface to *Contracandelas*. By Gerardo Mosquera. Havana, 1995.

"Doubletake: The Diary of a Relationship with an Image." In *Poetics of Space*. Ed. Steve Yates. Albuquerque: University of New Mexico Press, 1995. Appeared earlier in *Partial Recall,* 1992 (see Part I of this bibliography) and also in *Third Text* 1991 (see Part IV of this bibliography).

"Looking Around: Where We Are, Where We Could Be." In *Mapping the Terrain: New Genre Public Art*. Ed. Suzanne Lacy. Seattle: Bay Press, 1995.

"Showing and Telling." In *The Book of Jabbo: Revelations in Six Languages*. By Mondo Jud Hart. Washington, D.C.: Azul Editions, 1995.

[Statement in] *Confessions of the Guerrilla Girls*. New York: HarperCollins, 1995.

"Foreword" to *Saint Paul Cultural Garden*. By Cliff Garten et al. Forthcoming 1996.

"Anti-Amnesia." In *The Lower Manhattan Sign Project*, New York: Repohistory Collective, 1996, 4–7. Reprint from 1992, see Part IV of this bibliography.

III: Monograph Articles and Solo Catalogues
Alphabetical by artist

"The Abstract Realism of Alice Adams." *Art in America*, September 1979, pp. 72–76.

"Floating, Falling, Landing: An Interview with Emma Amos." *Art Papers* (November–December 1991): 13–16.

"Taking Liberties." *The Village Voice*, 14 December 1982. On Ida Applebroog.

"The Continuing Education of a Public Artist." In *Conrad Atkinson: Picturing the System*. London: Pluto Press/Institute for Contemporary Art, 1981.

"Color at the Edge." *Artnews* (May 1972). On Jo Baer. FTC.

"Nightmare of History, the Personal and the Political." In *Rudolph Baranik: Elegies, Sleep, Napalm, Night Sky*. Columbus: University Gallery of Fine Art, Ohio State University, 1987. Transcription of a panel on Baranik's work with William Olander, Jonathan Green, and Lippard.

"Iain Baxter: New Spaces." *Arts Canada* (June 1969): 3–7.

"Lost Meanings, Kept Secrets: Lance Belanger's Neo Lithic Tango." In *Tango: Lance Belanger*. Ottawa: The Ottawa Art Gallery, 1995.

"Ronald Bladen's 'Black Triangle.'" *Artforum* 5, no. 7 (March 1967): 26–27.

"Jonathan Borofsky at 2,096,974." *Artforum* 13, no. 3 (November 1974): 62–63.

"Louise Bourgeois: From the Inside Out." *Artforum* (March 1975): 26–33. FTC. Reprinted in French in *Louise Bourgeois*. Lyons: Musée d'Art Contemporain, 1990.

"The Blind Leading the Blind." *Bulletin of the Detroit Institute of the Arts* 59, no. 1 (spring 1981): 25–29. On Louise Bourgeois.

"An Artist's Attempt to Nail the Nukes." *Boulder Daily Camera*, 24 July 1988. On Hank Brusselback.

"Rudy Burckhardt: Moviemaker, Photographer, Painter." *Art in America*, March–April 1975, pp. 75–81.

"Below the Chastity Belt." *The Village Voice*, 4 January 1983, p. 30. On Carnival Knowledge.

" 'I have been arriving here for forty-seven years'—Carol Ann Carter." In *Carol Ann Carter: Living Room*. Indianapolis: Indianapolis Museum of Art, 1994.

"Visitations." In *My Body Is My Country: Josely Carvalho*. Hartford: Real Art Ways, 1991.

"Rosemarie Castoro: Working Out." *Artforum* 13, no. 10 (summer 1975): 60–62. FTC.

"Getting Hers: Judy Chicago's *Through the Flower*." *Ms.*, August 1974, pp. 42–43.

"Judy Chicago, Talking to Lucy R. Lippard." *Artforum* 13, no. 1 (September 1974).

"Dinner Party: A Four Star Treat." *Seven Days*, 27 April 1979, pp. 27–29. On Judy Chicago. Reprinted as "Setting a New Place: Judy Chicago's Dinner Party" in GTM.

"Judy Chicago's 'Dinner Party.'" *Art in America*, April 1980, pp. 115–26.

"Born Again." *The Village Voice*, 16 April 1985, p. 96. On Judy Chicago's "Birth Project."

"Uninvited Guests: How Washington Lost the Dinner Party." *Art in America*, December 1991, pp. 39–49. On Judy Chicago.

"Dark Ages." *The Village Voice*, 14 May 1985, p. 98. On Sue Coe.

[Untitled.] *Papo Colo: Will, Power, and Desire: Painting, Sculpture, Drawing, Performance 1976–1986*. New York: Rosa Esman Gallery and Exit Art, 1986.

"Funk Rises." In *Cake Walk*. New York: Just Above Midtown/Downtown, 1983. On Houston Conwill.

"Cool Wave." *The Village Voice*, 10 July 1984, p. 69. On Eileen Cowin.

"Hanne Darboven: Deep in Numbers." *Artforum* 12, no. 2 (October 1973): 35–39. FTC.

"Builder on the Edge of a Chaotic World." In *Peter Dean: A Retrospective*. New York: Alternative Museum, 1990.

"Three Generations of Women: De Kooning's First Retrospective." *Art International* 9, no. 8 (1965): 29–31.

"Tom Doyle." In *Tom Doyle*. Düsseldorf: Kunstverein für die Rheinlande und Westfalen, (1965).

"Space Embraced: Tom Doyle's Recent Sculpture." *Arts* (April 1966): 38–43.

"Jimmie Durham: Post-Modernist 'Savage.'" *Art in America*, February 1993.

"Shutdown." In *Home Scrap: Post-Industrial Landscapes*. New York: Carlo Lamagna Gallery, 1988. On Raymon Elozua.

"The Sculpture." In *Max Ernst: Sculpture and Recent Painting*. New York: The Jewish Museum, 1966.

"Dada into Surrealism: Notes on Max Ernst as Proto-Surrealist." *Artforum* 5, no. 1 (September 1966): 10–15. C.

"Max Ernst and a Sculpture of Fantasy." *Art International* 11, no. 2 (1967): 37–44.

"Max Ernst: Passed and Pressing Tensions." *The Hudson Review* 23, no. 4 (Winter 1970–71): 701–709.

"The World of Dadamax Ernst." *Artnews* (April 1975): 27–30.

"In a/Of the/Moment." In *Carole Fisher*. Minneapolis: The Minneapolis Institute of Arts, 1984.

"Rupert Garcia: Face to Face." In *Rupert Garcia: Prints and Posters 1967–1990*. San Francisco: The Fine Arts Museum of San Francisco, 1992.

"Sniper's Nest: On the Verge/*Al Borde*." *Z* magazine, July 1989, pp. 98–100. On Guillermo Gomez-Peña.)

"Distancing: The Films of Nancy Graves." *Art in America* 63, November 1975, pp. 78–82. FTC.

"Progressive Artist Gets His Due." *The Guardian*, 22 April 1987, p. 20. On Peter Gourfain.

"Icons of Need and Greed." *The Village Voice*, 25 May 1982, p. 87. On Peter Gourfain.

"One Foot out the Door." *In These Times*, 9–22 July 1986, p. 24. On Group Material.

"Binding, Bonding." *Art in America*, April 1982. On Harmony Hammond.

"The Southwest as Vortex: Harmony Hammond's Farm Ghosts." *Harmony Hammond: Farm Ghosts*. Tucson: Tucson Museum of Art, 1993.

"Eva Hesse: The Circle." *Art in America* LIX (May 1971): 68–73. FTC.

"Eva Hesse." *Kunstwerk* 25 (March 1972): 31–36.

"Out of Bounds." In *Susan Hiller*. London: Institute of Contemporary Art, 1985.

"Hinesight." *The Village Voice*, 25 December 1984, p. 114. Primarily on Lewis Hine.

"Out of the Tub and into Trouble: An Interview with Nicole Hollander." *Boulder Daily Camera*, 29 March 1987, pp. 6–9.

"Douglas Huebler: Everything about Everything." *Artnews* (December 1972): 29–31.

"Hands On." In *Alexis Hunter: Photographic Narrative Sequences*. London: Edward Totah Gallery, 1981.

"Full of It: Hasty but Fond Notes on Bob Huot's Diary Paintings." In *Robert Huot*. Albany: University Art Gallery, State University of New York, 1976.

"One Here Now." In *Patrick Ireland*. Washington, D.C.: National Museum of American Art, 1986.

"His Eye Is Always On The Line, " In *Noah Jemisin*, Brookville, NY: Hillwood Art Museum, 1993.

"Dancing with History: Culture, Class, and Communication." In *Man on Fire: Luis Jimenez*. Ed. Ellen J. Landis. Albuquerque: The Albuquerque Museum, 1994. In English and Spanish.

"Stemming from. . . . " In *Patricia Johanson: Fair Park Lagoon, Dallas, and Color Gardens*. New York: Rosa Esman Gallery, 1983.

"The Long View: Patricia Johanson's Projects, 1969–1986." In *Patricia Johanson: Drawings and Models for Environmental Projects, 1969–1986*. Pittsfield: The Berkshire Museum, 1987.

"Dear Ray [Johnson] . . . Love, Lucy." *Art Journal* (spring 1977): 240.

"Tragi-Comix: Art in Search of New Symbols" *In These Times*, October 23, 1985, p. 14. On Jerry Kearns.

Risky Business: Jerry Kearns. See Part VIII of this bibliography, 1987.

"Critical Kindness." In *Treasures of New York: John Kindness*. Dublin: Kerlin Gallery/Arts Council of Northern Ireland, 1990.

"Lacy: Some of Her Own Medicine." *The Drama Review: A Journal of Performance Studies* 32, no. 1 (spring 1988): 71–76. On Suzanne Lacy.

"Sniper's Nest: Speaking Up." *Z* magazine, July–August 1993, pp. 92–94. On Suzanne Lacy.

"Ellen Lanyon's Natural Acts." *Art in America*, May 1983.

"Elizabeth Layton." *Women and Aging: An Anthology. New Directions for Women*, January–February 1986. Reprinted in *Calyx*, nos. 2–3 (winter 1986): 148–57.

"June Leaf: Life Out of Life." *Art in America*, March–April 1978.

"June Leaf with the Wind behind Her: A Conversation." In *June Leaf: A Survey of Painting, Sculpture, and Works on Paper 1948–1991*. Washington, D.C.: Washington Project for the Arts, 1991.

"Sniper's Nest: Captive Audience." *Z* magazine, June 1989, pp. 90–93. On Andrew Leicester.

"Joanne Leonard: Distilled Life." In *Inside and Beyond: Photographs by Joanne Leonard*. Austin: Laguna Gloria Art Museum, 1980.

"Lost and Found." In *Joanne Leonard, Not Losing her Memory: Stories in Photographs, Words and Collage*, Ann Arbor: University of Michigan Museum of Art, 1992.

"Public Dreams." In *Glenn Lewis: Utopiary, Metaphorest & Bewilderness, Works from 1967–1993*. Burnaby, B.C.: Burnaby Art Gallery, 1993.

"Sol LeWitt: Nonvisual Structures." *Artforum* 5, no. 8, April 1967. Later reprinted in *Looking Critical: 21 Years of Artforum Magazine*. Ann Arbor: UMI Research Press, 1984.

"The Structures, the Structures and the Wall Drawings, the Structures and the Wall Drawings and the Books." In *Sol LeWitt*. New York: The Museum of Modern Art, 1978.

"Sniper's Nest: Mozambique's Malangatana." *Z* magazine, September 1990, pp. 80–83.

"Walls and Areas." In *Robert Mangold*. New York: Fischbach Gallery, 1965.

"Robert Mangold and the Implications of Monochrome." *Art and Literature: An International Quarterly* 9 (summer 1966): 116–30.

"Ana Mendieta." *Art in America*, November 1985, p. 190. Obituary.

[Reminiscence in] "Ana Mendieta: A Selection of Statements and Notes." *Sulfur* no. 22 (spring 1988): 76–77.

"Brenda Miller: Woven, Stamped." *Art in America* 64, May 1976, pp. 96–97.

"Kay Miller: Laughing Matters to Life." In *Laughing Matters: Kay Miller*. Chicago: Artemisia Gallery, 1991.

"Mary Miss: An Extremely Clear Situation." *Art in America* 62, March 1974, pp. 75–77.

"Joan Mitchell." Written for but not published by *Ms.* magazine, 1972. FTC.

"Ree Morton: At the Still Point of the Turning World." *Ree Morton: Retrospective 1971–1977*. New York: The New Museum for Contemporary Art, 1980. Excerpted from *Artforum* (December 1973); an earlier version appeared in *Made for Philadelphia*. Philadelphia: Institute of Contemporary Art, University of Pennsylvania, 1973. FTC.

"Beverly Naidus." *Artforum* 18 (Summer 1980): 81ff.

"Who's on [the] First." *The Village Voice*, 3–9 June 1981, p. 78. On Paulette Nenner. GTM.

"The Abstraction of Memory." In *Cesar Paternosto*. New York: Center for Inter-American Relations, 1981.

"Notes on Henry Pearson: Based on Conversations with the Artist." In *Henry C. Pearson*. Duluth: Tweed Gallery at University of Minnesota, 1965.

"Henry Pearson." *Art International* 12, no. 4 (May 1965): 29–34. Reprinted in *Henry Pearson: A Retrospective Exhibition*. Raleigh: North Carolina Museum of Art, 1969.

"Dreams on Wheels: Ernie Pepion." In *Ernie Pepion: Dreams on Wheels*. Missoula: Missoula Museum of the Arts, 1993. First appeared in *Art Museum Missoula* (summer/fall 1991).

"Catalysis: An Interview with Adrian Piper." *The Drama Review: A Journal of Performance Studies* 16, no. 1 (March 1972). FTC.

"Larry Poons: the Illusion of Disorder." *Art International* 11, no. 4 (April 1967). C.

"Kenneth Price." In *Robert Irwin, Kenneth Price*. Los Angeles: The Los Angeles County Museum of Art, 1966.

"Richard Pousette-Dart: Toward an Invisible Center." *Artforum* 13, no. 5 (January 1975): 51–53.

"Pulsa." *Arts Canada* 25 (December 1968): 59–60.

"Yvonne Rainer on Feminism and Her Film." *The Feminist Art Journal* 4, no. 2 (summer 1975): 5–11. FTC.

"Talking Pictures, Silent Words: Yvonne Rainer's Recent Movies." *Art in America*, May–June 1977, pp. 86–90.

[Text for] *Lynn Randolph: Recent Paintings*. Houston: Graham Gallery, 1984.

[Text for] *Ad Reinhardt*. New York: The Jewish Museum, 1966.

"Ad Reinhardt: 1913–1967." *Art International* 21, no. 8 (1967): 19. Obituary.

"Ad Reinhardt: One Art." *Art in America,* September–October 1974, pp. 65–75.

"Ad Reinhardt: One Work." *Art in America,* November–December 1974, pp. 95–101.

"Faith Ringgold Flying Her Own Flag." *Ms.* 5, July 1976, pp. 257–64. Revised as "Faith Ringgold's Black, Political, Feminist Art." *Ms.* (July 1976): 257–64. FTC.

"Beyond the Pale: Ringgold's Black Light Series." In *Faith Ringgold: Twenty Years of Painting, Sculpture and Performance.* New York: Studio Museum in Harlem, 1984. FTC.

"Reading from Reality." In *Tim Rollins & K.O.S.* Philadelphia: Lawrence Oliver Gallery, 1987.

"Sniper's Nest: America, Amerika: Art against the Odds." *Z* magazine, December 1989, pp. 75–81. On Tim Rollins & K.O.S.

"James Rosenquist: Aspects of a Multiple Art." *Artforum* (December 1965): 41–45. C.

"Christy Rupp: Natural History Meets Coney Island and the Sandinistas." In *Natural Selection: Sculptures by Christy Rupp.* Buffalo: Burchfield Art Center at Buffalo State College, 1990.

"Andres Serrano: The Spirit and the Letter." *Art in America,* April 1990, pp. 238–45. Excerpted in *Culture Wars,* 1992. See Part II of this bibliography.

"Delayed Reactions." In *Roger Shimomura: Delayed Reactions.* Lawrence, Ks.: Spencer Museum of Art, University of Kansas, 1995.

"Sniper's Nest: Conscience Matters." *Z* magazine, January 1989, pp. 65–67. On William Short.

"Irene Siegel." *Art Scene* 1, no. 8 (May 1968).

"Microcosm to Macrocosm/Fantasy World to Real World." *Artforum* (February 1974): 36–39. An interview with/by Charles Simonds.

"Bending." *Works by Michael Singer.* Northampton, Mass.: Smith College Museum of Art, 1977.

"Richard Smith: Conversations with the Artist." *Art International* 8, no. 9 (November 1964): 31–34.

"Tony Smith: The Ineluctable Modality of the Visible." *Art International* (summer 1967): 24–26.

"The New Work: More Points on the Lattice. An Interview with Tony Smith." In *Tony Smith: Recent Sculpture.* New York: M. Knoedler & Co., 1971.

"Tony Smith: Talk about Sculpture." *Artnews* (Summer 1976).

Nancy Spero. New York: A.I.R. Gallery, 1976.

"May Stevens' Big Daddies." In *May Stevens: Big Daddies 1967–75.* New York: Lerner-Heller Gallery, 1975. FTC.

"Masses and Meetings." In *May Stevens Ordinary, Extraordinary: A Summation 1977–1984.* Boston: Boston University Art Gallery, 1985.

"Lucy Lippard on May Stevens." In *May Stevens: One Plus or Minus One.* New York: The New Museum of Contemporary Art, 1988.

"Sniper's Nest: In Sight, out of Mind." *Z* magazine, 2 May 1988, pp. 66–67. On May Stevens.

"Pandora." In *Strider: Sculpture and Drawings.* Greensboro: Weatherspoon Art Gallery at the University of North Carolina, 1974. On Marge Strider. FTC.

"Michelle Stuart's Reading in Time." In *Michelle Stuart: The Elements 1973–1979.* New York: Fawbush Gallery, 1992.

[Text for] *Athena Tacha: Massacre Memorials and Other Public Projects.* New York: Max Hutchinson Gallery, 1984.

"Athena Tacha's Public Sculpture." *Arts* magazine (October 1988): 68–71.

"Generous Art." In *Carlos Villa,* Berkeley: Visibility Press, 1994.

"The Vicuña and the Leopard: Chilean Artist Cecilia Vicuña Talks to Lucy Lippard." *Red Bass,* no. 10 (Women's International Arts Issue, 1986): 16–19.

"*Cecilia Vicuña: Hilando la fibra comun.*" *Arte Internacional* 18 (January–March 1994): 80–87.

"Shima: The Paintings of Emmi Whitehorse." In *Neezhaa: Emmi Whitehorse Ten Years.* Santa Fe: Wheelright Museum of the American Indian, 1991.

"Watershed: Contradiction, Communication, and Canada in Joyce Wieland's Work." In *Joyce Wieland.* Toronto: Art Gallery of Ontario, 1987.

"Jackie Winsor." *Artforum* 12, no. 6 (February 1974): 56–58. FTC.

"Out of the Safety Zone." *Art in America* 78, no. 12, December 1990. On David Wojnarowicz.

"Introduction II" In *Flo Oy Wong,* Berkeley: Visibility Press, 1992.

"Turning Over New Leaves with Installation Art." *Boulder Daily Camera,* February, 1988. On Betty Woodman.

"Art Tranquil, Defiant: Kes Zapkus." *Art in America,* summer 1982.

IV: General Articles

This list also includes anthologized articles which have a reputation beyond the anthologies in which they appear.

1960s

"Ernst and Dubuffet: A Study in Like and Unlike." *The Art Journal* 21, no. 4 (Summer 1962): 240–45.

"New York Letter." *Art International* 8, no. 10 (December 1964): 51–55.

"New York Letter: Olitski, Criticism and Rejective Art, Stella." *Art International* 9, no. 1 (1965): 34–41.

"New York Letter." *Art International* 9, no. 2 (1965): 46–52.

"New York Letter: Perverse Perspectives." *Art International* 9, no. 3 (1965): 48–64. C.

"New York Letter." *Art International* 9, no. 4 (1965)

"New York Letter." *Art International* 9, no. 5 (1965): 51–55.

"The Third Stream: Constructed Paintings and Painted Structures." *Art Voices* 4, no. 2 (spring 1965): 44–49.

"New York Letter: Rejective Art." *Art International* 9, no. 6 (1965): 57–61. C.

"New York Letter." *Art International* 9, no. 7 (1965): 31–33.

"New York Letter." *Art International* 9, no. 8 (November 20 1965): 36–43.

"New York Letter: Miró and Motherwell." *Art International* 9, nos. 9–10 (1965): 33–35.

"New York Letter." *Art International* 10, no. 1 (1966): 90–95.

"New York Letter: Recent Sculpture as Escape." *Art International* 10 no. 2 (1966): 48–52. C.

"New York Letter: Off Color." *Art International* 10, no. 4 (April 1966): 73–79.

"Not 'Boring' But Richly Sensual." *The New York Times*, 26 June 1966.

"Rebelliously Romantic?" *The New York Times*, 5 June 1967.

"An Impure Situation: New York and Philadelphia Letter." *Art International* 10, no. 5 (May 1966): 60–65. C.

"New York Letter." *Art International* 10, no. 6 (summer 1966): 108–15.

"Heroic Years from Humble Treasures: Notes on African and Modern Art." *Art International* 10, no. 7 (September 1966): 17–25. C.

"Questions to Stella and Judd." *Artnews* (September 1966): 55–61. Interview by Bruce Glaser, edited by Lippard.

"New York Letter." *Art International* 10, no. 8 (October 1966): 58–61.

"Rejective Art." *Art International* 10, no. 8 (October 1966): 33–36. C.

"Eccentric Abstraction." *Art International* 10, no. 9 (November 1966). C. This article differs from the exhibition catalogue of the same name. See Part V of this bibliography.

"After a Fashion—The Group Show." *The Hudson Review* XIX, no. 4 (winter 1966–67): 620–26.

"The Silent Art." *Art in America*, January 1967, pp. 58–63.

"Eros Presumptive." *The Hudson Review* (spring 1967): 91–99.

"Visual Art and the Invisible World." With John Chandler. *Art International* (May 1967): 27–30.

"Homage to the Square." *Art in America*, July 1967, pp. 50–57.

"Beauty and the Bureaucracy." *The Hudson Review* (winter 1967–68): 648–56. C.

"Escalation in Washington." *Art International*, 12 no. 1 (January 1968): 42–46. C.

"The Dematerialization of Art." With John Chandler. *Art International* 12, no. 2 (February 1968). C.

"Architectural Revolutions Visualized." *Art International* 12, no. 4 (April 1968): 36–41. C.

"Synthetic Sirens in the Pink Light District." *New York Magazine*, n.d. (April 1968), pp. 46–47.

"Notes on Dada and Surrealism at the Modern." *Art International* 12, no. 5 (1968): 34–39. C.

"Constellation by Harsh Daylight: The Whitney Annual." *The Hudson Review* 21, no. 1 (spring 1968): 174–82.

"Vancouver." *Artnews* (September 1968).

"Notes in Review of 'Canadian Artists '68': Art Gallery of Ontario." *Arts Canada* (February 1969): 25–27.

"Time: A Panel Discussion." *Art International* 13, no. 9 (November 1969).

1970s

"Art within the Arctic Circle." *The Hudson Review* (February 1970): 665–74.

"Groups." *Studio International* 12, no. 6 (March 1970): 93–99. Magazine presentation of exhibition curated by Lippard.

"The Art Workers' Coalition: Not a History." *Studio International* (November 1970). GTM.

"The Dilemma." *Arts* magazine, November 1970. GTM.

"Software Battle." *Artforum* (December 1970): 37.

"Change and Criticism, Consistency and Small Minds." Introduction to C, 1971.

"Charitable Visits by the AWC to Whitney, MoMA and Met." *The Element* 2, no. 4 (March–April 1971). FTC, GTM, PGS (excerpts).

"Sexual Politics: Art Style." *Art in America* 59, no. 5, September 1971. FTC, PGS.

[Statement on feminist criticism.] *Women in Art* 1, no. 1 (winter 1971). FTC.

"Two Proposals: Lucy Lippard Presents the Ideas of Adrian Piper and Eleanor Antin." *Art and Artists* (March 1972): 44–47.

"Flagged Down: The Judson Three and Friends." *Art in America* 60, May 1972.

[Statement on criticism.] *Art Rite*, no. 1 (1973): 5.

" 'Unmanly Art' at the Suffolk Museum, Stonybrook, New York." *Artnews* (January 1973): 77.

"Household Images in Art." *Ms.* 1, no. 9, March 1973. FTC, PGS.

"One." *Studio International* (September 1973): 102–103.

"Two." *Studio International* (October 1973): 162.

"Why Separate Women's Art?" *Art and Artists* (October 1973): 8–9. Reprinted in Spanish in *Artes Visuales* (Mexico) (January–March 1976).

"Robert Goldwater (1907–1973)." *Art in America* 61, November 1973, p. 41.

"Three." *Studio International* (November 1973): 202.

"Four." *Studio International* (December 1973): 254.

"Some of 1968 (Excerpts from *Six Years: The Dematerialization of the Art Object*)." *Arts* magazine (December 1973): 45–47.

"Five." *Studio International* (January 1974): 48.

"The Death of a Mural Movement." Edited from an article by Eva Cockcroft. *Art in America*, January–February 1974. GTM.

"Six." *Studio International* 187, no. 963 (February 1974). Revised for FTC, PGS.

"Seven." *Studio International* (March 1974): 142–43.

"More Alternate Spaces: The L.A. Woman's Building." *Art in America* 62, May 1974, pp. 85–86. FTC, PGS.

"A is for Artpark." *Art in America*, November–December 1974, pp. 37–39.

"Sensuous, Sensual, Sexual and/or Erotic Abstraction." 1975? Written for an anthology edited by Joan Semmel, forthcoming. FTC, PGS.

"The Activity of Criticism." *Studio International* (May 1975): 185–86.

"What Is Female Imagery?" *Ms.* 3, no. 11, May 1975. FTC.

"American Political Posters: Style vs. Sincerity." *Seven Days* preview, no. 2, June 2 1975, p. 25.

"Camouflage: Films by Holt and Horn." *Art Rite,* no. 10 (fall 1975). FTC.

"Making Up: Role-Playing and Transformation in Women's Art." FTC, PGS. First published as "Transformation Art" in *Ms.* 4, no. 4, October 1975.

"(I) Alcuni manifesti politici (II) E alcune questioni da essi sollevate intorno all'arte e alla politica" ([I] Some political posters [II] Some questions they raise about art and politics). *Data Arte* 19 (November–December 1975): 64–69. GTM.

"Bailing Up, Bailing Out." *Quadrant* 20, no. 1 (January 1976): 62–63. Book review of Murray Bail's *Contemporary Portraits.*

"Four Contemporary Artists Go 'Back to Nature': A New Landscape Art." *Ms.,* April 1977, pp. 68–73. FTC, as "Points of View: Stuart, DeMott, Jacquette, Graves."

"The Pains and Pleasures of Rebirth: European and American Women's Body Art." *Art in America* 64, no. 3, May–June 1976. FTC, PGS.

"Projecting a Feminist Criticism." *Art Journal* 35, no. 4 (summer 1976): 337–39. Excerpt from introduction to FTC, 1976.

"Northwest Passage." *Art in America,* July–August 1976, pp. 59–63. See also "The Rites of a Northwest Passage," in Part V of this bibliography, 1976.

"The Geography of Street Time: A Survey of Streetworks Downtown." In *SoHo,* Akademie der Künste, Berliner Festwochen, 1976. GTM.

"Changing since Changing." Introduction to FTC, 1976. PGS.

"The Pink Glass Swan: Upward and Downward Mobility in the Art World." *Heresies* no. 1 (January 1977). GTM, PGS.

"The Artist's Book Goes Public." *Art in America,* January–February 1977. Reprinted in *The Artist's Book,* 1987. See Part II of this bibliography. Also in GTM.

"This Is Art? The Alienation of the Avant-Garde from the Audience." *Seven Days,* 14 February 1977. Longer version in GTM.

"Caring: Five Political Artists." *Studio International* 193, no. 987 (March 1977): 197–207. GTM (excerpts).

"Community and Outreach: Art Outdoors, in the Public Domain (Excerpts from a Slide Lecture)." *Studio International* (March–April 1977). GTM. Originally presented in July 1975 under the auspices of the Power Institute of the University of Sydney, in Sydney, Brisbane, Canberra, Melbourne, Launceston, Hobart, Adelaide, and Perth (Australia).

"'Sculpture Sited' at the Nassau County Museum." *Art in America,* March–April 1977, p. 120.

"Report from New Orleans. You Can Go Home Again: Five From Louisiana." *Art in America* July–August 1977: pp. 22–25.

"Dada in Berlin: Unfortunately Still Timely." *Art in America,* March–April 1978, pp. 107–17. GTM.

"Raising Questions, Trying to Raise Hell: British Socio-Political Art." *Seven Days,* August 1978, pp. 27–29. GTM.

"Making Something from Nothing (Toward a Definition of Women's 'Hobby Art')." *Heresies* no. 4 (winter 1978). GTM, PGS.

"Complexes: Architectural Sculpture in Nature." *Art in America,* January–February 1979, pp. 84–85.

"Report from Houston: Texas Red Hots." *Art in America,* July–August 1979, pp. 28–31.

"Report from Colorado: Women's Art Festival." *Art in America,* October 1979, pp. 29–31.

"Past Imperfect." *The Nation,* 17 November 1979, pp. 501–503. Book reviews of Germaine Greer's *The Obstacle Race* and Andrea Callen's *Women Artists of the Arts and Crafts Movement.* GTM.

"Retrochic: Looking Back in Anger." *The Village Voice,* 10 December 1979, pp. 67–69. GTM, PGS, as "Rejecting Retrochic."

1980s

"Waking Up in N.Y.: PADD's Goal Is the Development of an Effective Oppositional Culture." With Jerry Kearns. *Fuse* (March–April 1981): 99–101. Reprinted from *First Issue* no. 1, (1980).

"Real Estate and Real Art à la Fashion Moda." *Seven Days,* April 1980, pp. 33–34. GTM.

"Reluctant Heroine." *The Nation,* 7 June 1980, pp. 694–97. Book review of Laurie Lisle's *Georgia O'Keeffe.*

"The Ten Frustrations, or Waving and Smiling across the Great Cultural Abyss." *Artforum* 18, no. 10 (summer 1980): 62–71. GTM.

"My-Art-Is-My-Politics." *The Nation,* 20 September 1980, pp. 256–59. Book review of Ralph Shikes's and Paula Harper's *Pissarro.*

"Sex and Death and Shock and Schlock: A Long Review of 'The Times Square Show.'" *Artforum* (October 1980). By "Anne Ominous," a Lippard pseudonym. GTM.

"Sweeping Exchanges: The Contribution of Feminism." *Art Journal* (Fall–Winter 1980). GTM, PGS.

"Some Propaganda for Propaganda." *Heresies* no. 9 (1980). Illustrations by Lippard. GTM, PGS.

"Print and Page as Battleground: A Slide Lecture." New York: Franklin Furnace, 1981. GTM.

"Beyond Pleasure." *The Village Voice,* 11–17 February 1981. GTM.

"Running the U.S.-Cuban Blockade." *The Village Voice,* 11–17 February 1981, pp. 83–84.

"Power Plays." *The Village Voice,* 25 February–3 March 1981, p. 72. GTM, PGS.

"Fighting Racism in the Arts." *The Guardian,* 18 March 1981, p. 21.

"The Angry Month of March." *The Village Voice,* 25–31 March 1981, p. 91. As "Acting Up" in GTM.

"Color Scheming." *The Village Voice,* 22–28 April 1981, p. 79. GTM.

"A Child's Garden of Horrors." *The Village Voice,* 24–30 June 1981, p. 83. GTM.

"The Conscious Collective." *The Village Voice,* July 22-28, 1981, p. 74. As "The Conscience Collective" in GTM.

"RX Art." *The Village Voice,* 19 August 1981. GTM.

[Untitled.] With Jerry Kearns. *The Village Voice,* 9–15 September 1981, p. 78. GTM.

"Open Season." *The Village Voice,* 7–13 October 1981, p. 91. GTM.

"Cashing in a Wolf Ticket: Activist Art and *Fort Apache: The Bronx*." With Jerry Kearns. *Artforum* 20, no. 2 (October 1981): 64–73. GTM.

"Gardens: Some Metaphors for a Public Art." *Art in America*, November 1981, pp. 135–50.

"They've Got FBEyes for You." *The Village Voice*, 4–10 November 1981, p. 114. GTM.

"All Fired Up." *The Village Voice*, 2–8 December 1981, p. 100. GTM.

"Report: The 'Art Politik' Conference." *Upfront* no. 3 (December 1981–January 1982): 4–5, 10.

"Everything Happens All Over, All the Time, At Once." Anonymous news column in each issue of the PADD magazine *Upfront*, 1981–86.

"Hot Potatoes: Art and Politics in 1980." *Block* no. 4 (1981). GTM.

"Happy Newsyear from Lucy Lippard and Jerry Kearns." *The Village Voice*, 30 December 1981–5 January 1982. GTM.

"Making Manifest." *The Village Voice*, 27 January–2 February 1982. GTM.

"Social and Public Arts Resource Center." *Upfront* no. 4 (February–March 1982): 4.

"Don't Bank on It." *The Village Voice*, 2 March 1982, p. 77.

"Forbidden Fruits." *The Village Voice*, 30 March 1982, p. 105.

"Passion Plays." *The Village Voice*, 4 May 1982, p. 95.

[Statements by Lucy Lippard and Candace Hill-Montgomery, cocurators of "Working Women/Working Artists/Working Together,"] District 1199 Gallery, New York, 1982. *Woman's Art Journal* (spring–summer 1982).

"A Small Slice of Whose Pie?" *The Village Voice*, 8 June 1982, p. 82.

"How Cool Is the Freeze?" *The Village Voice*, 15 June 1982.

"June 12: Post-Vivem." *The Village Voice*, 13 July 1982, p. 79.

"Revolting Issues." *The Village Voice*, 27 July 1982, p. 76.

"The Outrage of the Artist." *In These Times*, 28 July–10 August 1982, p. 21. Revised compilation of "Icons of Need and Greed", "A Small Slice of Whose Pie?", and "How Cool Is the Freeze?" (1982, see above). Reprinted as "Visual Problematics," in GTM.

"Out of Control: Australian Art on the Left." *The Village Voice*, 19 October 1982, p. 63. GTM.

"Happy Newsyear (2)." With Jerry Kearns. *The Village Voice*, 11 January 1983, p. 71.

"Luchar!" *Upfront* no. 5 (February 1983): 6.

"Authority Problems." *The Village Voice*, 8 February 1983, p. 69.

"Street: Cowboys and Guerrillas." With Jerry Kearns and Diane Neumaier. *Upfront* no. 6–7 (1983): 8–11.

"Cross-Country Music." *The Village Voice*, 8 March 1983, p. 72. See also below, May 1985, "Cross-Country Music and the Journalization of Art."

"Biofeedback." *The Village Voice*, 22 March 1983.

"Black and White and Gray All Over." *The Village Voice*, 17 May 1983, p. 90.

"Passionate Views of the '30s." *In These Times*, 1–14 June 1983, pp. 20–21.

"Too Close to Home." *The Village Voice*, 14 June 1983, p. 94.

"Ethnocentrifugalism: Latin Art in Exile." *The Village Voice*, 12 July 1983, pp. 79–81.

"Hotter Than July." *The Village Voice*, 9 August 1983, p. 72. GTM.

"Fast Forward, A Rapid Zineology." *The Village Voice*, 6 September 1983, p. 72.

"Calling the Shots." *The Village Voice*, 4 October 1983, p. 116.

"Power Control." *The Village Voice*, 18 October 1983, pp. 82–83. Also published in *911 Reports* (November 1983): 2.

"Coming Soon: The Fall and Rise of the New Man." *The Village Voice*, 1 November 1983, p. 96.

"Feminist Space: Reclaiming Territory." *The Village Voice*, 29 November 1983, p. 120.

"A Ribbon around a Bomb." *The New York Times Book Review*. 1983. Book review of Hayden Herrera's *Frida Kahlo*.

"Native Intelligence." *The Village Voice*, 27 December 1983, p. 102.

"Friendship and Play: As It Stands, Performance Festival by Interaction Arts." *High Performance* no. 24 (1983).

"Union Made: Artists Working with Unions." With Jerry Kearns, cocurator. *Upfront* no. 7 (winter 1983–84): 7–12. Transcription of panel on exhibition at District 1199 Gallery, New York.

"Artists Call Is Heard." With Daniel Flores y Ascencio. *Art and Artists* (January 1984). Reprinted in *Cultural Democracy* no. 30 (spring 1984): 2, 4, 8.

"Headlines, Heartlines, Hardlines." *Art Papers* (January–February 1984). Later reprinted in *Cultures in Contention*, 1985. See Part II of this bibliography.

"Happy Newsyear from Lucy Lippard and Jerry Kearns." *The Village Voice*, 31 January 1984, p. 84.

"Suburbia under Siege." *The Village Voice*, 10 January 1984, p. 36.

"Art." *The Nation*, 28 January 1984, pp. 102–104. Special issue on Central America.

"Political Art Activism: A Workshop with Lucy R. Lippard." *Live Art* (February 1984): 32–34.

"The Politically Passionate." *The Village Voice*, 21 February 1984.

"Captive Spirits." *The Village Voice*, 20 March 1984, p. 74.

"Ireland's Long Division." *The Village Voice*, 15 May 1984, pp. 89–90.

"One Liner after Another." *The Village Voice*, 10 April 1984, p. 73.

"Time Will Tell." *The Village Voice*, 19 June 1984, pp. 100–101.

"Activating Activist Art." *Circa* magazine (Northern Ireland) no. 17 (July–August 1984): 11–17.

"Art in Solidarity." *The Village Voice*, 28 August 1984.

"Out of Sight, Out of Mind III: Asian and Hispanic Artists." Editor. *Upfront* no. 9 (fall 1984): 17–21.

"Mixed Messages from Public Artists." *The Village Voice*, 2 October 1984.

"Planting Art in Nicaragua." *The Village Voice*, 23 October 1984, p. 107.

"Not So Far from South Africa." *The Village Voice*, 13 November 1984, p. 91. Reprinted in *Art Against Apartheid*, a special issue of *Ikon*, second series no. 5–6, (1986): 170–75.

"Battle Cries." *The Village Voice*, 4 December 1984, p. 105.

"Activist Art Now (a picture essay)." *GTM*, 1984, pp. 324–38.

"Happy Newsyear from Jerry Kearns and Lucy R. Lippard." *The Village Voice*, 1 January 1985, p. 70.

"Reading between the Stripes." *The Village Voice*, 19 February 1985, p. 102.

"Necessary Evils." *The Village Voice*, 19 March 1985, p. 92.

"Born Again." *The Village Voice*, 16 April 1985, p. 96.

"Cross-Country Music and the Journalization of Art." *Art Paper* (Minneapolis) (May 1985): 16–18. Revised version of "Cross-Country Music" 1983, above.

"Clash of '85." *The Village Voice*, 11 June 1985. PGS.

"Re-Orienting Perspectives by Asian American Artists." *In These Times*, 10–23 July 1985, p. 21.

"With RR in the White House and Political Art in the Museums, What Next?" With Jerry Kearns. *Upfront* no. 10 (fall 1985): 5–7.

"Guerrilla Girls." *In These Times*, 13–19 November 1985. PGS.

"First Strike for Peace." *Heresies* no. 20 (1985). PGS.

"Public Relations a.k.a. Propaganda." *Rampike* special double issue (1985–86): 54. From exhibition curated by Lippard at Franklin Furnace, 1985.

"Woman and Her Image." *Washington Post Book World*, 19 January 1986, p. 9. Book review of Marina Warner's *Monuments and Maidens*.

"Artists Issue a Call for Justice." *The Boulder Sunday Camera*, 9 March 1986.

"Cultural Transfusions Enlivening Western Art." *In These Times*, 12–18 March 1986, p. 21.

"Made in the U.S.A.: Art from Cuba." *Art in America*, April 1986, pp. 27–35.

"See Colorful Colorado." *In These Times*, 23–29 April 1986, p. 21.

"Out of Place, Out of Mind." *In These Times*, 21–27 May 1986, pp. 20–21.

"Homeless at Home." *East Village Eye* (December 1986–January 1987): 45.

"Rape: Show and Tell." *In These Times*, 10–16 December 1986. PGS.

"Spirited Union of Faith and Aesthetics in Cuban Art." *In These Times*, 11–17 March 1987, pp. 21–22.

"Tunneling to Artistic Enlightenment." *In These Times*, 8–14 April 1987, pp. 20–21.

"Opinionated and Outspoken." *Boulder Daily Camera*, 12 April 1987. Interviews with Leonor Arguello de Huper and Molly Ivins.

"Women's Week Stars Blood and Guts Queens." *Boulder Daily Camera*, 12 April 1987.

"Women Confront the Bomb." *Boulder Daily Camera*, 17 May 1987. PGS.

"Countering Cultures: Min Joong, Political Art in Korea." *Art and Artists* (June–July 1987).

"A Woman's Touch . . . under the Hood." *The Boulder Sunday Camera*, 5 July 1987.

"Holding Up a Mirror to America: Native American Art." *The Guardian*, 16 December 1987, pp. 10–11.

"Hard Looks: The Social Role of Photography as the '80s End. A symposium with Barbara Jo Revelle/Alex Sweetman, Shelley Rice, Sophie Rivera, Mel Rosenthal, Abigail Solomon Godeau, edited by Lucy R. Lippard." *Upfront* no. 14–15 (winter 1987–spring 1988): 25–51, 75.

"Art from Puerto Rico's Rich Soil." *The Guardian*, 17 February 1988, p. 20.

"Laughing Matters: Ethnic Attitudes Surface in a Century of 'The Funnies.'" *The Boulder Sunday Camera*, 28 February 1988.

"Sniper's Nest: Mestizaje." *Z magazine*, March 1988, pp. 58–59.

"Bursts of Light: An Interview with Audre Lorde." *The Boulder Sunday Camera*, 13 March 1988.

"Sniper's Nest: Moving Target." *Z magazine*, June 1988, pp. 45–46.

"Sniper's Nest: Of Babies and Bathwater." *Z magazine*, July–August 1988: pp. 99–102. Republished in a much revised version in *Reimaging America*, 1990, see under Part II of this bibliography.

"Right Now Is Always the Best Age." With Mary Mizenko. *Heresies* no. 23 (1988): 12–18. Interviews with women of all ages about aging, also see Errata.

"Sniper's Nest: Apple Panache and Downtown Dowdy." *Z magazine*, February 1989, pp. 82–84.

"Boulder Writers Discuss Salman Rushdie." *The Boulder Sunday Camera Magazine*, 26 March 1989, pp. 11–12.

"Burning Issue: The Supreme Court Considers Whether Flag Desecration Is Art or Indecency." *Boulder Daily Camera*, 26 March 1989.

"Sniper's Nest: This Is the Church and This Is the People." *Z magazine*, April 1989, pp. 68–71. From an interview with Charles Frederick.

"Esprits Captifs." *Les Cahiers du Musée National d'Art Moderne* (Paris) 28 (summer 1989): 103–110.

"El nuevo arte cubano y su critico." *Union* (Havana) no. 7 (July–September 1989): 90–96.

"Both Sides Now: A Reprise." *Heresies* no. 24 (1989). PGS.

1990s

"Into the Next Ten Years." *CHAC Reporter* (Denver) (1990).

"Taking Pictures...And Giving Them Back." *Z magazine*, June 1990, pp. 76–79.

"Turning the Mirrors Around: The Pre-Face." *American Art* 5, nos. 1–2 (winter–spring 1991). Reprinted in *Worlds in Collision*. Eds. Carlos Villa and Reagan Louie. San Francisco: San Francisco Art Institute, 1994.

"Sniper's Nest: The Art Draft." *Z magazine*, April 1991, pp. 72–75.

"Silence Still = Death." *High Performance* no. 55 (fall 1991): 28–31.

"Doubletake: The Diary of a Relationship with an Image." In *Third Text* no. 16–17 (autumn/winter 1991): 134–144. See also under 1995 in Part II of this bibliography.

"Sniper's Nest: The Garbage Girls." *Z* magazine, December 1991. PGS.

"The Hand of Memory in Some African-American and Latina Art." *Ikon* no. 12/13 (1991).

"Out of Turn." *Transition* no. 52 (1991). Book review of Michele Wallace's *Invisibility Blues*. PGS.

"Confronting the Multi-Culture: A Talk by Lucy Lippard." *Cultural Democracy* 40 (spring 1992): 10.

"Sniper's Nest: Too Close to Home." *Z* magazine, April 1992, pp. 77–79.

"Sniper's Nest: Equal Parts." *Z* magazine, October 1992. PGS.

"Sniper's Nest: Anti-Amnesia." *Z* magazine, December 1992, pp. 63–66. Reprinted in 1996, see Part II of this bibliography.

"Sniper's Nest: Summer Politics." *Z* magazine, October 1993, pp. 53–56.

[Reply to inquiry on definitions of public art.] *Public Art Review* (1993).

"Political Art Documentation & Distribution: Archival Activism." *Museum of Modern Art Library Bulletin* no. 86 (winter 1993/'94): 4–6.

"The Lure of the Local in a Multicentered Society." *FATE in Review* 17 (Honolulu) (1994–95): 3–8. Excerpts from a lecture and forthcoming book.

"We're On the Move." *The Dissident* (Portland, Me.) 1, no. 5 (November 1995): 16–17.

"Moving Targets/Concentric Circles: Notes from the Radical Whirlwind." Introduction to PGS, 1995.

"Undertones: Nine Cultural Landscapes." In *Reframing Photography*. Ed. Diane Neumaier. Philadelphia: Temple University Press, forthcoming 1996. Appeared previously in PGS.

V: Catalogues for Exhibitions Curated by Lippard

Note: Lippard has curated over fifty exhibitions, but many did not have catalogues.

"Eccentric Abstraction." In *Eccentric Abstraction*. New York: Fischbach Gallery, 1966. Text (different from the article of the same title in *Art International*) and plastic announcement.

"Focus on Light." In *Focus on Light*. Trenton: The New Jersey State Museum, 1967. Co-curated with Richard Bellamy and Leah P. Sloshberg.

[Text for] *Max Ernst: Works on Paper*. New York: The Museum of Modern Art, 1967. Circulating exhibition 1967.

[Texts for] *557,087*. Seattle: World's Fair Pavilion, Seattle Center, 1969. And [texts for] *955,000*. Vancouver: Vancouver Art Gallery and Student Union Building Gallery, University of British Columbia, 1970. Two different versions of one exhibition. Catalogues were packets of index cards, one for each artist, plus texts by Lippard.

[Texts for] *2,972,453*. Buenos Aires: CAYC, 1970. Different artists from *557,087* and *955,000* exhibitions; index card catalogue.

[Untitled.] *July/August Exhibition Book*. Ed. Seth Siegelaub. London: Studio International, 1970. Curator of one "section" of this conceptual show.

[Text for] *Twenty-Six Contemporary Women Artists*. Ridgefield: The Aldrich Museum of Contemporary Art, 1971. FTC, PGS.

[Texts for] *c. 7,500*. Valencia: California Institute of the Arts, 1974. Traveling exhibition of women conceptual artists; index card catalogue.

"The Rites of a Northwest Passage." In *In Touch: Nature, Ritual and Sensuous Art from the Northwest*. Portland: The Portland Center for the Visual Arts, 1976. Longer version published as "Northwest Passage," 1976, see Part IV of this bibliography.

[Text for] *Contact: Women and Nature*. Greenwich, Conn.: Hurlbutt Gallery, 1977.

[Text for] *Strata: Nancy Graves, Eva Hesse, Michelle Stuart, Jackie Winsor*. Vancouver: Vancouver Art Gallery, 1977. Excerpts from this catalogue were published in *Vanguard* (October 1977).

[Text for] *Issue: Social Strategies by Women Artists*. London: Institute of Contemporary Arts, 1980. GTM, PGS.

[Text for] *All's Fair: Love and War in New Feminist Art*. Columbus: Hoyt L. Sherman Gallery of Fine Art, Ohio State University, 1983. PGS.

"It Was a Time for Anger." In *Abstract Painting: 1960–69*. Text for this exhibition on the '60s, curated with Jerry Kearns, is included in the catalogue bearing the title of an (unrelated) show which ran concurrently at P.S. 1. Long Island City: P.S. 1, 1983.

[Text for] *From History to Action*. Los Angeles: The Women's Building, 1984. Exhibition juried by Lippard.

[Text for] *Divisions, Crossroads, Turns of Mind: Some New Irish Art*. Madison, Wis.: Ireland America Arts Exchange, Inc., and Williamstown, Mass.: Williams College Museum of Art, 1987. Also published as *Divisions, Carrefours, États d'Esprit: Un Nouveau Art Irlandais*. Quebec: Musée de Quebec, 1987.

[Text for] *Acts of Faith: Politics and the Spirit*. Cleveland: The Art Gallery at Cleveland State University, 1988.

"Blue Starts." In *Blue Star 4: An Annual Exhibition of Works by San Antonio Artists*. San Antonio: The Blue Star Art Space, 1989. Exhibition juried by Lippard.

"Slouching toward a Decision." In *Slouching toward 2000: The Politics of Gender*. Austin: Women & Their Work, 1993. Exhibition juried by Lippard.

VI: Exhibition catalogues

"American Painting: Cult of the Direct and the Difficult." In *Two Decades of American Painting*. New York: The Museum of Modern Art International Council, 1966. Exhibition for Japan, India, and Australia. C.

"As Painting Is to Sculpture: A Changing Ratio." *American Sculpture of the Sixties*. Los Angeles: Los Angeles County Museum of Art, 1967.

"La diversité dans l'unité. Les styles géométriques récents aux États-Unis." *Depuis 45: L'Art de nôtre temps*. Brussels: La Connaissance S.A., 1969, vol. 1.

[Texts on artists for] *New York 13*. Vancouver: The Vancouver Art Gallery, 1969.

"Absentee Information and/or Criticism." In *Information*. New York: The Museum of Modern Art, 1970. C.

"Top to Bottom, Left to Right." In *Grids*. Philadelphia: Institute of Contemporary Art, University of Pennsylvania, 1972.

"The Romantic Adventures of an Adversative Rotarian or Alreadymadesomuchoff." In *Marcel Duchamp*. Eds. Ann d'Harnancourt and Kynaston McShine. New York: The Museum of Modern Art, and Philadelphia: Philadelphia Museum of Art, 1973.

"Introduction" to *Women Choose Women*. New York: New York Cultural Center/Women in the Arts, 1973.

"Why a Women's Art Show?" In *Ten Artists (* Who Also Happen to Be Women)*. Lockport, NY: The Kenan Center, 1973.

Introduction to *Works on Paper: Women Artists*. Brooklyn: The Brooklyn Museum and Women in the Arts Foundation, 1975.

[Text for] *Mothers of Perception*. Newport, RI: Cooper Gallery, 1975.

"Introduction" to *Women Artists Series Year Five*. New Brunswick, NJ: Mabel Smith Douglass Library, 1975.

"The Women Artists' Movement. What Next?" In *Neuvième Biennale de Paris*. Paris: Musée d'Art Moderne de la Ville de Paris, 1975.

"The Magnetism of Fragmentation." In *Style and Process*. New York: Fine Arts Building, 1976.

"Three." In *Three Directions*. Newport Beach: Newport Harbor Art Museum, 1976.

"The Anatomy of an Annual." In *Hayward Annual '78*. London: Arts Council of Great Britain, 1978.

"Body, House, City, Civilization, Journey." In *Dwellings*. Philadelphia: Institute of Contemporary Art, University of Pennsylvania, 1978.

"Again, Again and Again, Again and Again and Again, Again." In *Intricate Structure, Repeated Image*. Philadelphia: Tyler School of Art of Temple University, 1979.

"Back Again." In *West of West,* by Nigel Rolfe. Dublin: Bord Na Mona, c. 1979. Book on "A Sense of Ireland," an "exhibition" of prehistoric monuments all over Ireland.

"The Inside Picture from the Outside." In *Architectural Sculpture*. Los Angeles: The Los Angeles Institute of Contemporary Art, 1980.

"Musing, Memories, Movement." In *Her Own Space*. Philadelphia: Muse Gallery, January 1983.

"Give and Take: Ideology in the Art of Suzanne Lacy and Jerry Kearns." In *Art and Ideology*. New York: The New Museum of Contemporary Art, 1984.

"Overlay: Images from A.I.R." In *A.I.R.* New York: A.I.R. Gallery, 1984.

"Double Vision: Women of Sweetgrass, Cedar, and Sage." In *Women of Sweetgrass, Cedar, and Sage: Contemporary Art by Native American Women*. New York: Gallery of the American Indian Community House, 1985. PGS.

"Dreams, Demands, and Desires: The Black, Antiwar, and Women's Movements." In *Tradition and Conflict: Images of a Turbulent Decade 1963–1973*. New York: Studio Museum in Harlem, 1985.

"Out of the Studio . . . For Good." In *Out of the Studio: Art with Community*. Long Island City: The Public Art Fund Newsletter, 1987.

"Countering Cultures." In *Min Joong Art: New Movement of Political Art from Korea*. Toronto: A Space, 1987.

"Notes on the Independence Movement." In *1967: At the Crossroads*. Philadelphia: Institute of Contemporary Art, University of Pennsylvania, 1987.

"The Wings of Privacy." In *Inside/Outside: Private Art*. Portland: AREA Gallery at University of Southern Maine, 1987.

"Doubled Over." In *Vices/Follies/Stupidities/Abuses, Visual Satire: Artist's Books*. Tallahassee: Florida State University Gallery and Museum, 1988.

"Empathy and Indignation." In *Women Artists of the New Deal Era: A Selection of Prints and Drawings*. Washington, D.C.: The National Museum of Women in the Arts, 1988.

"Amazing Grace." In *Ten Years of Grace: An Exhibition of Vermont Grass Roots Art*. Cambridge, Mass.: The New England Foundation for the Arts, 1988?.

"Colorization." In *Contemporary Art by Women of Color*. San Antonio: Guadalupe Cultural Arts Center and Instituto Cultural Mexicano, 1990.

"Waiting to See." In *Awards in the Visual Arts*. Winston-Salem, NC: Southeastern Center for Contemporary Art, 1990.

"Intruders: Lynda Benglis and Adrian Piper." In *Breakthroughs: Avant-Garde Artists in Europe and America, 1950–1990*. Ed. John Howell. New York: Rizzoli International Publications, Inc., 1991.

"The Color of the Wind." In *Our Land/Ourselves: American Indian Contemporary Artists*. Albany: University Art Gallery, Albany State University, 1991.

"Here's Where It Hurts." In *This is My Body, This is My Blood*. Amherst: Herter Art Gallery, University of Massachusetts, 1992.

"Columbus Backwards." In *The Submuloc Show/Columbus Wohs*. Phoenix: Atlatl, 1992.

"Transformers." In *Sites of Recollection: Four Altars and a Rap Opera*. Williamstown: Williams College Museum of Art, 1993.

"Crossing into Uncommon Grounds." In *Common Ground/Uncommon Vision: The Michael and Julie Hall Collection of American Folk Art at the Milwaukee Art Museum*. Milwaukee: The Milwaukee Art Museum, 1993. Reprinted in *The Artist Outsider: Creativity and the Boundaries of Culture*, eds. Michael D. Hall and Eugene W. Metcalf, Jr. Washington, D.C., and London: Smithsonian Institution Press, 1994.

"In the Flesh." In *Backtalk*. Santa Barbara: Santa Barbara Contemporary Art Forum, 1993.

"Moving Targets/Concentric Circles: Notes from the Radical Whirlwind." In *Backtalk*. Santa Barbara: Santa Barbara Contemporary Art Forum, 1993. GTM, PGS.

"Transparencies." *History 101: The Re-Search for Family*. St. Louis: Forum for Contemporary Art, 1994. On Lippard's family history.

"The Road to Hell." In *Prison Sentences: The Prison as Site/The Prison as Subject*. Philadelphia: Eastern State Penitentiary and Moore College of Art and Design, 1995.

"Escape Attempts." In *Reconsidering the Object of Art: 1965–1975*. Los Angeles: The Museum of Contemporary Art, 1995.

"Distant Relations." In *Distant Relations*. Ed. Trisha Ziff. Santa Monica: Santa Monica Museum of Art, 1995.

"Around Here/Out There: Notes from a Recent Arrival." *Longing and Belonging: The Faraway Nearby*. Santa Fe: SITE Santa Fe, 1996.

"The World in Their Hands." *Souls Grown Deep: African American Vernacular Art of the South*. Atlanta: Michael Carlos Museum/Emory University, forthcoming 1996.

VII: Interviews with Lippard

[Edit Deak and Walter Robinson] "Freelancing the Dragon." *Art Rite* no. 5 (Spring 1974): 16–19. FTC.

Stephen, Ann. "At the Edge of a Feminist Criticism: An Interview with Lucy Lippard. *Meanjin Quarterly* 4 (1975): 380–87.

Womanart (winter–spring 1977).

[Untitled by] Amateau, Michele. In *Ocular: The Directory of Information and Opportunities for the Visual Arts* 2 no. 3 (fall 1977): 32–42.

Coxhead, David. "Growing Up: Lucy Lippard with David Coxhead." *Artmonthly* (London) (November 1979): 4–10.

Troy, David. "Art through the Eyes of an Arts Populist." *Artworkers News* (April 1980): 14–16.

Horsfield, Kate. "On Art and Artists: Lucy Lippard '74 and '79." *Profile* 1, no. 3 (May 1981): 1–8.

Melkonian, Neery. "Art in a Multicultural America: An Interview with Lucy R. Lippard." *Artspace* (September–October 1990). PGS.

"Interview: Lucy R. Lippard." Wilson, MaLin. *THE* (Santa Fe) (June 1995): 23–25.

Hamilton, Peter. In *UCLART: A Literary Art Journal* (1995–96).

VIII: Fictions and Visual Work

"The Storm." *The Abbot Courant* (Andover, Mass.) 80, no. 2 (June 1953): 36–37.

"Comprehension," "Restraint," "Reaction to a New England Field." *The Abbot Courant* (Andover, Mass.) 81, no. 1 (February 1954): 10, 42–43.

"A Character Sketch" and "Emotions." *The Abbot Courant* (Andover, Mass.) 81, no. 2 (May 1954): 32–34.

"The Chase." *The Grecourt Review* (Northampton, Mass.) 1, no. 1 (November 1957): 26–31.

"In the Heat of the Day." *The Grecourt Review* (Northampton, Mass.) 1, no. 3 (March 1958): 60–63. Reprinted in *Ivy* magazine (1958).

"Cocteau at the Pentagon." In *This Book Is a Movie: An Exhibition of Language Art and Visual Poetry.* Eds. Jerry G. Bowles and Tony Russell. New York: Dell Publishing, 1971.

"Imitation = Homage to Sol LeWitt." *Dust: An International Quarterly of the Arts* 4, no. 3 (1971): 20–21.

Untitled [Reprinted as "Waterlay"]. *Center* 4 (November 1972): 9–10. FTC.

"Caveheart for Charles." *Center* 5 (September 1973): 54–55. FTC.

"An Intense and Gloomy Impression for a Woman in the Nineties." *Big Deal* 2 (spring 1974): 3.

"Touchstones." *Tractor* 6 (1975): 30–31.

"New York Times II." *Center* 7 (April 1975): 54. Also published in *Unmuzzled Ox* 4, no. 1 (1976): 98.

"New York Times I." *The World* 30 (July 1976): 19–20. Reprinted in *Out of This World: The Poetry Project at the St. Mark's Church-in-the-Bowery.* Ed. Anne Waldman. New York: Crown Publishers, 1991.

Five Prose Fictions ("The Cries You Hear," "New York Times IV," "Headwaters," "Into Among," "First Fables of Hysteria"). New York, 1976. Xeroxed booklet for exhibition at A.I.R.

"Three Short Fictions" ("The Cries You Hear," "Into Among," "Headwaters"). *Heresies* no. 2 (1977): 22–24.

"Projections." *Sun & Moon: A Journal of Literature and Art* no. 4 (fall 1977): 78–86.

"Stonesprings: Prose and Photos." *Heresies* (spring 1978): 28–31.

"Excerpts from *I See/You Mean.*" *Center* 11 (July 1978): 50–59.

"Photo-Dialogue IV." *Criteria: A Critical Review of the Arts* 4, no. 1 (spring 1978): 16.

"Three Fictions" ("Hiding," "Rose Atoll," "Plateaus"). *Sun & Moon: A Journal of Literature and Art* nos. 6–7 (winter 1978–1979): 38–40.

"Art World." *Unmuzzled Ox: The Poet's Encyclopedia* 4, no. 4/5 (1979): 28–31.

"New York Times IV." In *A Day in the Life: 24 Hours in the Life of a Creative Woman.* Chicago: A.R.C. Gallery, 1979. PGS.

"Above It All and Below It All with Polly Tickle." *Images and Issues* (fall 1980): 32–33. Comic by "Lucy the Lip."

"Above It All and Below It All 2." *Images and Issues* (winter 1980–81): 34–35. Comic by "Lucy the Lip."

"Sweet Tooth and Royalty" and "Home Anthropology." *Cover* 5 (spring–summer 1981): 58–60.

"Home Economics." *Heresies* no. 13 (1981): 50–55.

"More on Home Economics." *Shantih: The Literature of Soho* 4 nos. 3–4 (winter–spring 1982): 100–102.

"Why Copy?" *Franklin Furnace Flue* 2, no. 1 (spring 1982): 24. Visual.

"Moving Stars," "Cross-Dressing Codes" (with Sabra Moore and Holly Zox), "Class Notes" (with Nicky Lindeman). In *Events.* New York: New Museum of Contemporary Art, 1983. Statements and wall-art collages.

"Turning Points." With Jerry Kearns. *Upfront* no. 6–7 (summer 1983).

"Jake and Lil on Crisis." With Jerry Kearns. In *Art and Social Change,* Oberlin: Allen Memorial Museum, 1983, pp. 70–71

"Propaganda Fictions." Text of 1979 performance, published in *Get the Message?,* 1984.

[Texts for] *Risky Business: Jerry Kearns.* New York: Kent Fine Art, 1987. Fictional texts keyed to Kearns' paintings.

"Putting Oneself Down on Paper." *Eau de Cologne III.* Cologne: Monika Spruth Galerie, 1989. Excerpts from *I See/You Mean,* presented as "autobiography" by Sabeth Buchmann.

"Stay Out Before . . . Let Us Out of War." With Caroline Hinkley. *The New Censorship* (Denver) 1, nos. 11–12 (February–March 1991): 10–11.

"Gone By." In *Garden Court.* Ed. Mike Glier. Elkins Park, Pa.: Tyler Galleries, Temple University, 1995. Fiction in response to Glier paintings.